Great Plains Indian
Illustration Index

Great Plains Indian Illustration Index

Compiled by
JOHN VAN BALEN

McFarland & Company, Inc., Publishers
Jefferson, North Carolina, and London

LIBRARY OF CONGRESS CATALOGUING-IN-PUBLICATION DATA

Van Balen, John.
Great Plains Indian illustration index / compiled by John Van Balen.
p. cm.
Includes bibliographical references.

ISBN 0-7864-1614-9 (illustrated case binding : 50# alkaline paper)

1. Indians of North America — Great Plains — Pictorial works.
2. Indians of North America — Great Plains — Portraits.
3. Indians of North America — Great Plains — Indexes. I. Title.
E78.G73V36 2004 978.004'97'00222 — dc22 2003020699

British Library cataloguing data are available

Cover image ©2003 Sarah Henry Sanders

Manufactured in the United States of America

*McFarland & Company, Inc., Publishers
Box 611, Jefferson, North Carolina 28640
www.mcfarlandpub.com*

Acknowledgments

This work would not have been possible without the assistance that I received from Michelle Nassen, Tricia Kosters, and Rita Carpenter, who participated in its preparation.

I would like to express my gratitude to my wife Jeanne and daughter Katie for encouraging me to finish the book.

Contents

Preface

The *Great Plains Indian Illustration Index* is designed to guide the user to photographs, maps, drawings and other illustrations that appear in selected books depicting Native Americans, their history and culture. More than 4200 subject headings are listed.

Because library catalog records do not adequately describe the contents of books or illustrative materials that they contain, it is not always easy to locate artworks or photographs depicting certain subjects. This reference work should make the task easier by directing individuals specifically to page numbers where illustrations appear and by describing the subject of the illustration. The *Great Plains Indian Illustration Index* is also a resource for finding artwork, photographs, and other illustrations by well-known artists and photographers such as John A. Anderson, Karl Bodmer, George Catlin, Edward Curtis, Charles King Bird, Seth Eastman, Oscar Howe, L.A. Huffman, Margaret LeFranc, Alfred Miller, James Mooney, Stephen Mopope, William Soule, Paul Zo-Tom and many others.

The works cited in this index were published between 1911 and the end of 2002 and provide references to Native American artifacts and cultural activities dating from pre–European contact to the present. Although the primary focus of this index is on the indigenous Great Plains tribes, illustrative materials relating to neighboring tribes—for example, the Apache—were included when found in the works examined for indexing. Over thirty tribes were removed from their homelands and resettled in the Indian Territory (present day state of Oklahoma) or to parcels of land set aside for them by the federal government on the Great Plains. Illustrative materials for these tribes were also selectively included when they added substantive content to the index. Such references may be useful even if they at first appear to fall outside of a researcher's particular area of interest, since many cultural affinities are shared among Native American tribes.

More than 340 books were examined; all are listed in the bibliography. The majority of the books scanned fall within the scope of anthropology, history, Indian-Government relations, arts and crafts. The indexed books are typically found in academic and larger public libraries. The books referenced in the index should be readily available through interlibrary loan services provided by community or academic libraries.

Great Plains tribes listed in the subject index include:

Apache	Creek	Omaha	Quapaw
Arapaho	Crow	Osage	Sac and Fox
Arikara	Gros Ventre	Otoe and Missouri	Sarcee
Assiniboine	Hidatsa	Ottawa	Seminole
Blackfoot	Iowa	Pawnee	Seneca
Caddo	Kansa	Peoria	Shawnee
Cherokee	Kickapoo	Plains Apache	Sioux
Cheyenne	Kitsai	Plains Cree	Stoney
Chickasaw	Kiowa	Plains Ojibwa	Tonkawa
Choctaw	Mandan	Ponca	Wichita
Comanche	Modoc	Pottawatomie	Wyandotte

Arrangement
and Use of the Index

The *Great Plains Indian Illustration Index* is arranged in two major sections: an alphabetically arranged index to subjects and personal names; and a bibliography listing all the works indexed.

Personal names and subject entries occur in this index in alphabetical order. Subject entries tend toward the specific. Selected *see* and *see also* references are provided. For example, the heading *Sioux Indians* is used in this work as a general term. However, *see also* references (related terms) will direct users to Sioux bands, reservations, tribal band divisions and dialects.

The more than 3500 personal names listed in this work will direct the user to photographs, drawings and other artistic works depicting those persons. However, this index can also help locate references about a person's life. The citation information included with each personal name flags the work that may have information about that person. (The reader should peruse that work's index to find specific references to the person.)

Tribal affiliation is included with the person's name if it is known. Keep in mind that it is possible for some Native Americans to have more than one tribal affiliation. Some individuals are further identified with their occupation (artist, photographer) or status within their tribes. When provided by the indexed work, both traditional and contemporary names (typically European or American) are also included. Persons of non–Indian lineage who had contact with the Great Plains Tribes are also included in this work; for example, traders, Indian agents, military personnel, missionaries, politicians and artists are included.

Typical examples of personal name and subject entries are provided below:

Personal name *Tribe*

Curly Chief: Pawnee Chief
(group photo), Blaine p216

Illustration *Author of work and page number on which illustration appears*

Personal name Occupation of individual
 / /
Miller, Alfred Jacob: Artist
 Bull Bear, 1837 (portrait), Hassrick, R. no paging
 \ \ /
 Subject Date of portrait No pagination available

Personal name
 /
Short Bull: Lakota

 type of illustration author and first significant word from title
 / \ /
(portrait by Loren Zephier), Sneve, V. (*They*) p32, Hanson, J. p80+
 / /
 pagination where illustration appears grouped illustrations not paged,
 illustrations start at p80

 Subject heading
 /
Bags (*see also* Shoulder Bags)

 Tribe that constructed the bag
 \ type of illustration
 \ /
 Yanktonai Sioux /
 Beaded bandolier bags (photo), Hoover, H. p81
 Parfleche (watercolor by Saul), Brokenleg, M. p51
 \ /
 topic of illustration author of work and page number where the illustration appears

Some of the works examined were published without pagination, or did not include pagination for those pages where illustrations were inserted into the body of the work. The plus sign (+) is used in this index to alert users that the illustration is located in a portion of the book that is not paged.

Illustrations listed without pagination are treated in the following manner:

Red Cloud: Oglala Sioux chief
 (photo), Hyde (*Sioux*), p76+
 /
 + symbol indicates the illustration either faces or follows page 76

Refer to the bibliography for complete information regarding authors and their works.

ILLUSTRATION INDEX

A

A-mis-quam (Wooden Ladle): Winnebago
(color painting by J. O. Lewis), Moore
(*Native*), p106
(color photo), McKenney v2, p274+

A-she-gah-hre: Osage
Osage Council, 1895 (group photo), Baird
(*Osage People*), p69

Aah-an-golta: Shoshone Chief
His son (group photo) 1883, Fowler (*Arapahoe Politics*), p74+

Abandoned (George Miller): Omaha
(photo), Barnes, p114+

Abbott, John: Osage
(photo by E. Curtis) 1927, Curtis (*Plains*),
plate 9

Abert, J.W.: Artist
Drawing of Bent's Fort, 1845, Wunder, p50

Abrams, Abner W.: Quapaw & Stockbridge
(photo), Baird (*Quapaws*), p72
1920 (photo), Baird (*Quapaw Indians*), p143

**Ac-kyo-py (Woman That Sets): Gros Ventre
Chief**
(sketch) 1855, Sturtevant, v13, p679

Acton Battle
Combat against Little Crow's warriors (painting), Carley, K., p52

Adair, William Penn: Cherokee Delegate
Confederate Cherokee Delegates to Washington, 1866 (group photo), Pierce, p41

Adalpepti: Kiowa
Demonstrating the use of bow and arrow
(photo by James Mooney), Merrill, p309
Wearing a feather bonnet and holding a shield
(photo by James Mooney), Merrill, p308

Adams, Simon (Dog Chief): Pawnee
(group photo), Blaine (*Some*), p42+

**Adams, Simond (Asa-kisure-sa, Chiefly Dog):
Pawnee**
1929 (photo), Murie (*Part II*), p229

**Addih-Hiddisch (Maker of Roads): Hidatsa
Chief**
(painting by K. Bodmer), Bodmer, Moore
(*Native*), p259, p315

Addison, Burdick: Arapaho
1977 (photo), Fowler (*Arapahoe Politics*), p170+

Addo-eta (Addo-eette, Big Tree): Kiowa Chief
(photo by W.S. Soule), Nye (*Plains*), p317,
Nye (*Carbine*), p142+, p144+

Adlguko (Yellow Hair): Kiowa
(group photo), Merrill, pii

Adlpaide: Kiowa
(group photo), Merrill, pii

**Ado-eete (Big Tree, Ado-eta, Addo-eetee):
Kiowa Chief**
(photo by W. Soule) 1870, Mayhall (*Kiowas*),
p30+

Adultery
Blackfoot
Punishment for (photo), Ewers, J. (*Blackfeet*),
p94+
Chiricahua Apache
Woman with mutilated nose (photo), Opler,
p410+

Agard, Aljoe: Sioux
(photo), Doll, D., p72

Agriculture
Cheyenne
Digging roots (photo), Bonvillain,
Cheyennes, p23
Winter feeding cattle (photo), Moore
(*Cheyenne*), p283
Crow
Hay Cropping, Hoxie, p275
Tobacco garden (photo), Lowie, p290+
Drying food, 1919 (photo by Gilbert L. Wilson),
Peters, V., p124+
Hay crop (photo), Farr, W., p116
Mandan
Hoeing, 1912 (photo by Gilbert L. Wilson),
Peters, V., p124+
Midwinter Fair (photo), Farr, W., p118
Pawnee
Gardening tools, Hyde (*Pawnee Indians,
1951*), p99
Piegan Indian
1924 (photo), Farr, W., p111
Rakes (drawing), Peters, V., p124+
Squash slices on willow splint, 1916 (photo by
Gilbert L. Wilson), Peters, V., p124+
Tobacco garden
(photo), Lowie, p290+
Tools, Agricultural
Moore, J. (*Cheyenne*), p22
Travois (photo by J.H. Sharp), Riebeth, p102
Upham, William
Harvesting oats, 1914 (photo), Samek, II., p98
Vegetable garden
With Albert Mad Plume (photo), Farr, W.,
p113
Wheat harvesting, 1920 (photo), Farr, W., p115

Ah-mou-a (The Whale): Sac and Fox Chief
(painting by G. Catlin), 1835, Heyman, p60

**Ah-no-je-nahge (He Who Stands on Both Sides):
Sioux**
(color painting by G. Catlin), 1835, Heyman,
p146

Ankima: Kiowa
With Dohasan, 1893 (photo by J. Mooney),
Mayhall (*Kiowas*), p222+, Nye (*Plains*),
p365

Anko: Kiowa
1898 (photo by F.A. Rinehart), Mayhall (*Indian
Wars*), p222+

Antelope: Caddo
(photo), Mayhall (*Indian Wars*), p78+

Antelope, Joe: Cheyenne
(photo), Moore, J. (*Cheyenne Nation*), p268

Antelope Whistler: Blackfoot
(photo), Hungry Wolf, A., p144

Anthony, Scott J.: U.S. Army Major
(photo), Coel, p143
Fort Lyon, October 1864. (photo), Schultz, D.,
(Month) p118+
First Colorado Cavalry (photo), Hoig, S. (*Sand
Creek*), no paging

Anza, Juan Bautista de: Governor of New Mexico
(drawing), Noyes (*Los Comanches*), p40

Ap-pa-noo-se: Sac and Fox Chief
(color photo), McKenney (*Vol. 2*), p106+
(color painting by G. Cooke), Moore (*Native*),
p105

Apache (*see also* Kiowa-Apache; Lipan Apache)
Adultery
Woman's nose cut (photo), Greene, A., p29
Agency Headquarters
1907 (group photo), Schweinfurth, p20
Alchisay
(drawing), Sneve (*Apaches*), p22
Apache Kid, The (color drawing), Reedstrom,
p32+
Asa
With Naiche and Charley (group photo),
Geronimo's Life, p80+
Awls
And its case (drawing), Sneve (*Apaches*),
p13
Baskets
Burden basket
Baskets
1910 (photo), (Stories), p68
Burden, 1983 (photo), Coe, R. p191, (draw-
ing), Sneve (*Apaches*), p13
Decorated with figures (photo), Minor,
p96
Hanging Pomo-style, 1983 (photo), Coe, R.,
p190
Olla, 1984 (photo), Coe, R. p186
Three miniature baskets, 1983 (photo),
Coe, R., p190
Tray, 1981 (photo), Coe, R. p187, 1984
(photo), Coe, R., p187

Bedonkohe
Last of the tribe (group photo), Geronimo,
p18+
Begay, Alberta
Daughter of Massai (photo), Robinson, S.,
p86
Berry, Tennysony
1913 (photo), Schweinfurth, p8
Big Mouth
Mescalero (photo), Robinson, S., p144
Bigman, Fred
With grandson Kenneth, 1963 (photo),
Schweinfurth, p9
Blackbear, Joe
1948 (photo), Schweinfurth, p6
Blackbear, Ray
1961 (photo), Schweinfurth, p5
Blackfeet Dancers, 1961 (group photo),
Schweinfurth, p151
Blackhawk
Wearing peace medal (photo), Schweinfurth,
p112
Bonito
Seated holding rifle (photo), Collins, p112
Bows
With flint-tipped arrows, Morehead, p146+
Burials
Cradleboard (infant) hanging from tree
(photo), Stockel, p21
Camps
(photo), Geronimo, p86+, Schweinfurth,
p110
Family group in Arizona (photo), Stockel,
p13
Cane
(drawing), Sneve (*Apaches*), p17
Chaletsin, Rose
1961 (photo), Schweinfurth, p7
Charley
With Asa and Whoa (group photo), *Geron-
imo*, p80+
Chato
Standing holding rifle (photo), Adams,
p329
Chebatah
1930 (photo), Meadowns, pxx+
Chief Josh
1898 (photo), (Stories), p72
Chihuahua
(photo), Robinson, S., p40
And family (photo), Geronimo, p190+
Children
1866 (photo) Boy, Robinson, S., p126
1883 (photo) Baby in cradleboard, Robinson,
S., p33
1901 (photo), p125, Schweinfurth
Boy bathing (photo by E. Curtis) 1907, Adam,
p43

Aprons
Plains Indian
Pattern for (drawing), Minor, p72

Ar-roches: Crow Indian
(group photo) 1910, Harcey, p165

Aragon, William: Shoshone
1935 (group photo), Fowler (*Arapahoe Politics*), p170+

Arapaho
Addison, Burdick
(photo) 1977, Fowler (*Arapahoe Politics*), p170+
Amulets
(color photo), Howell, p80
Case for
Containing umbilical cord amulet (photo), Fowler (*Arapaho*), p24
Navel-amulets (drawing), Kroeber, p57
Representing teeth, turtle, bird and skunk (drawing), Kroeber, p442, 443
Armlets
Ghost-dance armlet (drawing), Kroeber, p53
Various designs (drawing), Kroeber, p51
Arthur, Regina
(group photo) 1975, Fowler (*Arapahoe Politics*), p170+
Ba-e-tha
With sister (photo by W.S. Soule), Belous, p95
Bad Teeth (Byron Trosper)
(group photo) 1904, Fowler (*Arapahoe Politics*), p74+
Bags
Beaded pouch (drawing), Kroeber, p47
For holding porcupine-quills (drawing), Kroeber, p78
Paint container (drawing), Kroeber, p81, 82, 84
Quill-embroidered pouch for ration tickets (photo), Fowler (*Arapaho*), p93
Rawhide bags (drawing), Kroeber, p120, 122, 124, 126, 128, 129, 131
Sacred bag
Contents of Woman's (drawing), Kroeber, p209
Sacred bag contents (photo), Kroeber, p461
Soft hide bag, quilled (color photo), Fowler (*Arapaho*), p70
Woman's belt pouch for small items (color photo), Fowler (*Arapaho*), p71
Woman's pouch for combs and body paint (color photo), Fowler (*Arapaho*), p71
Ball
Used by women (drawing), Kroeber, p395
Bates Battle 1874 (map), Fowler (*Arapahoe Politics*), p51

Battle of Wolf Creek, 1838 (map), Grinnell (*Fighting*) p54
Beef Issue
(photo), Trenholm, p110+
Butchering beef (photo), Trenholm, p110+
Darlington agency (photo) 1890, Fowler (*Arapaho*), p94
Bell, Dave (photo) 1988, Fowler (*Arapaho*), p115
Belts
Belt and trailer
Woman's (photo), Contemporary Metalwork, p52
Dance belt (drawing), Kroeber, p171+
Benefit dance
Watonga, Oklahoma (group photo), Fowler (*Arapaho*), p113
Bent, Jesse (group photo) 1891, Fowler (*Tribal*), p58+
Bi-nan-set (Big Mouth) (photo by W.S. Soule), Nye (*Plains*), p205
Big Cow
(photo by W.S. Soule), Belous, Nye (*Plains*), p85, p291
Big Mouth
(photo), Contemporary Metalwork, p10, Trenholm, p110+
Big Mouth (Bi-nan-set)
(photo by W.S. Soule), Nye (*Plains*), p205
Seated holding ax (photo), Hoig, S., (*Battle*), p172+
Big Road, Winnie (group photo) 1975, Fowler (*Arapaho Politics*), p170+
Bird Chief (group photo) 1871, Fowler (*Tribal*), p58+
Bird Chief, Jr. (group photo) 1911, Fowler (*Tribal*), p58+
Bird Chief, Sr.
(group photo) 1911, Fowler (*Tribal*), p58+
With Wife (photo) 1923, Fowler (*Tribal*), p58+
Black Coal (Shot-off-Fingers)
(group photo), Trenholm, p302+
(group photo) 1877, Fowler (*Arapahoe Politics*), p74+
(group photo) 1883, Fowler (*Arapahoe Politics*), p74+
(photo) 1882, Fowler (*Arapaho*), p56
Black Coal, Sumner (group photo), Fowler (*Arapaho*), p64
Black Coyote (Watonga)
(group photo) 1891, Fowler (*Tribal*), p58+
(photo), Trenholm, p206+
Delegation to Washington, D.C. (group photo) 1899, Fowler (*Arapaho*), p100
Black Man
(photo by E. Curtis) 1927, Curtis (*Plains*), plate 41

Papago
Mesquite wood, metal pin, 1970–75 (photo),
Coe, R., p226
Oneota
Stone awl (photo), McKusick (*Men*), p158
Sac and Fox
Bone worked into awls (photo), McKusick
(*Men*), p212
Sioux
1982 (photo), Coe, R. p133, 1980 (photo),
Coe, R., p133
Straight-blade
(drawing), Hanson, J., p61
Talking Crow
Forked Point (photo), Smith, C., Plate XXII
Various types. (photo), Smith, C., Plate XX
Wounded Knee battlefield, found at (photo),
Hanson, J., p62

Awl Case
Beaded awl case (drawing), Mails (*Mystic*),
p285

Awl Game
Kiowa
Dice & tally sticks (photo), Merrill, p125

Axe (*see also* Clubs; War Clubs)
French Ax with sloping eye, 1680–1720 (draw-
ing), Hanson, J., p13
Half-ax (photo), Hanson, J., p56
Oglalas
Marked "U" (drawing), Hanson, J., p55
Sioux: Yanktonai
War clubs and axes (watercolor by Saul),
Brokenleg, M., p55
South Dakota, western (drawing), Hanson, J.,
p55
Stone Ax (photo), Wemett, W., p153

Aztalan: Locale
Winnebago (map), Petersen p40+

B

Ba-e-tha: Arapaho
With sister (photo by W.S. Soule), Belous, p95

Babb, Theodore: Comanche Captive
(photo), Noyes (*Los Comanches*), p230

Baby Coverlet and Pillow
1980, (photo) Coe, R., p113

Baco, Emma: Kiowa
(group photo) Family Outing, Hail, p49

Bacon Rind: Osage Chief
(group photo) with Fred Lookout, Wilson
(*Underground*), p139
(group photo) with wives, 1931, Wilson
(*Underground*), p177

(photo), La Flesche (*Osage*), p25
Tribespeople and Frank Phillips (photo),
Wilson (*Osage*), p73
With wives (photo), Wilson (*Osage*), p79

Bad Cobb, Tom: Sioux
(photo), *Crazy Horse School*, p39

Bad Eye: Kiowa
(drawing) Lattice cradles, Hail, p30

Bad Heart Bull: Sioux
Demonstrators in North Carolina protesting
Bad Heart Bull's murder (photo by Norgar),
Crow Dog, M., p110+

Bad Heart Bull, Vincent: Sioux Artist
Moving Camp, 1968 (painting), *Contemporary
Sioux Painting*, p37
(photo), *Contemporary Sioux Painting*, p36

Bad Marriage, James: Blackfoot
Fort Shaw Industrial School, 1915 (photo),
Farr, W., p62

Bad Teeth (Byron Trosper): Arapaho
1904 (group photo), Fowler (*Arapahoe Politics*),
p74+

Bad Warrior, Martha: Lakota
With sacred bundle, 1936 (photo), Feraca, S.,
p48

Bad Whirlwind: Sioux Chief
Headstone (photo), Walstrom, V., p84

Badger Creek: Locale
Blackfoot agency on Badger Creek, 1876–78,
Ewers, J. (*Blackfeet,*), p238+

Badges
Bear Shield Ranch Show Badge (photo),
Hanson, J.A., p108
Indian Policeman (photo), Hanson, J.A.,
p107
Ranch Show Badge (drawing), Hanson, J.A.,
p107

Badlands: South Dakota
1864 (map), Clodfelter, M. p179, 1890 (photo),
Eastman, E., p48+
Indians pull a wagon up a steep slope, 1894
(photo by J. Anderson), Hamilton, H., p216
Onagazi, Stronghold Table (photo), Doll, D.,
p14
(photo), *Crazy Horse School*, p3

Badroad, Tom: Gros Ventre
(group photo) 1887, Sturtevant, v13, p681

Bag and Pouch (*see also* Shoulder Bag)
Arapaho
Beaded pouch (drawing), Kroeber, p47
Belt pouch for small women's items (color
photo), Fowler (*Arapaho*), p71
Paint container (drawing), Kroeber, p81,
82, 84

Bakaylle, Baptiste: Skidi Pawnee

**Bakeitzogie (The Yellow Coyote, Dutchy):
Chiricahua Apache**

Baker, Johnny: Businessman

Baker's Fight

Ball

Troop maneuvers leading to Battle of Little
 Big Horn (map), Skarsten, M., p53
Two Moons: Cheyenne, (photo by Sharp),
 Riebeth, C., p50

Battle of Washita
 (Illustration), Hyde (*Life*), p294+
 Commemorating Washita Battle
 (group photo), Brill, p23
 Map showing movements of Custer's troops,
 Brill, p157
 (painting by C. Schreyvogel), Berthrong
 (*Southern*), p368+
 Prisoners of war
 Indian captives at Camp Supply (group
 photo), Hoig, S. (*Battle*), p148+
 View of the battlefield (photo) 1930s, Brill,
 p175

Battle of Wolf Creek
 1838 (map), Grinnell (*Fighting*), p54

Battle of Wolf Mountains: Montana
 1877 (drawing), Greene, J. (*Yellowstone*), p167
 Arial View (photo), Greene, J. (*Yellowstone*),
 p174
 Drawing, 1877, Greene, J. (*Battles*), p198
 Fifth Infantry against warriors, 1877 (painting
 by Remington), Greene, J. (*Yellowstone*), p172
 Map, 1877, Greene, J. (*Yellowstone*), p174, p200
 Sketch map, 1891 (photo), Greene, J. (*Yellow-
 stone*), p169

Battle of Wood Lake: Minnesota
 Decisive encounter of Sioux Uprising (drawing
 by Connolly), Carley, K., p55
 State monument (photo by Becker), Carley, K.,
 p59
 View of where fought (photo by Becker), Car-
 ley, K., p58

Bayard, George D.: U.S. Army
 (photo), Chalfant (*Cheyennes & Horse*), p171

Bayhylle, Baptiste: Skidi Pawnee Interpreter
 (group photo), Milner, p48+
 (photo) 1885, Hyde (*Pawnee Indians*), p324
 With Sky Chief and his three brothers (photo),
 Hyde (*Pawnee Indians*), p278

Beacom, John; Lt.: Photographer
 Agency school at Badger Creek, 1890 (group
 photo by Lt. John Beacom), Farr, W., p21
 Blackfoot
 Old Agency employees, 1891 (photo by Lt.
 J. Beacom), Farr, W., p17

Bead (*see also* Beadwork)
 Medium-sized beads, translucent, faceted, 1870
 (drawing), Mails (*Mystic*), p289
 Pony beads
 1800–40 (drawing), Mails (*Mystic*), p289
 Seed beads
 1840s (drawing), Mails (*Mystic*), p289

Beadwork
 Arapaho Indians: Northern
 Tobacco bag: buckskin, porcupine quills,
 glass beads, 1885 (photo), Penney, D., p182
 Arapaho Indians: Southern
 Tobacco bag
 Buckskin, glass beads, 1890 (photo), Pen-
 ney, D., p185
 Buckskin, glass beads, flicker feathers,
 brass hawk bells, 1880 (photo), Penney,
 D., p184
 Arikara Indians
 Blanket strip: wool fabric, buffalo hide, glass
 beads, 1870 (photo), Penney, D., p161
 Assiniboine Indians
 Gun Case
 Or Gros Ventre: buffalo hide, glass bead,
 1890 (photo), Penney, D., p212
 Knife case
 Or Gros Ventre: rawhide, brass studs,
 glass beads, pigment, 1880 (photo),
 Penney, D., p213
 Moccasins
 1982 (photo), Coe, R. p145
 Or Gros Ventre: buckskin, rawhide, glass
 beads, cotton, 1890 (photo), Penney, D.,
 p214
 Assiniboine/Sioux Indians
 Moccasins, beaded and quilled, 1982–83
 (photo), Coe, R., p176
 Scabbard, beaded, 1983 (photo), Coe, R.,
 p144
 War Shirt, 1982–83 (photo), Coe, R. p174–75
 Blackfoot Indians
 Blanket strip: buffalo hide, glass beads, 1870
 (photo), Penney, D., p159
 Buckle, beaded, 1980–81 (photo), Coe, R.
 p154
 Gun Case: buckskin, glass beads, 1890
 (photo), Penney, D., p211
 Knife case: rawhide, buffalo hide, glass beads,
 1885 (photo), Penney, D., p213
 Man's leggings: buckskin, glass beads, pig
 ment, 1880 (photo), Penney, D., p208
 Moccasins
 1982 (photo), Coe, R. p154
 Buffalo hide, rawhide, saddle leather,
 buckskin, glass beads, 1890 (photo),
 Penney, D., p214
 Necklace, Medallion, 1982 (photo), Coe, R.,
 p154
 Blackfoot Indians: Canadian (Piegan)
 Dance purse, 1982 (photo), Coe, R., p155
 Cheyenne Indians
 Baby Carrier: wood, cowhide, brass tacks,
 glass beads, 1885 (photo), Penney, D., p180
 Blanket strip: buffalo glass beads, 1860
 (photo), Penney, D., p160

Cheyenne Indians: Northern
Baby carrier: buffalo hide, rawhide, glass beads, 1870 (photo), Penney, D., p157
Knife case
1982 (photo), Coe, R. p147
Buffalo rawhide, buckskin, glass beads, 1860 (photo), Penney, D., p164
Moccasins: buffalo hide, glass beads, 1840–50 (photo), Penney, D., p154
Necklace, beaded medallion, 1980–82 (photo), Coe, R., p147
Cheyenne Indians: Southern
Tobacco bag: buckskin, glass beads, tin cones, horsehair, brass hawk bells, 1890 (photo), Penney, D., p183
Chippewa Indians
Garters
Glass beads, cotton fabric, twine, wool yarn, brass hook-eyes, 1850 (photo), Penney, D., p105
Glass beads, cotton thread, wool yarn, 1850 (photo), Penney, D., p106
Man's leggings: cotton velveteen, polished cotton, glass beads, wool twill, 1890 (photo), Penney, D., p144
Sash, glass beads, cotton thread, wool yarn, 1850 (photo), Penney, D., p104
Shoulder bags
1885 (photo), Penney, D., p122
Wool fabric and yarn, cotton fabric, silk ribbon, glass, metallic beads, 1851 (photo), Penney, D., p102
Wool fabric, yarn, cotton fabric, silk ribbon, glass beads, 1850 (photo), Penney, D., p103
Chippewa/Cree Indians
Belt and buckle, beaded, 1981 (photo), Coe, R., p151
Buckle, beaded, 1982 (photo), Coe, R., p151, 180
Pepper shaker rattle, 1970 (photo), Coe, R., p153
Crow Indians
Belt, 1965–75 (photo), Coe, R., p149
Blanket strip: buffalo hide, glass beads, wool stroud, 1870–75 (photo), Penney, D., p159
Buffalo hide with beaded strip: buffalo hide, glass beads, wool, 1890 (photo), Penney, D., p196
Elk hide robe: glass beads, deer hooves, brass hawk bells, wool yarn, 1880 (photo), Penney, D., p197
Gun Case: buckskin, glass beads, wool stroud, 1890 (photo), Penney, D., p198
Horse outfit, 1982–83 (photo), Coe, R., p179
Knife case: rawhide, buckskin, glass beads, 1890 (photo), Penney, D., p202

Lance Case: rawhide, buckskin, glass beads, wool stroud, quills, 1890 (photo), Penney, D., p199
Martingale: buckskin, wool stroud, wool fabric, glass beads, brass sleigh bells, 1890 (photo), Penney, D., p201
Moccasins
Buckskin, rawhide, glass beads, 1885 (photo), Penney, D., p203
High-topped, 1965–70 (photo), Coe, R., p148
Necklace, Medallion, 1970–80 (photo), Coe, R., p149
Saddlebag (drawing), Mails (*Mystic*), p289
Tobacco bag: buckskin, glass beads, 1890 (photo), Penney, D., p201
Crow/Navajo Indians
Buckle, beaded, 1981–82 (photo), Coe, R., p150
Delaware Indians
Shoulder Bag
Wool fabric, cotton fabric, silk ribbon, glass beads, 1860 (photo), Penney, D., p115
Gros Ventre Indians
Gun Case
Or Assiniboine: buffalo hide, glass bead, 1890 (photo), Penney, D., p212
Knife case
Or Assiniboine: rawhide, brass studs, glass beads, pigment, 1880 (photo), Penney, D., p213
Leggings
Girls': cloth, wool, ribbon, brass shoe buttons, glass beads, 1915 (photo), Penney, D., p210
Moccasins
Or Assiniboine: buckskin, rawhide, glass beads, cotton fabric, 1890 (photo), Penney, D., p214
Ioway Indians
Moccasins
Buckskin, glass beads, 1875 (photo), Penney, D., p118
Buffalo hide, buckskin, glass beads, 1860, Penney, D., p117
Iroquois Indians
Bird, 1980 (photo), Coe, R. p78
Moccasins: buckskin, wool fiber, porcupine quills, glass beads, 1800–30 (photo), Penney, D., p73
Picture frame, 1980 (photo), Coe, R., p78
Kiowa Indians
Baby Carrier: wood, wool, cotton, glass beads, rawhide, buckskin, studs, tin cones, 1880 (photo), Penney, D., p180
Dance set, 1980 (photo), Coe, R., p157

Slavey Indians
 Necklaces: tufted moose-hair, beads (1980–81), Coe, R., p250
 Talking Crow pottery beads (photo), Smith, C., Plate XXII
Winnebago Indians
 Bag, shoulder, 1890 (photo), Penney, D., p123
 Cuffs, 1977–79 (photo), Coe, R., p99
Yanktonais
 Beading on wrist cuffs (photo), Hoover, H. (*Yankton*), p90

Bean, Ellis P.: Indian Agent
 (drawing), Clarke, p46+

Bean, William (Mahpiyato, Blue Cloud): Yankton Sioux Chief
 Headstone, (photo), Walstrom, V., p2
 (photo) Flood, R. (*Volume 2*), p68
 (portrait by L. Zephier), Sneve, V. (*They*), p41

Bear, Amie Honemeeda: Kiowa
 (photo), Hail, p123

Bear, Amy: Kiowa
 (photo) With Curly "Bud" Ballew and Carrie, Noyes (*Comanches*), p84

Bear, Curtis Oren: Osage
 (photo) with Jamison Bear, Callahan, p36

Bear, Jack: Sac & Fox
 With wife (photo), Green, C., p33

Bear, Jamison: Osage
 (photo) with Curtis O. Bear, Callahan, p36

Bear, William "Bill": Kiowa
 (photo), Hail, p122

Bear Above, The: Cheyenne Indian
 (drawing by J.W. Abert) and wife, Berthrong (*Southern*), p208+

Bear Arm: Mandan Artist
 Distribution and ownership of eagle-trapping camps (drawing by Bears Arm), Bowers, A., p212

Bear Butte: South Dakota
 (photo), Wunder, p40

Bear Catcher: Kansa
 (painting by G. Catlin), 1831, Unrau (*Kansa*), p78+

Bear Chief: Blackfoot
 Group photo, 1909 (by E.L. Chase), Farr, W. p65
 Principal Piegan Chiefs, 1897 (photo by J.N. Choate), Ewers, J. (*Story*), p53, Farr, W., p37

Bear Child, Josephine: Blackfoot
 Willow Creek School
 1907 (group photo by J.H. Sherburne), Farr, W., p53

Bear Dance
 Sioux, (painting), Bonvillain (*Santee*), p30

Bear Dog: Brule Sioux
 1892 (photo by J. Anderson), Hamilton, H., p181

Bear Head: Sioux Chief
 Group of Sioux (photo by J. Anderson), Hamilton, H., p186
 Men of the Brule Sioux, Rosebud Agency, 1894 (photo by J. Anderson), Hamilton, H., p259

Bear in the Forks of a Tree (Ne-Sou-A-Quoit): Fox Chief
 (color photo), McKenney (Vol. 1), p312+

Bear in the Middle: Crow
 (group photo) 1890, Sturtevant, v13, p709

Bear Looks Behind: Sioux
 Men of the Brule Sioux, Rosebud Agency, 1894 (photo by J. Anderson), Hamilton, H., p259

Bear on Flat: Mandan
 At eagle-trapping site (photo), Bowers, A., p244
 Pit when covered and Bear on Flat (photo), Bowers, A., p244

Bear on the Left (Kiasax): Piegan Blackfeet
 (watercolor by K. Bodmer), Bodmer, p254

Bear Shield: Blackfoot
 1900 (photo), Hungry Wolf, A., p316

Bear Shield "Tree": Lakota
 Wounded Knee, 1996 (drawing), Feraca, S., p16

Bear Stands Up (Mato Najin): Sioux
 1900 (photo by J. Anderson), Hamilton, H., p291

Bear that Comes and Stands: Sisseton
 (photo), 1872, Diedrich, M. (*Odyssey*) p91
 Son of Standing Buffalo (drawing by Hall), Diedrich, M. (*Odyssey*), p90

Bear Wolf (Se-ta-pit-se): Crow
 (group photo) 1873, Sturtevant, v13, p699

Bear Woman: Cheyenne
 Beading a pair of moccasins (photo) 1900, Seger (*Early, 1979*), p50+

Bearclaw Necklace
 Ioway Indians
 Otter pelt, grizzly bearclaws, glass beads, 1830 (photo), Penney, D., p113
 Mesquakie Indians
 Bearclaws, glass beads, silk ribbon, 1870 (photo), Penney, D., p111
 Otter pelt, grizzly bearclaws, glass beads, silk ribbon, 1860 (photo), Penney, D., p112

Beard: Minneconjou
 (photo), 1976, Michno, G., p29

Beard, Dewey
White Lance, Joseph Horn Cloud, 1907 (photo), Starita, J., p126

Bear's Arm: Hidatsa
An Indian Camp, 1910 (drawing), Maurer, E., p256
(photo), Beckwith, M., p269

Bears Arm: Mandan Artist
Eagle-trapping ceremony camps and pits, Old Bear, leader (drawing), Bowers, A., p209

Bears Belly: Hidatsa Indian
(photo by E. Curtis) 1908, Schneider p88

Bears Coat: Hunkpapa Chief
Headstone (photo) Walstrom, V. p56

Bear's Heart: Cheyenne
Drawing of himself, Szabo, p60
Painting of a courting scene, Szabo, p51
Self portrait painting, Szabo, p114+

Bear's Shirt (Woh-se Im-meh-can-tan): Gros Ventre Chief
(sketch) 1855, Sturtevant, v13, p679

Beaubien, Paul: Archeologist
Effigy Mounds National Monument (group photo), McKusick (*Men*), p130

Beaver, John: Quapaw Indian
(photo), Baird (*Quapaws*), p77
Gathering of Quapaw leaders in traditional dress (group photo), Baird (*Quapaws*), p80
Leaders in native dress posed by outdoor tents (group photo), Baird (*Quapaw Indians*), p214

Beaver Bundle Dance: Blackfoot
Women doing sacred Beaver Bundle Dance (photo), Hungry Wolf, A. p101

Beaver Cap: Kiowa
Black-striped tipi (color photo), Ewers (*Murals*), p40

Beckwourth, Jim: Trapper
Black trapper, guide, honorary Indian Chief (photo), Schultz, D., (*Month*), p118+

Bedalatena (Belo Kozad): Kiowa
(photo by J.P. Harrington), Merrill, p314

Beecher, Frederick H.: U.S. Army
(photo), Hoig, S., p100+, Monnett (*Battle*), p83

Beecher Island Fight
Forsyth Scouts fighting (drawing), Monnett (*Battle*), p135
Map of the Republican Valley, Monnett (*Battle*), p133
Painting by F. Remington, Monnett (*Battle*), p141
Rescue of the Forsyth Scouts, Monnett (*Battle*), p174

Beef Drying *see* Food Preparation; Jerky

Beef Issue (*see also* Ration Distribution)
Blackfoot
Issue day for beef rations at Blackfoot Agency (photo), Farr, W., p14
Slaughterhouse at Blackfoot Agency—reaching for the entrails, 1887 (photo), Farr, W., p15
Butte Creek issue station, 1897 (photo by J. Anderson), Hamilton, H., p95
Cattle distribution issued, 1889 (photo by J. Anderson), Hamilton, H., p98
Cut Meat
Beef day, 1893 (photo by J. Anderson), Hamilton, H., p107
Wowoso, 1897 (photo by J. Anderson), Hamilton, H., p93, 94
Cutting up meat, 1893 (photo by J. Anderson), Hamilton, H., p109
Oglala Indians (photo), McGillycuddy, J., p187
Red Cloud Agency (photo), Buecker, T., p13
Rosebud Agency
(photo by J. Anderson), Hamilton, H., p106
1889 (photo by J. Anderson), Hamilton, H., p100
1889 (photo by J. Anderson), Hamilton, H., p99
1891 (photo by J. Anderson), Hamilton, H., p102
1893 (photo by J. Anderson), Hamilton, H., p103
Slaughter and issue house (photo by J. Anderson), Hamilton, H., p96
Slaughtering cattle for beef issue, 1891 (photo by J. Anderson), Hamilton, H., p101
Sioux
At Standing Rock Agency (photo), Standing Bear, L., p72
Family skinning steer (photo by J. Anderson), Hamilton, H., p108
Receiving their beef rations, 1893 (photo by J. Anderson), Hamilton, H., p105
Women washing cattle pauches and entrails in creek (photo by J. Anderson), Hamilton, H., p104

Begay, Alberta: Apache
(photo), Robinson, S., p86

Belindo, Dennis: Kiowa
(photo), *Contemporary Painting*, p67

Bell, C.M.: Photographer
Cheyenne & Arapaho Delegation, 1891, Fowler (*Tribal*), p58+
(photo) Renville, Gabriel, 1880–1881 (photo), Meyer, R.W. (*History*), p228+

Bell, Dave: Arapaho
Basketball (photo) 1988, Fowler (*Arapaho*), p115

Big Bear (Muntcehuntce): Otoe-Missouria Chief
(photo), Sturtevant, v13, p455

Big Beaver: Northern Cheyenne
Drawing of Riding Among the Dead, Greene,
J. (*Lakota*), p69

Big Beaver, Rosy: Blackfoot
W.P.A. Sewing Club from Two Medicine (group
photo by Olga Ross Hannon), Farr, W. p134

Big Billy, Maggie: Sarcee
Preparing pemmican (photo) 1920s, Sturte-
vant, v13, p630

Big Bird: Hidatsa
Medicine bundle (photo), Cash, J. (*Three*), p17

**Big Bow (Zepko-eete, Zepko-ette, Zip-koh-eta):
Kiowa Chief**
(photo by W.S. Soule), Nye (*Plains*), p225
(photo), Hoig, S. (*Kiowas*), p208
Visiting children with Sun Boy, Carlisle Indian
School (photo J.N. Choate), Merrill, p306

Big Bow, Woody: Kiowa
(photo), *Contemporary Painting*, p67

Big Chief: Osage Chief
(group photo), Wilson (*Underground*), p33
Band Chiefs (group photo), Wilson (*Osage*),
p41
Tribal leaders (group photo), Wilson (*Osage*),
p52

Big Chief: Ponca
(group photo) 1877, Sturtevant, v13, p426

Big Cloud: Cheyenne
Counting Coup," 1880 (drawing), Maurer, E.,
p215

**Big Corner Post (Omachksi-Gohkstokaksin):
Blackfoot**
(photo), Hungry Wolf, A., p309

Big Cow: Arapaho
(photo by W.S. Soule), Nye (*Plains*), p291,
Belous, p85

Big Crow: Northern Cheyenne
And wife, 1927 (photo), Limbaugh, R.H. pXII

Big Crow (Ko-a-tunk-a): Osage
(painting by George Catlin) 1834, Rollings
(*Osage*), p97
Three Osage warriors (drawing), Wilson
(*Osage*), p20

Big Crow, Donald: Comanche
(photo) Family, Hail, p64

Big Crow, Mrs. Donald: Comanche
(photo) Family, Hail, p64

Big Day, Henry: Crow
With daughter (photo), Voget, F., p80
With William Big Day, 1941 (photo), Voget, F.
p135

Big Day, William: Crow
With Henry Big Day, 1941 (photo), Voget, F. p135

Big Eagle (Thomas Chapman): Pawnee Chief
(color photo), Tyson, frontispiece

Big Eagle: Santee Sioux
(color painting by G. Catlin), 1835, Moore
(*Native*), p199

Big Eagle: Sioux Chief
1858 (photo), Anderson, G., p149, Carley, K.,
p19
(group photo), 1858, Mdewakanton-Wah-
pekute delegation to Washington, 1858

Big Elk, The (Ong-pa-ton-ga): Omaha Chief
(color painting by G. Catlin), 1832, Moore
(*Native*), p171
(color photo), McKenney (Vol. 1), p274+
(painting by C.B. King), 1821, Moore (*Native*),
p68

Big Elk: Ponca
(group photo) 1877, Sturtevant, v13, p426

**Big Foot: Sioux Chief (*see also* Wounded Knee;
Ghost Dance)**
Big Foot's band at Ghost Dance at Cheyenne
River: August, 1890 (photo), Hyde, G.,
(*Sioux*), *no* paging
Mass Grave at Wounded Knee, (photo) Mon-
ument, Walstrom, V., p128
(portrait by Loren Zephier), Sneve, V. (*They*)
p43
Route from Cheyenne River Reservation to
Pine Ridge Agency (map), Green, J., p31
The Body of Big Foot, at Wounded Knee,
December 1890 (photo), Fielder, M., p54,
Starita, J. p123

Big Head: Brule Sioux
Men of the Brule Sioux, Rosebud Agency, 1894
(photo by J. Anderson), Hamilton, H., p259

Big Head: Southern Cheyenne
(group photo by W.S. Soule), Belous, p75

Big Head: Yanktonais Sioux
Chief (photo), Diedrich, M. (*Odyssey*), p55

Big Hill Joe or Governor: Osage Chief
(group photo), Wilson (*Underground*), p33

Big Horse: Brule Sioux
Men of the Brule Sioux, Rosebud Agency, 1894
(photo by J. Anderson), Hamilton, H., p259

Big Kansas (Choncape): Otoe-Missouria Chief
(drawing by Charles Bird King) 1821, Irving,
p102+
(painting by C.B. King), Moore (*Native*), p108
Lithograph, Edmunds (*Otoe*), frontispiece

Big Looking Glass (Pianarnoit): Comanche
1894 (photo), Hagan, p111+, p225, Wallace
(*Comanches*)

Delegation to Washington, 1897 (group photo),
Hagan, p228

Big Man, Max: Crow Indian
(group photo), Harcey, p188
(group photo) 1927, Hoxie, p320

Big Medicine: Crow Indian
(group photo), 1910, Hoxie, F., p252
(group photo), Hoxie p245, Riebeth, p124

Big Medicine Man: Skidi Pawnee
In front of earth lodge (group photo), Dorsey
(*Traditions*), pxxii+

Big Moon, Jack: Blackfoot
In capote made of a Hudson's Bay blanket,
searching for game with a brass telescope
(photo), Farr, W. pxii
With White Quiver, Willow Creek, 1900
(photo), Farr, W., p92

Big Mouth: Arapaho
(photo), *Contemporary Metalwork*, p10

Big Mouth: Mescalero
(photo), Robinson, S., p144

Big Mouth (Bi-nan-set): Southern Arapaho Chief
(photo by W.S. Soule), Nye (*Plains*), p205,
Trenholm, p110+
Seated holding ax (photo), Hoig, S. (*Battle*),
p172+

Big Nose, Mrs.: Blackfoot
Coming to the lodge after a three-day fast
(photo), Farr, W. p77

Big Osage
Villages (map), Din, p112–13

Big Partisan (Blotka Honka Tanka) or Polecat: Sioux
(photo by J. Anderson), Hamilton, H., p295

Big Rib: Blackfoot
1887 (photo), Dempsey, H., p105

Big Road, Winnie: Arapaho
1975 (group photo), Fowler (*Arapahoe Politics*),
p170+

Big Shoulder: Crow
(photo), Nabokov, P. (*Two*), p98+

Big Snake: Piegan
Blackfoot Indians Chiefs, 1848, (painting by
Paul Kane), Ewers, J. (*Story*), p31

Big Snake: Ponca
(group photo) 1877, Sturtevant, v13, p426

Big Soldier (Wak-ta-geli): Brule Chief
1834 (portrait by Karl Bodmer), Hassrick, R.,
p100+
Brule Chief, with pipe tomahawk (drawing),
Hanson, J.A., p39

Big Spotted Horse: Pitahawirata Pawnee
1875 (photo), Blaine (*Pawnee Passage*), p62

Big Timbers: Colorado/Nebraska
Captain Eugene Ware's map of the Republican
"Big Timbers," Moore, J. (*Cheyenne Nation*),
p161
Cottonwood trees (photo), Moore, J. (*Cheyenne
Nation*), p162

Big Tobacco (Chandi Tanka): Yankton Sioux
(photo), Flood, R. (*Volume* 2) p37

Big Tree (A'do-eete, A'do-eette, Addo-eta): Kiowa Chief
(photo by W.S. Soule), Belous, Nye (*Plains*),
p34, p317
(photo by W.S. Soule) 1870, Mayhall (*Indian
Wars*), p30+
1870 (photo by W. S. Soule), Mayhall (*Kiowas*),
p62+
His sister (drawing), Battey, p317
With Satanta at St. Louis (photo), Hoig, S.
(*Kiowas*), p176

Big Tree Ahote, Alma: Kiowa
(photo), Hail, p128

Big Tree Ahote, Marietta: Kiowa
(group photo) with sister Alma, 1893, Hail,
p128
(photo), Hail, p128

Big Turkey Camp
On Rosebud Creek, 1888 (photo by J. Ander-
son), Hamilton, H., p66

Big Wolf: Blackfoot
1939 (photo), Hungry Wolf, A., p322
(photo), Hungry Wolf, A., p274

Big Woman: Cheyenne Indian
(photo), Grinnell (*Cheyenne*) p48+

Bigheart: Osage Governor
Osage Council, 1895 (group photo), Barid
(*Osage People*), p69

Bigheart, James: Osage
(photo), Wilson (*Osage*), p54

Bigheart, Peter G.: Osage Chief
(photo) 1909, Wilson (*Underground*), p113

Bigman, Fred: Apache
With Grandson, 1963 (photo), Schweinfurth, p9

Bigman, Kenneth: Apache
With Fred Bigman, 1963 (photo), Schwein-
furth, p9

Birch Coulee Battle *see* Battle of Birch Coulee

Birchbark Containers
1980–81 (photo), Coe, R., p252
Algonkian Indians
1980–81 (photo), Coe, R., p79
Carrier Indians
1975 (photo), Coe, R., p251
Sewing, cherry bark, spruce root, 1972–78
(photo), Coe, R., p251

Black Coyote (Watonga): Southern Arapaho
(photo), Berthrong (*Cheyenne*), p56, Trenholm, p206+
1891 (group photo), Fowler (*Tribal*), p58+
Delegation to Washington, D.C. (group photo) 1899, Fowler (*Arapaho*), p100

Black Crow: Ponca
(group photo) 1877, Sturtevant, v13, p426

Black Dog, The (Tchong-tas-sab-bee): Osage
(drawing), Wilson (*Osage*), p60
(group photo), Wilson (*Osage*), p48
Tribal leaders (group photo), Wilson (*Osage*), p52

Black Drink (Osceola): Seminole Chief
(color painting by G. Catlin), 1838, Heyman, p57, p223

Black Elk (Hehaka Sapa): Oglala Sioux
(photo) 1947, Johnson (*Distinguished*), p21
Posing with Elk (photo), Robinson, C., p192+

Black Elk, Charlotte: Sioux
(photo), Doll, D. p28

Black Elk, Wallace: Oglala Sioux
Praying at Wounded Knee (photo), Crow Dog, L., p152+

Black Hawk: Ioway Chief
Ioway Chiefs visiting the Commissioner of Indian Affairs in Washington, 1866 (photo by Zeno A. Shindler), Blaine (*Ioway*), p267

Black Hawk: Kiowa-Apache
(photo by W.S. Soule), Belous, p39

Black Hawk (Black Eagle?): Kiowa-Apache
(photo by W.S. Soule), Nye (*Plains*), p383

Black Hawk (Ma-ka-tah-me-she-kia-kiah, Muk-a-tah-mish-o-kia-kah): Sac and Fox Chief
(color painting by C.B. King), 1837, Moore (*Native*), p51
(color painting by G. Catlin), 1832, Heyman, p217
(color photo), McKenney (Vol. 2), p58+

Black Hills: South Dakota
Frost-free days (map), Moore, J. (*Cheyenne Nation*), p71
Rainfall (map), Moore (*Cheyenne Nation*), p70

Black Horn (Tahe Sapa): Hunkpapa Sioux
1900 (photo by J. Anderson), Hamilton, H., p291
European sword (photo), Hanson, J.A., p44

Black Horse: Quohada Comanche Chief
With wife (photo), Nye (*Plains*), p309

Black Horse Society
Grass Dancers led by Tom Medicine Bull (photo by T. Magee), Farr, W., p93

Black Kettle: Southern Cheyenne Chief
1864 (group photo) Berthrong (*Southern*), p208+, Coel, p230–231, Hoig, S. (*Sand Creek*), no paging, Hyde (*Life*), p198+
(photo), Brill, p51, Schultz, D. (*Month*), p118+
(drawing by John Metcalf), Schultz, D., (*Month*), p118+
(drawing), Berthrong (*Southern*) p208+
Portrait of his daughter (photo), Mayhall (*Indian Wars*), p183+

Black Legs Society
Kiowa
1994 (photo), Meadows, pxx+
Dance, 1994 (photo), Meadows, pxx+
Turn-around or reverse dance, 1994 (photo), Meadows, pxx+

Black Magpie: Kiowa
Star Picture tipi (color photo), Ewers (*Murals*), p39

Black Man: Arapaho
(photo by E. Curtis) 1927, Curtis (*Plains*), plate 41

Black Moccasin (Eh-toh'k-pah-she-pee-shah): Hidatsa
(color painting by G. Catlin), 1832, Heyman, p208, Schneider, p51

Black Owl, John: Southern Cheyenne
(photo), Moore, J. (*Cheyenne Nation*), p219

Black Pipe District: Locale
Dance house, 1890 (photo by J. Anderson), Hamilton, H., p161
Field Matron's cottage, 1897 (photo by J. Anderson), Hamilton, H., p95

Black Plume: Blackfoot
Dressed for raid, 1920 (photo), Hungry Wolf, A., p274
With wives, 1892 (photo), Hungry Wolf, A., p275

Black Rock: Sioux Chief
(color painting by G. Catlin), 1832, Moore (*Native*), p173

Black Weasel: Blackfoot
Blackfoot Tribal Council, group photo, 1909 (by E.L. Chase), Farr, W., p65

Black Wolf: Arapaho
1891 (group photo), Fowler (*Tribal*), p58+

Black Wolf: Southern Cheyenne Chief
(group photo) 1884, Berthrong (*Cheyenne*), p157, Seger (*Early, 1934*), 78+

Blackbear, Aurelia (Littlebird): Cheyenne Indian
(photo) Working on moccasins, Moore, J. (*Cheyenne*), p169

Bunker Hill: Kansas
View of terrain (photo), Chalfant (*Cheyennes*),
p76

Bureau of Indian Affairs: Washington D.C.
BIA building take-over, Washington, D.C.,
November 1972
Crow Dog, Leonard, with a friend (photo),
Crow Dog, L., p152+
Means, Russel, speaks during take-over
(photo), Crow Dog, L., p152+
Young Horse, Floyd (photo), Crow Dog, L.,
p152+

Burial
Blackfoot
Scaffold in cottonwood trees (photo by
T. Magee), Farr, W., p. xx
Blackfoot tree burial (Diorama in Museum
of the Plains Indians, Browning, MT),
Ewers, J. (*Story*), p50
Burial tree near Belly River (photo), Hungry
Wolf, A., p228
Stone effigy where Many Spotted Horses
killed Kootenay Indian (photo), Dempsey,
H., p65
Crazy Horse: Sioux Chief
Location of scaffold (photo) Walstrom, V.,
p59+
Possible location of grave (photo) Walstrom,
V., p132
Sepulcher Tree (photo), Walstrom, V.,
p59+
Crow
Burial Scaffolds (photo by Sharp), Riebeth,
C., p91
Grave of Crazy Wolf (photo), Woodruff, J.,
p96
Tree Burial (photo), Wildschut, W. (*Medi-
cine Bundles*), Fig. 35
Scaffold
(color photo), Terry, p35
Sioux
Burial scaffolds (photo), Bonvillain (*Santee*),
p33, p34
Graves on Black Pipe Creek at edge of
Badlands, 1886 (photo by J. Anderson),
Hamilton, H., p235
Bonvillain (*Santee*), photo by Barry, Wemett,
W., p228
Warriors grave (photo by Huffman),
Hedren, P., p264
Tree Burials, 1886 (photo by J. Anderson),
Hamilton, H., p233
Woodland Culture
Casey's Mound Group (drawing), McKusick
(*Men*), p121
Wounded Knee
Burial detail (photo), Starita, J., p130

Yankton Sioux Indians
Scaffold burials at Greenwood, 1860 (photo),
Flood, R. (*Volume 2*), p8

Burke, John: U.S. Army Major
With Red Cloud and Rocky Bear, 1890 (photo),
Larson, R., p169+

Burleson, Edward: Businessman
(photo), Clarke, p110+

Burnet, David G.: President of Texas
(photo), Clarke, p110+

Burnett, F.G.
(group photo) 1904, Fowler (*Arapahoe Politics*),
p74+

Burnett, Tom: Comanche Advocate
With Quanah Parker, 1900 (photo), Neeley,
p132+

Burns, Robert: Southern Cheyenne Chief
(group photo), Berthrong (*Cheyenne*), p158
(group photo) 1909, Moore, J. (*Cheyenne
Nation*), p107

Burns, Willie: Southern Cheyenne
(group photo), Berthrong (*Cheyenne*), p153

Bushyhead, Jerome Gilbert: Cheyenne
(photo), *Contemporary Painting*, p69

Bustle (Dance)
Mesquakie
(photo) 1910, Torrance, p55+
Sioux
(photo), *Crazy Horse School*, p71
Eagle and owl feathers, hawk bells, mirror,
taffeta (color photo), Howell, p51
Hawk and eagle feathers, beadwork, ribbon
edging (color photo), Howell, p49
Northern traditional bustle, 1996, Szabo,
p82

Butchering Beef
Northern Arapaho (photo), Trenholm, p110+

Butner, H.W.: U.S. Army Major General
1935 (photo), Nye (*Carbine*), p406+

Butte Creek: South Dakota
Beef issue station, 1897 (photo by J. Anderson),
Hamilton, H., p95
Day school, 1890 (photo by J. Anderson),
Hamilton, H., p145

Button
Catholic, 19th century, (photo), Hanson, J.,
p104
Found at Teton campsite, Fort Robinson, NE,
1875 (photo), Hanson, J., p104

Butts, Betty: Sculptor
Sculpture of the bust of Cochise, Stockel, p70

Buzzard: Cheyenne
Drawing at home, Szabo, p114+

C

Calf Looking, Mrs.: Blackfoot
W.P.A. Sewing Club from Two Medicine (group photo by O. R. Hannon), Farr, W., p134

Calf Robe: Blackfoot
1910 (photo), Hungry Wolf, A., p287
(photo) 1889, Dempsey, H., p127
With rawhide rope (photo), Hungry Wolf, A., p292

Calf Robe, Sam: Blackfoot
With Tom Dog Gun & Aloysius Evans at Heart Butte, 1932 (photo), Farr, W., p133

Calf Shirt: Blackfoot
Drawing by Sohon, 1855, Dempsey, H., p48
With a live snake, 1898 (photo by T. Magee), Farr, W. p95, (photo), Hungry Wolf, A., p270, (photo), Dempsey, H., p141

Calf Tail
Medicine lodge ceremony — giving a name to a man (photo by T. Magee), Farr, W., p96

Calf Woman: Mandan
People Above ceremonial bundle with owner, Calf Woman and her grandson (photo), Bowers, A., p302

Calhoun, Frederic S.: U.S. Army Lieutenant
Men who contributed to the Crazy Horse Surrender Ledger (group photo), *Crazy Horse*, p8

Calico, Frank: Oglala Lakota
Page of school notebook, 1890 (drawing), Maurer, E., p284

California Joe: U.S. Army Scout
(photo), Hoig, S., (Battle), p148+

Calling Last: Blackfoot
1958 (photo), Hungry Wolf, A., p100
Dancing (photo), Hungry Wolf, A., p100

Camp Bowie: Arizona
Dress parade (photo), Reedstrom, p76

Camp Circles
Cheyenne
Camp circles (drawing according to G. Grinnell), Laubin (*Indian*), p184
Omaha (drawing), Laubin (*Indian*), p184
Sioux
Camp on Little Big Horn, 5/25/1876, Laubin (*Indian*), p184

Camp Radziminski: Oklahoma
Sketch, Chalfant (*Without*), p52

Camp Supply: Oklahoma
(drawing), Brill, p145, Hoig, S. (*Kiowas*), p130
Southern Arapaho & Cheyenne await rations (photo) 1870, Fowler (*Arapaho*), p54
View of post (drawing) 1878, Hoig (*Fort Reno*), p76, Hyde (*Life*), p294+

Camp Weld: Locale
Sketch by J.E.D. Dillingham, 1862, Coel, p228

Camp Weld Council
Camp Weld, 1862 (drawing by Dillingham), Coel, M., p228
Cheyenne and Arapaho arrive in Denver, Sept. 1864 (photo), Schultz, D., (*Month*) p118+
Denver citizens awaiting arrival of Indian leaders, 1864 (photo), Coel, M., p228
Group photo, 1864, Coel, M. p230–231, Schultz, D., (*Month*), p118+ Berthrong (*Southern*), p208+
Wagons carrying Indian delegation (photo), Coel, M., p229

Campbell, Ben Nighthorse: Northern Cheyenne
(photo), Edmunds (*New Warriors*), p262

Campbell, Curtis: Sioux
(photo), Doll, D., p75

Campbell, Fred C.: Superintendent
With Heart Butte farmers (group photo), Farr, W., p120

Camps
Apache (photo), Schweinfurth, p110
Assiniboine
Tepees and storage racks (photo), Sturtevant, v13, p576
Cheyenne
Tepees and meat drying (photo), Jones, G., p151
Woman bringing wood to her tepee (photo), Jones, G., p114
Comanche (photo) 1870, Wallace (*Comanches*), p14+
Moving Camp (drawing by George Catlin), Noyes (*Los Comanches*), p46
Iron Mountain's Camp (photo) 1873, Richardson, p151
Kiowa (drawing by Samuel Seymour) 1820–21, Mayhall (*Kiowas*), p62+
Camp (drawing by Zo-Tom), (*1877*), p25+
Camp (photo), Hail, p16
Kicking Bird's village (photo), Jones, G., p126
Scene showing wagons and various forms of tents (photo by James Mooney), Merrill, p326
Scene with meat drying racks and a variety of tents in use (photo by James Mooney), Merrill, p325
Scene with sweat lodge frames (photo by James Mooney), Merrill, p324
Osage (photo), Wilson (*Osage*), p59

Pawnee
 On the Plains, 1866 (photo by J. Carbutt),
 Blaine (*Pawnee Passage*), p73
 Scene in Indian Territory (photo by W. S.
 Prettyman), Blaine (*Pawnee Passage*), p193
Wichita
 Camp (photo), Newcomb (*People*), p44–45
 Encampment, 19th century Wichita (photo
 by William S. Soule), Newcomb (*People*),
 p80–81
 Village, 1890 (photo), Newcomb (*People*),
 p89

Cane
 Sioux, 1982 (photo), Coe, R., p127

Canoe
 Algonquin, 1981 (photo), Coe, R., p72
 Ojibwa (Chippewa)
 Women lashing canoe edges, 1930 (photo),
 Sommer, R., p49

Cannon, Tom Wayne: Kiowa
 (photo), *Contemporary Painting*, p69

Cantonment Indian School
 (photo) Oklahoma, Seger (*Early, 1934*), p78+
 View of school (photo), Berthrong
 (*Cheyenne*), p329

Cantonment North Fork Canadian River:
Oklahoma
 Artist's view, Kime, p269
 Region around Cantonment & wagon roads
 (map), Kime, p269

Cape
 Comanche
 Woman's deerskin cape (color photo),
 Taylor, p34–35
 Jacarilla Apache
 Beaded (drawings & photos), Mails (*Apache*),
 p384–385

Capes, Drusilla Jean: Wichita
 (photo), *Contemporary Metalwork*, p42

Capote
 Cayuse/Nez, 1983 (photo), Coe, R., p167
 Winter blanket coat (drawings), Mails (*Mystic*),
 p348–49

Caps *see* Hats

Captain Jim: Skidi Pawnee
 (group photo), Blaine (*Some*), p42+
 (photo), Chamberlain, p109, Walters, p122
 Famous Pawnee Scouts, 1906 (group photo),
 Chamberlain, p36
 Pawnee Scouts (group photo), Lacey, p80

Captain, Augustus: Osage
 Trader and three Osage Indians (group
 photo), Wilson (*Osage*), p48
 Tribal leaders (group photo), Wilson (*Osage*),
 p52

Capture, John: Gros Ventre
 (photo) 1985, Sturtevant, v13, p687

Carlisle Indian School: Pennsylvania
 Arapaho children (photo), Fowler (*Arapaho*),
 p73
 First boys' class, 1879 (photo), Standing Bear,
 L., p134
 First girls' class, 1879 (photo), Standing Bear,
 L., p134
 Sioux Chiefs, 1880, (photo) Hyde, G. (*Spotted*),
 p204
 Southern Cheyenne Chiefs (group photo) 1884,
 Berthrong (*Cheyenne*), p330
 Students wearing non–Indian clothes (photo),
 Wunder, p74

Carpenter, Louis H.: U.S. Army
 (photo), Monnett (*Battle*), p167

Carpio, Mrs. Mamie Kiowa (Toquode):
Comanche
 (photo) Family Picture, Hail, p63

Carpio, Sam: Comanche
 (photo) Family Picture, Hail, p63

Carr, Eugene A.: U.S. Army Colonel
 (photo), Collins, p17
 Drawing of a map of the Cibecue battle,
 Collins, p62–64
 Officers involved in the Cibecue battle (group
 photo), Collins, p124–125

Carriage
 (photo) Martha Napawat's baby Thomas, Hail,
 p22

Carries the War Staff: Crow
 1905 (photo by Throssel), Albright, P., p155

Carrington, Frances (Grummond)
 Wife of Henry B. Carrington (photo), Brown,
 D., p128+

Carrington, Henry B.: U.S. Army General
 (photo), Olson, J., p178+, Brown, D., p128+
 Military operations on the Plains (map), Car-
 rington, H., p32+

Carson, Christopher (Kit): Explorer
 (photo), Chalfant (*Dangerous*), p151, Hoig, S.
 (*Kiowas*), p85, Hyde (*Life*), p102, Mayhall
 (*Indian Wars*), p78+, Rollings (*Comanche*),
 p79

Carson, Hampton: Member of the Indian
Rights Association
 (photo), Clark, p78+

Carter, South Dakota
 1913 (photo), Moore, J. (*Political*) p40, 1988
 (photo), Moore, J. (*Political*), p41

Carter, William H.: U.S. Army Captain
 Officers involved in the Cibecue battle (group
 photo), Collins, p124–125

Charley: Apache Chief
(group photo), *Geronimo's Life*, p80+, Geron-
imo, p80+

Charm Bag
Kickapoo
Wool yarn, cotton cord, glass beads, 1880
(photo), Penney, D., p134
Mesquakie
Wool yarn, 1875 (photo), Penney, D., p134
Wool yarn, cotton cord, glass beads, 1880
(photo), Penney, D., p135

Charms
Arapaho
War charm (drawing), Kroeber, p454+

Chase, Champion S.: Lawyer
(group photo), Milner, p48+

Chase, E.L.: Photographer
Blackfoot Agency
Government Square (photo by E.L. Chase),
Farr, W., p50
Browning Day School
1913–14 (photo by E.L. Chase), Farr, W.,
p60
Cut Bank Boarding School
Students display vegetables grown for
school, 1912 (photo by E.L. Chase), Farr,
W., p58
Tennis Court, Browning, MT, 1912 (photo by
E.L. Chase), Farr, W., p51

Chasenah, Emma Coosewoon: Kiowa
(group photo), Hail, p47

Chasing Bear: Yanktonais Sioux
Chief, 1905 (photo by Fiske), Diedrich, M.
(*Odyssey*) p55

Chasuwy (Old Man Komah): Comanche
(group photo) With Seekadeeah and family,
Noyes (*Comanches*), p64

Chat-tle-kon-kea: Kiowa Chief
(photo), Methvin, p48+

Chato: Apache
Hunting with companion (photo), Perry, p75
Standing holding rifle (photo), Adams, p329

Chau-cha-uia-teuin: Teton Sioux
(painting by K. Bodmer), 1833, Moore (*Native*),
p237

Chaufty, Leon James: Photographer
Photo of Wolf Mule, McAndrews, p27

Chaui Pawnee
Blue Hawk (group photo), Milner, p48+
Front and back views of the Chawi bundle
(photos), Murie (*Part II*), p185
John Rouwalk (Raruhwa-ku, His Mountain),
1900 (photo), Murie (*Part II*), p202
La-ru-chuk-are-shar (photo), Milner, p48+

Performing calumet pipe ceremony (photo),
Dorsey (*Traditions*), p184+
Pitalesharo (photo), Milner, p48+
Yellow Sun (group photo), Milner, p48+

Che kus kuk: Sac & Fox Chief
(photo), Green, C., p37

Che-sho-hun-kah: Osage
Osage Council, 1895 (group photo), Baird
(*Osage People*), p69

Che-ve-te Pu-ma-ta (Iron Bull): Crow Chief
(group photo) 1873, Sturtevant, v13, p699

Chebatah: Lipan Apache
1930 (photo), Meadows, pxx+

Cheevers: Yamparika Comanche
(group photo), 1885, Kavanagh, p46
1872 (photo), Hagan, p36
1875 (group photo), Hagan, p13

Cherokee
Ball game sticks, 1983 (photo), Coe, R., p84
Baskets
Coffin Basket, 1982 (photo), Coe, R., p115
Lidded, 1981 (photo), Coe, R., p85
Storage, with lid, 1983 (photo), Coe, R., p83
Wastebasket, 1981 (photo), Coe, R., p 83
Blowgun and darts, 1983 (photo), Coe, R., p84
Boudinot, Elias (drawing), Ehle, p88+
Boudinot, Harriet Gold (drawing), Ehle, p88+
Bowles, William Augustus (photo), Clarke, p46+
Building a house to hold the printing press for
the Cherokee newspaper (photo), Ehle, p328+
Cabins
1888 (photo), Nobakov, p112
Battle of the Neches
Camps of Chief Bowles before and during
the Battle (map), Clarke, p106
Cherokee Nation, 1889 (map), McLoughlin,
p259
Chief Bowles
(drawing by Grayson Harper), Clarke, p78+
(drawing by William A. Berry), Clarke, p46+
Confederate Cherokee Delegates to Washing-
ton, 1866 (group photo), Pierce, p41
Dutch (drawing by George Catlin), Clarke,
p46+
Fields, Richard (photo), Clarke, p78+
Geographical distribution
Cherokee country in the eighteenth century
(map), Malone pix, Pierce, p8
Cherokee country, 1825 (map), Malone, px
Indian Territory in Oklahoma (map),
McLoughlin, p114–115
Land claimed by the descendants of the
Texas Cherokees when their delegation
appeared before the Indian Claims Com-
mission in 1948 (map), Clarke, p123
Land grant in Texas (map), Clarke, p23

Chief Johnson: Tonkawa Chief
 (photo), Newlin, p92

Chief Joseph: Nez Perce
 (photo), DeMontravel, p231+, MacEwan, G.
 plate 4, Vestal, S. (*New*), p240+

Chief Josh: Apache
 1898 (photo), Hagan, p72

Chief of the Bears (Nionoch-Kiaiu): Piegan
 Blackfeet
 (watercolor by K. Bodmer), Bodmer, p243

Chief of the Pointed Horn (Ahschupsa
 Masihichsi): Hidatsa
 (watercolor by K. Bodmer) 1834, Bodmer, p316

Chief White Man (Dorconealhla): Plains Apache
 With Daveko (photo) 1890, Sturtevant, v13,
 p933

Chiefly Dog (Asa-kisure-sa, Simond Adams):
 Pawnee
 1929 (photo), Murie (*Part II*), p229

Chihuahua: Chiricahua Apache Chief
 (photo), Robinson, S., p40
 (group photo), Geronimo, p46+
 With family (photo), Geronimo, p190+

Child of the Wolf (Makuie-Poka): Piegan
 Blackfoot Chief
 (watercolor by K. Bodmer), Bodmer, p257,
 Moore (*Native*), p248

Children (*see also* Children *as subdivision*
 under tribal names)
 Apache, 1901 (photo), Schweinfurth, p125
 Boy with child in cradle (photo), Hail, p124
 Comanche
 (drawing by George Catlin), Noyes (*Los
 Comanches*), p132
 (group photo) 1900, Cash, (*Comanche*),
 p83
 Girl with horse (photo), Noyes (*Comanches*),
 p71
 Poco, Sherman (photo), Noyes (*Comanches*),
 p71+
 Quanah Parker's children (photo) 1892,
 Wallace (*Comanches*), p238+
 Fort Sill
 School Children (photo), Hail, p22
 Goat cart (group photo), Hail, p47
 Hummingbird, Mable (Maunkaugoodle)
 (photo), Hail, p14
 Kiowa
 Baby (photo), Hail, p56
 Two Girls, 1890 (photo), *Stories*, p6
 Pawnee
 At the reservation school, 1871 (photo),
 Lacey, p81
 Riverside School in Oklahoma, 1901 (photo),
 Schweinfurth, p197

Chino, Wendell: President Mescalero Apaches
 (photo), Dobyns, pv, Robinson, S., p207

Chippewa *see* Obijwa; Plains Obijwa

Chiricahua Apache (*see also* Apache)
 Adultery
 Woman
 With mutilated nose (photo), Opler, p410+
 Amulets
 (photo), Opler, p266+
 Bakeitzogie (The Yellow Coyote, Dutchy)
 (photo), Reedstrom, p73
 Basket
 Burden basket (photo), Opler, p380+
 Camps
 (photo), Opler, frontispiece
 Cochise
 Seated holding blanket (photo), Adams,
 p331, Thrapp (*Apacheria*), p112+
 Cradle
 Women carrying the cradle (photo), Opler,
 p12+
 Fire drill
 With hide scraper and knife sheath (photo),
 Opler, p394+
 Geographical distribution
 Location of bands in aboriginal times (map),
 Opler, p3
 Hats
 Ceremonial hats for protection in war
 (photos), Opler, p310+
 Headdress
 Horned headdress (drawing), Sneve
 (*Apaches*), p6
 Masked dancer (photos), Opler, p108+
 Hoop-and-pole game
 Men play game (photo), Opler, p448+
 Objects needed to play the hoop-and-pole
 game (photo), Opler, p448+
 Masked Dancers
 (photo), Opler, p100+
 Coming down from the hill at dusk (photo),
 Opler, p112+
 Worshiping the Fire (photo), Opler, p112+
 Moccasins (photo), Opler, p380+
 Mount Vernon Barracks (group photo), 1890,
 Reedstrom, p84
 Puberty rites
 Erecting the ceremonial structure (photo),
 Opler, p94+
 Girl dressed for puberty ceremony (photo),
 Opler, p96+
 Round Dance (photo), Opler, p122+
 Saddlebag
 (photo), Opler, p394+
 Shirts
 Fringed buckskin with designs (photo),
 Morehead, p242+

Lattice cradle, wood, brass pins, deerskin
(color photo), Hail, p70
With hide doll, made of wood, pigments
and silk (color photo), Hail, p130
Toyebo, Lester Floyd and Mary White Horse
(photo), Hail, p73
Winnebago
With cradleboard, 1970 (photo), Coe, R.,
p101
(photo), Petersen p78+
Women
With babies in cradles (photo), Hail, p28

Cradleboards *see* **Cradle**

Craft Clubs
Blackfoot, Starr School, Old Agency, Brown-
ing & Two Medicine in front of craft shop,
Browning, 1929(photo), Farr, W., p136

Crafts (*see specific arts or items*)

Crawford, Bryan: Sioux
(photo) Doll, D., p54

Crawford, Charles R.: Santee Sioux
Delegation to Washington, DC, (group
photo), 1858, Meyer, R. (*History*), p108+

Crawford, Samuel J.: Kansas Governor
(photo), Brill, D. (*Treaty*), p32+, Hoig, S.
(*Battle*), p76+

Crawler: Hunkpapa
(photo) Michno, G., p47

Crazy Bear: Kiowa
Horse picture tipi (color photo), Ewers, J.
(*Murals*), p25

**Crazy Dogs: Blackfoot Men's Warrior Society
(*see also* Mad Dogs)**
Blackfoot Medicine Lodge dance, July 4, 1907
(photo by T. Magee), Farr, W., p90

Crazy Horse: Teton Sioux Chief
Bust of (Ernest Berke), Fielder, M., p21
Custer vs. Crazy Horse (drawing by Kills Two),
Gump, J., p97
Gentles, William, *Killing of Chief Crazy Horse*,
p144
Location of death scaffold (photo) Walstrom,
V., p59+
Possible location of grave (photo) Walstrom,
V., p132.
Officers pursuing Crazy Horse (photo), Milton,
J., p51
(photo), Milton, J. p21, *Killing of Chief Crazy
Horse*, p41
Sepulcher Tree (photo) Walstrom, V., p59+
Sculpture of Crazy Horse (photo) Milton, J., p2
Surrender of Crazy Horse's band, 1877 (draw-
ing), Buecker, T., p1

Crazy Horse Surrender Ledger
(facsimile), *Crazy Horse*, p23

Men who contributed to the ledger census
(group photo), *Crazy Horse*, p8

Crazy Mule: Cheyenne Chief
Presenting his warbonnet (drawing), Ewers, J.
(*Plains*), p71

Crazy Thunder: Oglala Sioux
(photo by E. Curtis) 1907, Adam, p81

**Crazy Walking, Martin (Rain in the Face):
Hunkpapa Chief**
Headstone (photo) Walstrom, V., p52

Crazy Wolf: Cheyenne
Counts coup on infantrymen (drawing),
Hedren, P., p163

Cree (*see also* Plains Cree)
Assinniboine-Cree attack Piegan camp outside
Ft. McKenzie, Aug. 28, 1833
(drawing by K. Bodmer), Ewers, J. (*Story*),
p29
Backrest Banner
Hide, 1900 (photo) Maurer, E., p154
Camp
1871 (photo) Hungry Wolf, A., p159
Dental Printmaking
Birch bark sheet, 1983 (photo), Coe, R., p112
Mittens, 1980 (photo), Coe, R. p69
Mukluks, 1975–77 (photo), Coe, R., p69
Pipe bags, caribou hide 1979–80 (photo),
Coe, R., p178
Pipe bowls
Black stone, catlinite, lead, 1840–60, Penney,
D., p234
Quillwork
Pipe bags, caribou hide 1979–80 (photo),
Coe, R., p178
Snow shovel (photo), Coe, R., p71
Snowshoes, 1979–80 (photo), Coe, R., p70

Creek/Seminole
Clothing, Dress, Cherokee "Torn-Tailored,"
1982 (photo), Coe, R., p87

Crier, Mrs. Pete: Oglala Sioux
Group Photo, *Crazy Horse School*, p12

Crispin, Tom: Arapaho
1935 (group photo), Fowler (*Arapahoe
Politics*), p170+
Business council delegation (photo) 1908,
Fowler (*Arapaho*), p62
(group photo) 1908, Fowler (*Arapahoe
Politics*), p74+

**Crittenden, Robert: Acting Governor of
Arkansas**
(drawing), Baird (*Quapaw Indians*), p73

Crockett, David: Frontiersman
(drawing), Ehle, p328+

Crook, George: U.S. Army General
(color drawing), Reedstrom, p32+

Crows Hearts Place
Hidatsa-Mandan Nueta Community —
"Crow's Hearts Place," View of a tipi settlement (photo), Cash, J. (*Comanche*), p47

Crunelle, Leonard: Artist
Sakakawea (bronze statue), Schulenberg, R. p86

Cruppers
Crow
Beaded (drawings), Mails (*Mystic*), p234
Omaha
Brass buttons/tacks and black beads (photo), Sturtevant, v13, p405

Cruzat, Francisco: Lieutenant Governor of Spanish Illinois
(painting), Din, p99

Cry of the Wild Goose (Sa-lo-so, Tsa'l-au-te): Kiowa
(photo by W.S. Soule), Belous, p30, Nye (*Plains*), p327
(photo), Nye (*Carbine*), p94+

Crystal Stone: Blackfoot
Wife of Buffalo Bull's Back Fat, 1832 (painting by G. Catlin), Ewers, J. (*Blackfeet*), p46+
(color painting by G. Catlin), 1832, Heyman, p164

Cuffs
Arapaho
Canvas, beads, tanned deerskin (color photo), Howell, p57
Gross Ventre
Deerskin, beads, muslin lining (color photo), Howell, p57
Mesquakie (color photo) 1925, Torrance, p55+
Winnebago, beaded, 1977–79 (photo), Coe, R., p99

Culture Districts
1000 AD (map), Schlesier, K., p294
1500 AD, historic period tribe locales (map), Schlesier, K., p303
500 AD, Late Archaic, (map), Schlesier, K., p292

Cunningham, Asa: Osage
With sister, Dana and Deanna Rector (color photo), Baird (*Osage People*), p97

Cunningham, Dana: Osage
With sister, Asa and Deanna Rector (color photo), Baird (*Osage People*), p97

Cup-and-Ball Game
Arapaho (drawing), Kroeber, p397

Cup-and-Pin Game
Ojibwa, 1980 (photo), Coe, R., p96

Curioushorn, Cora: Cheyenne
(group photo), Moore, J. (*Cheyenne Nation*), p269

Curioushorn, Elizabeth: Cheyenne
(group photo), Moore, J. (*Cheyenne Nation*), p269

Curley: Crow
(group photo) 1910, Harcey, p165
(painting by J.H. Sharp), Riebeth p110+
Portrait of a Grass Dancer, 1887 (drawing), Maurer, E., p216

Curley Head: Southern Cheyenne
(group photo), Hoig, S. (*Battle*), p148+
(photo), Brill, p239

Curly Bear: Blackfoot
1912 (photo by Walter Shelley Phillips), Farr, W., p155
Blackfoot Tribal Council
(group photo), 1909 (by E.L. Chase), Farr, W., p65
Delegation to Washington DC, 1903, Group Photo (by D.L. Gill), Farr, W., p64
Noted warrior, 1903 (photo), Ewers, J. (*Blackfeet*), p191+

Curly Chief (Kit-ke-kahk-i): Skidi Pawnee Chief
(drawing), Grinnell (*Pawnee*), p348
Group of Pawnee (group photo), Dorsey (*Traditions*), no paging
Prominent Chiefs (group photo), Blaine (*Pawnee Passage*), p216

Curly Head: Gros Ventre Chief
Wearing his war medicine, Fort Belknap Indian Reservation, Hays Montana, 1937 (photo by Richard A. Pohrt), Penney, D., p331
(photo) with Feathered Pipe bundle, 1925, Fowler, p75
(group photo) 1887, p681, Sturtevant, v13

Curse, Thomas: U.S. Army Lieutenant
Infantry and Cavalry School, 1891 (photo), Collins, p36–37

Curtis, Charles: Kansa, U.S. Congressman & Senator
(photo), Edmunds (*New Warriors*), p16, Unrau (*Kaw*), p73

Curtis, Edward S.: Photographer
(photo) 1899, Adam, frontispiece
Apache on horseback (photo), Perry, p147
Arapaho
Man smoking pipe (photo) 1910, Fowler (*Arapaho*), p12
Atsina
Horse travois (photo) 1908, Fowler (*Arapaho*), p15
Cheyenne child
Cheyenne (photo), Curtis (*Edward*), p42
Dog Woman
Cheyenne (photo), Curtis (*Edward*), p285

D

Quapaw
 Cornhusk doll (photo) 1959, Sturtevant, v13,
 p509
Sioux
 1800s (photo), Sommer, R., p28
 Buckskin dress, leggings beaded (photo),
 Minor, p364
 "No-Face Doll," 1982 (photo), Coe, R.,
 p139
 Tanned cowhide, muslin, glass beads, den-
 talium, 1890 (photo), Penney, D., p194
Tonkawa
 Buckskin (photo), Sturtevant, v13, p959

Dominques-Velez de Escalante Expedition
 Bernado Miera y Pacheo, 1778 (map),
 Kavanagh, p64

Doniphan, Alexander W.: U.S. Army Colonel
 (sketch), Chalfant (*Dangerous*), p144

Donovan, Jack: Colorado Milita
 (photo), Monnett (*Battle*), p158

Dorconealhla (Chief White Man): Plains Apache
 With Daveko (photo) 1890, Sturtevant, v13,
 p933

Dorion, Cass
 Iowa Chiefs visiting the Commissioner of
 Indian Affairs in Washington, 1866

Dorion, Cass
 (photo by Zeno A. Shindler), Blaine (*Ioway*),
 p267

Dorion, Elisha
 Ioway Chiefs visiting the Commissioner of
 Indian Affairs in Washington, 1866
 (photo by Zeno A. Shindler), Blaine (*Ioway*),
 p267

Dorsey, George Amos: Photographer
 (photo), Chamberlain, frontispiece
 Sun Dance (photo) 1901, Fowler (*Arapaho*),
 p34

Dorsey, James Owen: Ethnographer
 (photo), Barnes, p114+

Double Walker (Nom-ba-mon-nee): Omaha
 (color painting by G. Catlin), 1832, Moore
 (*Native*), p155, Heyman, p124

Double Woman Dancers
 Sioux, 1890 (ink and crayon on paper),
 Penney, D., p30

Doubleday, Ralph Russell: Photographer
 (photo of Arapahoe frontier days), McAndrews,
 p39

Doves, The: Blackfoot
 Pigeons, a young men's warrior society, perform
 their special dance (photo), Farr, W., p88

Doyah, Ray Charles, II: Kiowa
 (photo), Hail, p60

Doyetone: Kiowa
 (photo) With Honemeeda, Hail, p19

Dragg, Jerry: Sioux
 Carrying wood (photo), Mails, T.
 (*Sundancing*), p207
 Drawing by Mails, Mails, T. (*Sundancing*), p46
 Places rocks for fireplace, 1975 (photo), Mails,
 T. (*Sundancing*), p221

Drags Wolf: Sioux Chief
 1942 (photo by Monroe Killy), Cash, J. (*Three*),
 p67

Drawing (*see also* Pictograph)
 Hunkpapa Sioux
 Chief Running Antelope
 Drawings from ledger book, Maurer, E.,
 p73
 Pictorial killing record, 1856 (drawing),
 Ewers, J. (*Plains*), p193
 Little Finger Nail
 Ledger book drawings, 1879, Monnett (*Tell*),
 p154
 Meyers Springs
 (Copied 1935 by F. Kirkland), Maurer, E., p71
 Running Antelope
 Pictorial killing record, 1856 (drawing),
 Ewers, J. (*Plains*), p193
 Sioux
 Autograph book, (Print) 1890, Penney, D.,
 p290, 292–93

Dress (*see also* Clothing; *specific names of garments*)
 Arapaho
 Buckskin, feathers, pigment, 1890, Penney,
 D., p286
 Ghost Dance, girl's buckskin (color photo),
 Fowler (*Arapaho*), p66
 Girl's ceremonial dress (drawing), Kroeber,
 p454+
 Woman's cloth (photo E.S. Curtis) 1910,
 Fowler (*Arapaho*), p27
 Blackfoot
 Dress with beadwork (color photo), Taylor,
 p22–23
 Wool, button, glass beads, brass beads,
 bells or Trimbles, ribbon, 1890 (photo),
 Penney, D., p209
 Brule Sioux
 Girl's dress of dark blue trade cloth, Taylor,
 p92–93
 Cherokee
 "torn-tailored," 1982 (photo), Coe, R., p87
 Cheyenne
 Blanket dress
 Decorated with cowrie shells (photo),
 Minor, p34
 Elk-skin dress (color photo), Taylor,
 p60–61

Du Chene, Le Soldat: Osage Chief
(drawing), Din, p259

Du Lac, Perrin: Cartographer
Map of the Missouri, 1802, Hyde (*Pawnee Indians*), p44–45

Ducle: New Mexico
Indian Agency (photo), 1911, Mails (*Apache*), p355

Dudley, David (Hunts Buffalo): Yankton Sioux
1910 (photo) Flood, R. (v2), p90

Dugout
1892 (photo) in Comanche country, Wallace (*Comanches*), p78+

Dull Knife: Northern Cheyenne Chief
(photo by L.A. Huffman) 1879?, with Bobtail Horse, Brown, M., p115
(photo), Brill, p239, Hoig (*Fort Reno*), p60
(group photo by W.S. Soule), Belous, p75
Seated holding pipe (photo), Boye, p126, Kime, p7
With Little Wolf
(photo) 1873, Boye, p50
(photo) 1877, Monnett (*Tell*), p18

Dull Knife, George
Lawman, with sons Guy and Gordon
(photo), Starita, J., p185
With cousin Albert Poor Bear, at Yellow Bear Camp, 1930 (photo), Starita, J., p255
With son Guy (photo), Starita, J., p170

Dull Knife, Guy, Jr.
In Vietnam (photo), Starita, J., p283

Dull Knife, Guy, Sr.
1930s (photo), Starita, J., p239
1960 (photo), Starita, J. p264
Early in marriage (photo), Starita, J. p228
Four generations of the Dull Knife family
(photo by B. Feder), Starita, J., p343
(photo by B. Feder), Starita, J., opposite p1
(photo), Robinson, C., p192+
With cousin Enos Poor Bear (photo), Starita, J., p188
With father, 1905 (photo), Starita, J., p170
World War I (photo), J. p212, Starita

Dull Knife, Jeffery
(Guy's brother) WWII (photo), Starita, J., p242

Dull Knife, Mary
With friends (photo), Starita, J., p171

Durgan, Millie (Saintohoodie Goombi): White Kiowa Captive
(photo), Hail, 77, Mayhall (*Indian Wars*), 78+, Nye (*Carbine*), p286+

Dust Bowl
Farmer in Oklahoma (photo), Wilson (*Osage*), p84

Oklahoma
Farm machinery in Cimarron County
(photo), Wilson (*Osage*), p83

Dutch (Tah-chee): Cherokee Chief
(color photo), McKenney (v1), p330+
(drawing by George Catlin), Clarke, p46+

Dutchy (The Yellow Coyote, Bakeitzogie): Chiricahua Apache Scout
Reedstrom (photo), p73
With General Crook and Alchesay (group photo), Aleshire, p244, Reedstrom, p156

Dwelling (*see also* Tipi)
Caddo
Wattle and daub, roof covered with can mats
(photo), Nabokov (*Native*), p97
Ioway
(photo), Blaine (*Ioway*), p88
Bark houses (photo), Sturtevant, v13, p437
Covered with metal sheets (photo), Blaine
(*Ioway*), p311
Pole and bark-covered houses, 1887 (photo),
Blaine (*Ioway*), p293
Kansa
Circular bark house (photo) 1896, Sturte-
vant, v13, p467
Parker, Quanah
And his family at Star House (photo),
Neeley, p132+
His home "Star House," near Cache, Okla-
homa (photo), Noyes (*Comanches*), p79,
(photo), Neeley, p132+
His home, 1900 (photo), Hagan, p274
Summer arbor (photo), Neeley, p132+
Pawnee
Earth lodges
(photo), Tyson, p45
1886 (photo), Blaine (*Pawnee Passage*), p4
Village in Nebraska, 1875 (photo), Milner,
p48+
Quapaw Indians
Homes before and after receiving mining
royalties (photos), Baird (*Quapaws*), p97
Sac and Fox
Summer house, gable-roofed (photo) 1885,
Navokov, p23
Texas Farmhouse (photo), Noyes (*Comanches*),
p100

Dyer, Daniel: Quapaw Indian Agent
(photo), Baird (*Quapaws*), p70, Hoig (*Fort Reno*), p125

E

Eadle-tau-hain (Boyalye): Kiowa
(photo), Nye (*Carbine*), p286+

F

Pueblo Indians, 1984 (photo), Coe, R., p202
Sioux
 Yankton Sioux: (tree dweller) wood, paint,
 19th century, Penney, D., p248
 Vera Cruz, 300–900 AD (photo), Ewers, J.
 (*Plains*), p136

Fire, Silas: Quapaw
 Leaders in native dress posed by outdoor tents
 (group photo), Baird (*Quapaw Indians*), p214
 Quapaw leaders in traditional dress (group
 photo), Baird (*Quapaws*), p80

Fire Bear: Crow
 1905 (photo by Throssel), Albright, P., p111
 (painting by J. H. Sharp), Riebeth p94+
 (photo), Hoxie, p163

Fire Chief (Jonathan Parker): Omaha
 (photo), Barnes, p114+

Fire Making
 1840 campsite (drawing), Hanson, J.A., p68
 Crow Indian, (drawing), Lowie p87
 Elderly man building fire by friction (photo by
 J. Anderson), Hamilton, H., p277
 Firedrill, Crow Indian (drawing), Lowie, p87
 High Bear making a fire with flint and steel,
 (photo by J. Anderson), Hamilton, H., p228
 Oglala (drawing), Hanson, J.A., p68

Fire Pits
 Archaic Indians
 Northern Plains (photo), Wood, R. (*Archae-
 ology*), p153

Fire Thunder, Cecilia: Sioux
 (photo), Doll, D., p59

Fire Wolf: Cheyenne
 (photo by L.A. Huffman), Brown, p201

Fire Wood: Northern Arapaho
 Small red painted robe (photo), Szabo, p37

Firearms
 Blunderbuss rifle prized by Quapaws (photo),
 Baird (*Quapaws*), p48
 Burnette lock detail of 1844 (photo), Hanson,
 J.A., p16
 English
 Trade gun — two brass plates of early English
 trade guns, 1750–70 and 1720–50 (drawings),
 Hanson, J.A., p12
 Flintlock Rifle
 French 1600s, Rollings (*Comanche*), p48
 Longarm and lock detail (sketch), O'Shea,
 p179
 Made by Leman (photo), Hanson, J.A., p21
 French trade gun, showing brass side plate with
 oval mirror section, 1680–1720 (drawing),
 Hanson, J.A., p12
 Gunstock
 Decorated (drawing), Mails (*Mystic*), p475

Decorated with brass tacks and bound with
 hide (drawing), Mails (*Mystic*), p478
Surrendered by Sitting Bull, Hanson, J.A.,
 p21
Henry, J.
 Indian rifle, Hanson, J.A., p19
Northwest Trade gun
 American-made by Henry Leman, Lancaster
 Pennsylvania. 36' barrel is original length.,
 Hanson, J.A., p17
 Belgian-made, dated 1844, Hanson, J.A. p19
 Detail of brass dragon or sea serpent side
 plate (photo), Hanson, J.A., p15
 English made, by Barnett, dated 1805, 48"
 barrel is original and probably longer than
 was supplied to Tetons, Hanson, J.A., p17
 English-made by Barnett dated 1870, barrel
 shortened, comb of stock cut away Hanson,
 J.A., p19
 English-made by W. Jacot, barrel was short-
 ened for use on horseback, Hanson, J.A., p17
 English-made by William Chance, 1830–60.
 Barrell length is original, but wood fore
 has been cut off, Hanson, J.A., p17
 Parker Field and Co. (photo), Sturtevant,
 v13, p709
Plains Indians
 Flintlock musket .69 caliber (color photo),
 Terry, p30
Oglala
 (photo), Fielder, M., p105
 Oglala Warrior (photo), Fielder, M., p96
 Red Dog with Sharps buffalo rifle, Hanson,
 J.A., p24
Percussion rifle, Leman (photo), Hanson, J.A.,
 p21
Remington percussion revolver from Sioux
 (photo), Hanson, J.A., p24
Springfield U.S. cavalry Model 1873 (photo),
 Hanson, J.A., p23
Spanish
 Escopeta (photo), Morehead, p130+
Spencer repeating percussion rifle
 Decorated with brass tack symbols (draw-
 ing), Mails (*Mystic*), p475
Winchester Model 1866
 (photo), Hanson, J.A., p21

Firedrill
Crow Indian
 (drawing), Lowie, p87

Firesteel (fire starter)
1840 campsite (drawing), Hanson, J.A., p68
Oglala (drawing), Hanson, J.A., p68
Making a fire with flint and steel, 1911 (photo
 by J. Anderson), Hamilton, H., p228

First Rider, George: Blackfoot
1919 (photo), Hungry Wolf, A., p233

Follows the Woman: Oglala Sioux
1889 (photo by J. Anderson), Hamilton, H.,
p47

Folsom Points
(photo), Schneider, p18
Great Plains
Selected artifacts (drawing), Wood, R.
(*Archaeology*), p100
Selected sites (map), Wood, R. (*Archaeology*),
p98
Spearpoint
(illustration of), Alex, p65

Fonda: Oklahoma
Area around Fonda (map), Moore, J. (*Cheyenne*),
p245

Fontenelle, Logan: Omaha Interpreter
(photo), Boughter, p123

**Food and Food Preparation (*see also* Buffalo;
Hunting)**
Arapaho
Family preparing meal (photo), Fowler
(*Arapaho*), p40
Beef
Cheyenne skinning beef, 1887, Fielder, M.,
p31
Beef Drying *see* Jerky
Buffalo paunch
Hung on poles over fire (drawing), Mails
(*Mystic*), p535
Butchering
Cutting up meat, 1893 (photo by J. Ander-
son), Hamilton, H., p109
Cheyenne
Cheyenne skinning beef, 1887, Fielder, M.,
p31
Hanging meat (photo), Moore, J. (*Cheyenne*),
p55
Jerky (Meat drying) (photo), Jones, G., p151
Red Owl, Mabel
With Sallie Stand Out, dressing and dry-
ing meat (photo), Limbaugh, R.H., pVIII
Cooking
By throwing heated stones in beef stomach
container (photo), Anderson, J., no paging
Cooking meat in a paunch, 1911 (photo by
J. Anderson), Hamilton, H., p229
Making papa (sausage), 1916 (photo), Pow-
ers, M., Number 14
Making wasna (pemmican), 1945 (photo),
Powers, M., Number 16
Women, 1940 (photo), Powers, M., Number
15
Drying food
1919 (photo by Gilbert L. Wilson), Peters,
V., p124+
Drying corn, 1920 (photo), Hoover, H.
(*Wildlife*), p12

High Bear: Brule Sioux
Cooking meat in a paunch, 1911 (photo),
Hamilton, H., p229
By throwing heated stones in beef stomach
container (photo), Anderson, J., no paging
Jerky
1893 (photo), Hamilton, H. p110, p112, 1897
(photo), Hamilton, H., p111
1897 (photo by J. Anderson), Hamilton, H.,
p111
Mandan
Red Calf Woman
Stirring a cooking pot suspended from
a tripod over her Mandan-style small
blaze fire (photo), Cash, J. (*Three*), p27
Nothern Cheyenne
Red Owl, Mabel
With Sallie Stand Out, dressing and dry-
ing meat (photo), Limbaugh, R.H.,
pVIII
Oglala
Making papa (sausage), 1916 (photo), Pow-
ers, M., Number 14
Making wasna (pemmican), 1945 (photo),
Powers, M., Number 16
Women, 1940 (photo), Powers, M. Number
15
Red Owl, Mabel: Northern Cheyenne
With Sallie Stand Out, dressing and drying
meat (photo), Limbaugh, R.H., pVIII
Rosebud Sioux
Cooking a meal at Spring Creek (photo),
Anderson, J., no paging
High Bear cooking by throwing heated
stones in beef stomach container (photo)
Anderson, J. no paging
Preparing a meal (photo), Anderson, J. no
paging
Preparing Easter dinner at Upper Cutmeat,
1930 (photo), Anderson, J., no paging
Sioux
Cooking (photo), Mails, T. (*Sundancing*), p28
Women washing beef entrails (photo),
Anderson, J., no paging
Slaughtering beef (Sioux) (photo), Hamil-
ton, H., p108, 1893 (photo), Hamilton, H.
p109, 1891 (photo), Hamilton, H., p101
Turnips, wild, Blackpipe District, 1920
(photo), Hoover, H. (*Wildlife*), p136

Fool Bull (Tatanka Witko): Oglala Sioux
1900 (photo by J. Anderson), Hamilton, H.,
p286
Rosebud Sioux (photo), Anderson, J., no pag-
ing

Foolish Elk: Oglala Sioux
1892 (photo by J. Anderson), Hamilton, H.,
p181

Delegation to Washington, D.C. (group photo) 1877, Fowler (*Arapahoe Politics*), p74+

Holding pipe (photo) 1851, Fowler (*Arapaho*), p45

Friday: Cheyenne Chief
(group photo) 1854, Berthrong (*Southern*), p368+

Friday, Ben: Arapaho
(photo) 1979, Fowler (*Arapahoe Politics*), p170+

Friday, Robert: Arapaho
1935 (group photo), Fowler (*Arapahoe*), p170+

Frightened, Joe: Sioux
And his wife, Annie, 1889 (photo by J. Anderson), Hamilton, H., p205, 1892 (photo by J. Anderson), Hamilton, H., p181

Frizzlehead, Max: Kiowa
Agency Headquarters, 1907 (group photo), Schweinfurth, p20

Fuller, Melville Weston: Supreme Court Chief Justice
1899, (group photo), Clark, p78+

Fun: Chiricahua Apache
1886, (photo), Perry, p125, Robinson, S., p36

Furnas, Robert W.: Omaha Indian Agent
(photo), Boughter, p126

G

Gaapiatan: Kiowa
Holding his shield and lance (photo by J. Mooney), Merrill, p307

Gah'e: Apache
(photo), Stockel, p176

Gahige (Garner Wood): Omaha Indian Chief
(group photo), Barnes, p114+
Tipi (photo), Ridington, p108

Gall (Piza): Hunkpapa Sioux Chief
1880 (photo by Barry), Greene, J. (*Lakota*), p44
(portrait by Loren Zephier), Sneve, V. (*They*), p21
(drawing by Barry), Wemett, W., p240
Fort Buford, Dakota Territory, May 1881 (photo), Manzione, J., p95
Grave (photo by L.A. Huffman), Brown, M., p232
(photo), Schulenberg, R., p100, Vestal, S. (*New*), p226+, Michno, G., p86, Fielder, M., p58, Innis, p185
Village at Poplar Creek, 1881 (photo by Barry), Greene, J. (*Yellowstone*), p232

Gallant Warrior (Wahktageli): Yankton Sioux
(watercolor by K. Bodmer), Bodmer, p186

Galvez, Bernardo de: Governor of Louisiana
(painting), Din, p123

Gambling
Carved and painted sticks used in several games (color photo), Terry, p33
Basket gamble (drawing), Minor, p346
Gambling games (color photo), Terry, p32
Kiowa and Apache, 1900 (photo), Mayhall (*Kiowas*), p222+
Plains Indians
Gambling games (color photo), Terry, p32–33

Game (Pi-sing): Kansa
1868 (photo) Unrau, (*Kansa*), p78+

Games (*see also* Gambling)
Apache
Boys playing marbles at Rainy Mountian School, 1902 (photo), Ellis, p85
Hoop-and-pole game
Men playing (photo), Opler, p448+
Objects needed to play the game (photo), Opler, p448+
Moccasin Game, (photo), Petersen p74+
Playing cards, deerhides, 1880 (photo), *Stories*, p71
Arapaho
Bullroarer
Stick with thong (drawing), Kroeber, p396
Cup-and-Ball Game (drawing), Kroeber, p397
Guessing game
Counters (drawing), Kroeber, p373
Counting-stick (drawing), Kroeber, p375
Feather used as a pointer (drawing), Kroeber, p374
Feathered stick with wheel (drawing), Kroeber, p376
Hoop Game
Darts for game (drawing), Kroeber, p384
Model of game hoop (drawing), Kroeber, p383
Awl Game
Kiowa (photo), Merrill, p125
Ball
Hide & sewn (photo), Schneider, p39
Ball-game sticks
Cherokee, 1983 (photo), Coe, R., p84
Ball players in costume (drawing by Catlin), Wemett, W., p122
Ball Team (photo), Flood, R. v2 p16
Baseball
Team (photo), Bonvillain (*Santee*), p82
Basket and ball game (drawing), Minor, p348
Basket gamble (drawing), Minor, p346
Basketball team, 1901 (photo), Farr, W., p61

Netted Wheel game
(drawing), Dorsey (*Traditions*), p300+
Ring and javelin game
(drawing), Dorsey (*Traditions*), p254+
Plains Apache
Gambling set (photo), Sturtevant, v13, p930
Plains Indians
Gambling games (color photo), Terry, p32–33
Potawatomi Indians
Bowl and dice game, 1981 (Prairie band)
(photo), Coe, R., p112
Ring and javelin (drawing), Dorsey (*Traditions*), p254+
Santee
Engaged in lacrosse (painting), Bonvillain
(*Santee*), p26
Shinny sticks and balls (drawing), Minor, p360
Skidi Pawnee
Buffalo javelin game (drawing), Dorsey
(*Traditions*), p254+
Double ball (drawing), Dorsey (*Traditions*),
p254+
Large ring and javelin (drawing), Dorsey
(*Traditions*), p254+
Netted Wheel (drawing), Dorsey (*Traditions*), p300+
Spinning tops or whirligigs (drawing), Minor,
p357
Stick Slide game (drawing), Minor, p352
Stone game (drawing), Minor, p358
Toss and catch (drawing), Minor, p351
Whip tops (drawing), Minor, p357
Yankton Sioux
Boys playing Elk Game (drawing by Saul),
Hoover, H., (*Wildlife*), front cover
Buffalo Game (watercolor by Saul), Broken-
leg, M., p47
Elk Game (watercolor by Saul), Brokenleg,
M., p37
Ice Glider Game (watercolor by Saul),
Brokenleg, M., p41
Spear-and-Hoop Game (watercolor by Saul),
Brokenleg, M., p45
Winter Games (watercolor by Saul), Broken-
leg, M., p43
Yanktonais
Buffalo Game (watercolor by Saul), Bro-
kenleg, M., p47
Elk Game (drawing by Saul), Hoover, H.
(*Wildlife*), front cover
(watercolor by Saul), Brokenleg, M.,
p37
Ice Glider Game (watercolor by Saul),
Brokenleg, M., p41
Spear-and-Hoop Game (watercolor by Saul),
Brokenleg, M., p45
Winter Games (watercolor by Saul), Broken-
leg, M., p43

Gan Impersonators
Gan wands (drawing), Mails (*Apache*), p325
Masks (drawing), Mails (*Apache*), p324
Mescalero Apache
(photo & drawing), Mails (*Apache*), p323

Gap-in-the-Timber (Ho-weah, Gap-in-the-Woods): Yapparika (Noconi) Comanche Chief
(photo by W.S. Soule), Mayhall (*Indian Wars*), p30+, Nye (*Plains*), p245

Gap-in-the-Woods *see* Gap-in-the-Timber

Gardening (*see also* Agriculture)
Mad Plume, Albert
With wife Susan, son Fred & granddaughter
Irene in vegetable garden (photo), Farr, W.,
p113

Gardening Tools
Digging stick (photo), Hyde (*Traditions*), p138
Hoe, iron (photo), Hyde (*Traditions*), p138
Rakes
Antler (photo), Hyde (*Traditions*), p138
Willow (photo), Hyde (*Traditions*), p138

Gardipe, Andrea: Pawnee
Pocahontas Club (group photo), Tyson, p95

Gardner, Alexander: Photographer
(photo of Guipago) (Lone Wolf), 1872, May-
hall (*Kiowas*), p142+
(photo of Guipago's wife), Merrill, p303
(photo of Pacer), 1872, Mayhall (*Kiowas*),
p142+
Two Strike, 1872 (photo), Fielder, M., p33

Garfield, James A.: Jacarilla Apache
(drawing), Mails (*Apache*), p375

Garnett, Billy
1884 (photo), Hyde, G., (*Sioux*), p76+

Garnett, William
And his family (photo), *Killing of Chief Crazy Horse*, p86
(group photo) Washington, 1883, Larson, R.,
p169+
With Pourier, Baptiste "Big Bat" (photo),
Killing of Chief Crazy Horse, p87

Garnier, Baptiste "Little Bat": French/Sioux
(photo), *Killing of Chief Crazy Horse*, p134
With family (photo), *Killing of Chief Crazy Horse*, p135

Garretson, M.S.: Artist
The Herd (drawing) 1860, Coel, p58

Garters
Mesquakie
(color photo) 1830–90, Torrance, p55+
Ojibwa
Glass beads, cotton fabric, twine, wool yarn,
brass hook-eyes, 1850 (photo), Penney, D.,
p105

Glass beads, cotton thread, wool yarn, 1850
(photo), Penney, D., p106
Or Ottawa: wool yarn, glass beads, 1820–40
(photo), Penney, D., p81
Wool yarn, glass beads, 1830–50 (photo),
Penney, D., p77
Osage
And eardrops: 1965 (photo), Coe, R., p109
Ottawa
Or Chippewa: wool yarn, glass beads, 1820–
40 (photo), Penney, D., p81
Wool yarn, glass beads, 1820–40 (photo),
Penney, D., p81, p83
Potawatomi
Wool yarn, glass beads, 1850 (photo),
Penney, D., p83
Sauk (photo), 1800, Torrance, p13

Garvie, James W. (Tatanka Kinina): Yankton Sioux
(photo), Flood, R. v2 p70

Garvie, Winona Keith: Yankton Sioux
(photo), Flood, R. v2 p70

Gatewood, Charles B.: U.S. Army Lieutenant
Apache Scouts (group photo) 1880, Collins,
p34–35
With his wife (photo), Thrapp (*Apacherai*),
p240+
With Sam Bowman and scouts (photo),
Thrapp (*Apacheria*), p240+

Geikaumah, Bert: Kiowa
(group photo), Merrill, pii

Geimausaddle, Hattie: Kiowa
1901 (group photo), Ellis, p85

Geionety, George: Kiowa
(photo), *Contemporary Painting*, p70

Generelly, Fluery: Artist
Drawing of Quapaw Indians selling bear meat
in 1820, Arnold, p40

Genoa Manual Labor School: Nebraska
1872 (photo), Sturtevant, v13, p521

Gentles, William: Private U.S. Army
He killed Crazy Horse, *Killing of Chief Crazy
Horse*, p144

Gerard, Frederick F.: Army Scout
(photo), Innis p186–187

German, Adelaide: White Indian Captive
(photo), Jones, G., p143
(group photo) 1875, Monnett (*Massacre*), p58

German, Catherine: White Indian Captive
(photo), Jones, G., p141
(photo) 1875, Monnett (*Massacre*), p56

German, Julia: White Indian Captive
(group photo) 1875, Monnett (*Massacre*), p58
(photo), Jones, G., p143

German, Sophia: White Indian Captive
(photo) 1875, Monnett (*Masacre*), p56
(photo), Jones, G., p141

Geronimo (Goyathlay): Apache
(photo by E.S. Curtis), Curtis (*Edward*), p21
(photo by Fred R. Meyer), McAndrews, p82
(photo by G. Long), Noyes (*Comanches*), p80
1884 (photo), DeMontravel, p231+
1887 (photo), Robinson, S., p180
1888 (photo), Reedstrom, p22
1890 (photo), Reedstrom, p22
1902 (photo), Reedstrom, p23
1906 (photo), Stockel, p112
Armed with solders (photo), 1886, Reedstrom,
p76
Before an oak arbor (photo), 1898, Noyes
(*Comanches*), p83
Fort Bowie with Natchez (photo), 1886, Reed-
strom, p69
Holding rifle (photo) 1887, Aleshire, p4
Hostile Chiricahuas (group photo) 1886,
Thrapp (*Apacheria*), p240+
Hunting with son and two men (group
photo), Horse Capture, p76–77
Interviewed for his book (group photo),
Geronimo, pvii
Meeting with General Crook (photo), Aleshire,
p286
Mount Vernon Barracks (photo), 1890, Reed-
strom, p84
Painting on a Souvenir Shield, *Contemporary
Painting*, p23
Prisoner of War
(photo), Reedstrom, p30
(photo), 1905, Reedstrom, p85
1886 (group PHoto), Aleshire, p306
On their way to Florida (group photo),
Stockel, p44–45
Riding a horse (photo), 1886, Aleshire, p63
Seated wearing hat (photo), Aleshire, p326
Standing holding rifle (photo), 1886, Thrapp
(*Victorio*), p224
Wearing a hat, 1880 (photo), Reedstrom, p20
Wearing American clothing (photo), Reed-
strom, p19
Wearing American cut vest and jacket
(photo), Adams, frontispiece
Wearing traditional clothing (photo), *Geron-
imo*, p8+, Reedstrom, p26
With Asa Deklugie (photo), Geronimo, p100+
With family, 1896 (photo), Nye (*Carbine*), p390+
With General Crook (photo), Perry, p127
With his warriors in Mexico (photo), 1886,
Thrapp (*Apacheria*), p240+
With Kiowa Chief Lone Wolf (photo), *Geron-
imo*, p108+
With Naiche on horseback, 1886 (group photo),
Perry, p125

Good Eye: Kiowa
Constructing an arbor (photo), 1899, Nabokov (*Native*), p26

Good Fox: Chawi Pawnee Doctor
(photo by DeLancey Gill), 1902, Murie (*Part II*), p184

Good Gun: Piegan
Campbell, Fred C.: Superintendent with Heart Butte farmers (group photo), Farr, W., p120, (group photo) Big Badger Creek Agency, 1886 or 1887, Farr, W., p18

Good Medicine Pipe (Ish-ip-chi-wak-pa-i-chis): Crow
(group photo) 1873, Sturtevant, v13, p699

Good Shield, Nellie: Sioux
Prior to 1890 (photo by J. Anderson), Hamilton, H., p207

Good Shot, Oscar: Northern Cheyenne
With Dr. Marquis, 1926 (photo), Limbaugh, R.H., pIII

Good Striker: Blackfoot
(photo), Hungry Wolf, A., p317

Good Victory Spotted Eagle: Blackfoot
With Mrs. Wolf Plume (photo), Farr, W., p132

Good Voice, Joe: Brule Sioux Chief
Camp, 1897 (photo by J. Anderson), Hamilton, H., p190
Headstone (photo) Walstrom, V. p94
Ho Waste, a subChief, Oak Creek District, 1900 (photo by J. Anderson), Hamilton, H., p267
Men of the Brule Sioux, Rosebud Agency, 1894 (photo by J. Anderson), Hamilton, H., p259

Good Voice Eagle (Wanbli Ho Waste): Sioux
1911 (photo), Anderson, J., no paging
1911 (photo by J. Anderson), Hamilton, H., p290

Good Voiced Crow
Civil War cavalry saber (photo), Hanson, J.A., p44

Good Woman: Sioux
(photo by J. Anderson), Hamilton, H., p130

Goodale (Eastman), Elaine
Before 1880 (photo), Eastman, E., p48+, 1891 (photo), Eastman, E., p48+
White River Mission, January 1887 (group photo), Eastman, E., p48+
With day school students, 1887 (photo), Eastman, E., p48+
With her driver and outfit, 1890 (photo), Eastman, E., p48+

Goodbird: Hidasta
Buffalo Bird Woman and Son of a Star in a Bullboat, 1914 (drawing by Goodbird), Peters, V., p124+

Cache pit (drawing from sketch by Goodbird), Peters, V., p124+

Goodeagle, Francis: Quapaw
Tribal leaders in traditional dress by outdoor tents, with grandson (photo), Baird (*Quapaw Indians*), p214

Goodeagle, Francis: Quapaw Indian
Quapaw leaders in traditional dress (group photo), Baird (*Quapaws*), p80

Goodell, Fannie: Sac and Fox
(photo), Green, C., p21

Goodell, Isaac: Sac and Fox
(photo), Green, C., p21

Goodfox, Lawrence: Pawnee
Tribal Council and Nasharo advisors (group photo), Tyson, p99

Goodfox, Mary: Pawnee
Pocahontas Club (group photo), Tyson, p95

Goodnight, Charles: Rancher and Scout
(photo), Marrin, p157, Neeley, p132+
Scouts (group photo), Geronimo, p70+

Goodrider, Charlie: Blackfoot
(photo), Hungry Wolf, A., p303

Gooinkeen, Helen: Kiowa
1901 (group photo), Ellis, p85

Goombi: Kiowa
With family (photo), Hail, p78

Goombi, Almeta Jane: Kiowa
(photo), Hail, p81
(photo) Family picture, Hail, p78

Goombi, Ellen: Kiowa
(photo) Family Picture, Hail, p78

Goombi, Joe: Kiowa
(photo) Family Picture, Hail, p78

Goombi, Lillian: Kiowa
(photo), Hail, p78, p79, p81

Goombi, Millie Durgan: White Captive
(photo), Mayhall (*Kiowas*), p62+, Nye (*Carbine*), p286+

Goose, Charlotte: Cheyenne
With her daughter (group photo), Moore, J. (*Cheyenne Nation*), p269

Goose, Esther: Cheyenne
With her daughter (group photo), Moore, J. (*Cheyenne Nation*), p269

Goose, Giles: Sioux Chief
Headstone (photo) Walstrom, V., p58

Gotebo: Kiowa Chief
(photo), Geronimo's Life, p144+

Gouyen: Apache
(group photo), Robinson, S., p16
With family (photo), Stockel, p40

Saddle
Woman's, wood, rawhide, sinew, brass tacks
(color photo), Howell, p63
St. Paul's Mission
1937 (group photo), Fowler, p112
Shield
Buckskin, wool stroud, eagle feathers, brass
hawk bells, glass beads, porcupine quills,
1860, Penney, D. p280
Shirts
Dog Lodge Shirt (photo), Sturtevant, v13,
p687
Man's, deerskin, porcupine quills, ermine,
brass beads (color photo), Howell, p46
Singing Bird
With husband White and Yellow Cow
(photo) 1907, Sturtevant, v13, p681
Sitting on High (group photo) 1887, Sturtevant,
v13, p681
Thick (group photo) 1938, Sturtevant, v13,
p681
Tipis
Painted tipi, 1991 (photo), Maurer, E. p244
Women raising tepee (photo), Sturtevant,
v13, p680
Travois
Woman on horse (photo by E.S. Curtis)
1908, Fowler (Arapaho), p15
War bonnet
Eagle feathers, wool cloth, ermine and
weasel skins, 1885, Penney, D., p218
White and Yellow Cow
With wife Singing Bird (photo) 1907,
Sturtevant, v13, p681
Woh-se Im-meh-ca-tan (Bear's Shirt)
(sketch) 1855, Sturtevant, v13, p679
Woman That Sets (Ac-kyo-py)
(sketch) 1855, Sturtevant, v13, p679
Yoke (clothing)
Girl's yoke, deerskin, beaded, basket beads
(color photo), Howell, p72

**Gros Ventre Man (Cleaver Warden, Hitunena):
Arapaho**
(photo), Trenholm, p302+

Grouard, Frank: Scout
(photo), Vaughn p48+

Ground Bear: Arapaho Chief
(group photo) 1883, Fowler (Arapahoe Politics),
p74+

**Gu-ee-ah-pay (Trotting Wolf, Coyote Walking):
Kiowa**
With wife (photo by W.S. Soule), Belous, p46

Guaddle, Joe: Kiowa
With Nettie Odlety (photo), Hail, p118

Guadeloupe: Caddo Chief
1872 (photo), Smith, F., p102

**Guerrier, Edmund: Southern Cheyenne
Interpreter**
(group photo) 1871, Fowler (Tribal), p58+
(group photo), Berthrong (Southern) p368+
(photo), Nye (Plains), p255, Grinnell (Fighting)
p174+

Guess, George (Se-quo-yah):
(color photo), McKenney v1, p130+
(drawing), Bass, p36+, Pierce, p21
(painting), Malone, p82+

Guessing Game
Arapaho
Counters (drawing), Kroeber, p373
Counting-stick (drawing), Kroeber, p375
Feather used as a pointer (drawing),
Kroeber, p374
Feathered stick with wheel (drawing),
Kroeber, p376

Gui-pah-go (Lone Bear): Kiowa Chief
(photo by W.S. Soule), Nye (Plains), p221

Gui-tain (Heart of a Young Wolf): Kiowa
(photo by W.S. Soule), Nye (Plains), p321

Guipago (Lone Wolf): Kiowa Chief
(photo by W.S. Soule), Belous, p40
(photo), Nye (Carbine), p94+
1872 (photo by Alexander Gardner), Mayhall
(Kiowas), p142+

Gun Cases (see also Scabbard)
Assiniboine
Buffalo hide, glass bead, 1890 (photo),
Penney, D., p212
Blackfoot
Buckskin, glass beads, 1890 (photo),
Penney, D., p211
Crow
Beaded gun case (photo), Wildschut, W.
(Beadwork) Fig. 34
Beaded gun case with shoulder sling (draw-
ing), Mails (Mystic), p479
Buckskin, glass beads, wool stroud, 1890
(photo), Penney, D., p198
Gros Ventre
Buffalo hide, glass bead, 1890 (photo),
Penney, D., p212
Sioux
Beaded with buckskin fringes (drawing),
Mails (Mystic), p479

Gun That Guards the House: Mandan
(photo), Schulenberg, R., p92

Gunavi: Kiowa
Conclusion of a Peyote ceremony (photo by
James Mooney), Merrill, p321

Gunstock War Club (see also War Club)
Northern Plains Tribe (photo), Ewers (Views),
p59

Halfpatter-Micco (Billy Bowlegs): Seminole
Chief
 (color photo), McKenney v2, p8+

Hall, Mary: Sioux
 (photo), Doll, D., p68

Hamilton, Elizabeth: Pawnee
 Indian Service Club (group photo), Tyson, p95

Hamilton, Joi: Cheyenne Chief
 (group photo) 1909, Moore, J. (*Cheyenne
 Nation*), p107

Hamilton, Josephine Pryor: Osage Artist
 (photo), Wilson (*Osage*), p91

Hamilton, Robert: Reverend
 Baptizing (group photo) 1905, Fowler (*Tribal*),
 p58+

Hamilton, Walter R.: Southern Cheyenne
 (photo), Moore, J. (*Cheyenne Nation*), p220

Hammers (*see also* Tools; *specific names of tools*)
 Berrymasher
 (drawing), Mails (*Mystic*), p252
 Plains Indian
 Elk-horn hammer (color photo), Terry, p19

Hammon Camp
 Home of Frank & Christine Starr (photo) 1953,
 Fowler (*Tribal*), p58+

Hampton Institution: Locale
 1886 (photo), Eastman, E., p48+

Hancock, Winfield S.: U.S. Army Major General
 (photo), Hoig, S. (*Battle*), p76+
 (photo), Jones, D. (Treaty), p32+, Monnett
 (*Battle*), p37
 Encampment at Fort Harker, Kansas (drawing)
 1867, Nye (*Plains*), p285
 Fort Dodge with Kicking Bear (drawing),
 Hoig, S. (*Kiowas*), p96

Hand Drum (*see also* Drum; Musical
Instruments)
 Assiniboine
 Wood, deerskin, pigment, 1860–70, Penney,
 D., p284
 Sioux
 Wood, pigskin, pigment, 1900, Penney, D.,
 p285

Hand Game Set
 Chippewa/Cree, 1975–82 (photo), Coe, R.,
 p153

Hand Shaker (Mow-way): Comanche
 (photo) 1867–74, Chalfant (*Without*), p61

Hannon, Olga Ross: Photographer
 W.P.A. Sewing Club from Two Medicine (group
 photo), Farr, W., p134

Hansson, Marian Kaulaity: Kiowa
 (photo), Merrill, p333

Haokah
 The Anti-Natural God; one the Giants of the
 Dahcotahs (drawing by White Deer), East-
 man, M. (1962), p205+

Hard Hart: Kansa
 (drawing) 1857, Unrau (*Kansa*), p78+

Hard Rope: Osage Chief
 (group photo), Wilson (*Underground*), p33
 Band Chiefs (group photo), Wilson (*Osage*),
 p41
 Tribal leaders (group photo), Wilson (*Osage*),
 p52

Hardie, Francis H.: U.S. Army Captain
 (sketch), Hoig (*Fort Reno*), p198

Harjo, Tahnee Ahtone: Kiowa
 (photo), Hail, p85

Harney, William: U.S. Army General
 (group photo) in council, Trenholm, p46+
 Medicine Lodge Commission (group photo),
 Hyde (Life), p294+

Harper, Grayson: Artist
 Drawing of Chief Bowles, Clarke, p78+

Harper, Lizzie Dailey: Otoe-Missouria
 (photo by Marjorie M. Schweiterz), *Grand-
 mothers*, p169

Harragarra, Deana Jo: Kiowa
 (photo), *Contemporary Metalwork*, p31

Harrington, John P.: Photographer
 Photo of Belo Kozad (Bedalatena), Merrill,
 p214

Harris, Bryon: Comanche
 Family (group photo), 1967, Harris, p72+

Harris, Fred: Comanche
 1949 (photo) Wedding day, Harris, p72+
 1964 (group photo) On the campaign trail,
 Harris, p72+
 1967 (group photo) Harris family, Harris, p72+
 1967 (photo) With LaDonna, Harris, p72+
 1968 (photo) During Humphrey's presidential
 campaign, Harris, p72+
 1978 (photo) Ceremony at Taos Pueblo, Harris,
 p72+

Harris, George: Shoshone
 1904 (group photo), Fowler (*Arapahoe
 Politics*), p74+

Harris, Kathryn: Comanche
 1950 (group photo), Harris, p72+
 1964 (group photo) On the campaign trail,
 Harris, p72+
 1967 (group photo) Harris family, Harris, p72+

Harris, LaDonna: Comanche
 (photo), Edmunds (*New Warriors*), p122, Roll-
 ings (*Comanche*), p103, Sommer, R., p125
 1945–46 (photo), Harris, p72+

Three Osage warriors (drawing), Wilson
(*Osage*), p20

**He Who Kills the Osages (Haw-che-ke-sug-ga):
Otoe-Missouria Chief**
(color painting by G. Catlin), 1832, Heyman,
p121, Moore (*Native*), p150
(drawing by G. Catlin), Irving, p214+

**He Who Moistens the Wood
(Naugh-haigh-hee-kaw): Winnebago**
(painting by G. Catlin), 1828, Heyman, p31

**He Who Puts Out and Kills (Mo-sho-la-tub-bee):
Choctaw**
(watercolor by George Catlin), Troccoli, p126

He Who Smokes (Schuh-de-ga-che): Ponca
(sketch by K. Bodmer), Bodmer, p169

**He Who Stands on Both Sides (Ah-no-je-nahge):
Sioux**
(color painting by G. Catlin), 1835, Heyman,
p146

**He Who Ties His Hair Before
(Ee-hee-a-duck-chee-a): Crow**
(watercolor by G. Catlin), Troccoli, p101

**Head of the Buffalo Skin (Hotokaueh-Hoh):
Piegan Blackfeet**
(watercolor by K. Bodmer), Bodmer, p247

**Head Ornaments (*see also* Bonnets; Headband;
Headdress)**
Arapaho
Bunch of feathers, with green plume (draw-
ing), Kroeber, p408
Ghost Dance (drawing), Kroeber, p330
Peyote ceremony (color photo), Fowler
(*Arapaho*), p67

Headband
Malecite, beaded with pouch, 1969–70 (photo),
Coe, R., p65
Mesquakie
German silver (photo) 1880, Torrance, p55+
Sioux head and wristbands worn for Sun Dance,
1974 (photos), Mails, T. (*Sundancing*), p254–
255

**Headdress (*see also* Bonnet; Feather Bonnett;
Feathers)**
Arapaho
Animal symbolism and quills (drawing),
Kroeber, p54
Arrow symbolism (drawing), Kroeber, p343
Bird symbolism (drawing), Kroeber, p329
Cross headdress (drawing), Kroeber, p454+
Crow feathers (drawing), Kroeber, p335
Dog-Dancer of lowest degree (drawing),
Kroeber, p206
Eagle feather, 1890 (photo), Maurer, E. p232
Head Chief's scepter & headdress (drawing),
Fowler (*Arapahoe Politics*), p74+

Hoop wound with yellow quills (drawing),
Kroeber, p53
Upright feather (drawing), Kroeber, p327
With small Bow and Arrows (drawing),
Kroeber, p331
With wheel and bow (drawing), Kroeber,
p332
Blackfoot
Buffalo horn headdress, 1840 (drawing),
Mails (*Mystic*), p111
Eagle feather, 1890 (photo), Maurer, E.,
p232
Low Horn, Jack, making a headdress, 1958
(photo), Dempsey, H., p43
Red Crow, 1892 (photo), Hungry Wolf, A.,
p253
Buffalo
Plains region, tribe unknown (color photo),
Heyman, p133
Cheyenne
Headpiece, eagle feathers, bull's tail hair
(color photo), Howell, p53
Comanche
(photo), Rollings (*Comanche*), p41
Hunkpapa Lakota
Buffalo society, by No Two Horns, 1900
(photo), Maurer, E., p232
Mesquakie
(photo) 1920, Torrance, p55+
Northern Plains
Antelope horn, hide, cloth, quills (photo),
Ewers (*Views*), p27
Osage
Tribespeople and Frank Phillips (photo),
Wilson (*Osage*), p73
Plains Indian
Medicine man headdress
Buffalo horn, fur, and horse tail (photo),
Minor, p264
Sioux
Porcupine guard hair, deer hair eagle feath-
ers (color photo), Howell, p52
Roach headdress dyed red horsehair (photo),
Minor, p44
Southern Arapaho
Ghost Dance (color photo), Fowler
(*Arapaho*), p66
Yanktonais
Eagle-Feather headdress (watercolor by
Saul), Brokenleg, M. ,p44
Making of a headdress (watercolor by Saul),
Brokenleg, M., p46

Heap of Birds, Edgar: Artist
In Our Language, 1982 (photos), *Contemporary
Native American Art*, no paging

Heap of Buffalo: Southern Arapaho Chief
(group photo) 1864, Coel, p230, p231

Plains Indian
(photo), Minor, p94
Scraping a hide (drawing), Mails (*Mystic*), p211
Sioux
Tools, 1873 (photo), Hanson, J., p64
Southern Cheyennes
(photo), Hanson, J.A., p62
Stages of the tanning process (painting by
George Catlin), Wunder, p33
Woman scraping hide (drawing), Wemett, W.,
p136

High Bear: Oglala Sioux
(photo by L.A. Huffman), Brown, M., p56,
(photo), Buecker, T., p175, (photo), *Crazy
Horse,* p175
Cooking
By throwing heated stones in beef stomach
container (photo), Anderson, J., no paging
Cooking meat in a paunch, 1911 (photo by
J. Anderson), Hamilton, H., p229
Group of Sioux Chiefs (photo by J. Anderson),
Hamilton, H., p186
In police coat, 1896 (photo by J. Anderson),
Hamilton, H., p220
Making a fire with flint and steel, 1911 (photo
by J. Anderson), Hamilton, H., p228
Men of the Brule Sioux, Rosebud Agency, 1894
(photo by J. Anderson), Hamilton, H., p259

High Bull: Cheyenne
Chased by Crows (drawing), Hedren, P., p157

High Eagle: Skidi Pawnee
1906 (group photo), Chamberlain, p36
(group photo), Blaine (*Some*), p42+, Lacey,
p80

High Hawk: Brule Sioux
(photo by E. Curtis) 1907, Curtis (*Plains*),
plate 6
Ceremonial tipi, 1895 (photo), Anderson, J.,
no paging
Men of the Brule Sioux, Rosebud Agency, 1894
(photo by J. Anderson), Hamilton, H., p259
With Two Strike and Crow Dog (photo),
Fielder. M., p47

High Horse (Tasunke Wankatuya): Sioux
1900 (photo by J. Anderson), Hamilton, H.,
p280

High Horse, Paul: Sioux
At Wanblee World War I and II memorial
(photo), *Crazy Horse School*, p17

High Lance (Schim-a-co-che): Crow
(painting by A. Miller), Miller, p27

High Pipe: Sioux
1910 (photo by J. Anderson), Hamilton, H.,
p304
Men of the Brule Sioux, Rosebud Agency, 1894
(photo by J. Anderson), Hamilton, H., p259

High Plains: Central
Late Woodland distribution (map), Schlesier,
K., p230
Upper Republican and Intermountain distrib-
ution (map), Schlesier, K., p236

High Plains: Southern
Early Plains Village (map), Schlesier, K., p274
Middle Plains Village (map), Schlesier, K., p284
Plains Woodland (map), Schlesier, K., p268

Highland: Kansas
Ioway and Sac/Fox Mission School (photo),
Blaine (*Ioway*), p217

Hileman, T. J.: Photographer
Blackfoot camp, 1900 (photo), Farr, W., pxiv

Hill, Asa T.: Anthropologist
(photo), frontispiece, Grange

Hill, Bobby: Kiowa
(photo), *Contemporary Painting*, *Painted
Tipis*, p41, p70

Hill, Joan: Cherokee Artist
(photo), Pierce, E., p55
Wars and Rumors of Wars (painting), Pierce,
E., pii

Hill Site: Iowa (State)
Tools and weapons
Logan Creek complex (drawing), McKusick
(*Men*), p58

Hillers, John K.: Photographer
(group photo) members of the 1894 delegation
to Washington, Merrill, p317

Hind Gun: Blackfoot
(photo), 1900, Dempsey, H., p133

Hinhan Sa (Red Owl): Yankton Sioux
1905 (photo) Flood, R. v2, p87

**His Chiefly Sun (Ra-tu-tsa-ke-te-saur,
Raruhcakure sa ra): Skidi Pawnee**
(photo), Chamberlain, p20

His Fight: Hunkpapa Lakota
Drawings from ledger book, Maurer, E., p73

His Hoop (Chankdeska Tawa): Yankton Sioux
1905 (photo) Flood, R. v2, p88

**His Mountain (John Rouwalk, Raruhwa-ku):
Chawi Pawnee**
1900 (photo), Murie (*Part II*), p202

His-oo-san-chees (Little Spaniard): Comanche
(painting by George Catlin), Wallace
(*Comanches*), p14+
(watercolor by George Catlin), Troccoli, p138

His Thunder: Sioux
Lower Dakota Delegation to Washington, 1858
(photo), Diedrich, M. (*Odyssey*), p40

Hishkowits (Porcupine): Cheyenne Shaman
(photo) 1907, Johnson (*Distinguished*), p177

I

J

Leggings
 Buckskin fringings (drawing), Mails
 (*Apache*), p374
 Man's buckskin, Prairie style (drawing),
 Mails (*Apache*), p372
Moccasins
 Rawhide (photo's), Mails (*Apache*), p375
Necklace
 Tube bead (photo), Mails (*Apache*), p377
Police
 With two cattle thieves (group photo),
 Mails (*Apache*), p362
Relay race
 (photo's), Mails (*Apache*), p395–398
Shirts
 Abstract beaded design (color photo), 1850s,
 Horse Capture, p109
 Fringings (drawings), Mails (*Apache*), p374
 Man's buckskin (drawing), Mails (*Apache*),
 p372
 Man's buckskin war shirt (drawing), Mails
 (*Apache*), p370
Warriors
 Seated in tipi (group photo), 1898, Mails
 (*Apache*), p362
 Wardress holding lance (drawing), Mails
 (*Apache*), p380
 Wearing beaded shoulder bands & beaded
 hair tubes (drawing), Mails (*Apache*),
 p349

Jim, Clifford: Artist
 (drawing of a Skidi priest observing through
 a smokehole), Chamberlain, p176

Jim, Tawakoni: Wichita
 1870 (photo), Smith, F., p123

Johnson, Charles A.: U.S. Army Lieutenant
 Men who contributed to the Crazy Horse
 Surrender Ledger (group photo), *Crazy
 Horse*, p8

Johnson, Maggie: Omaha
 (photo by Jillian Ridington), Ridington, p167
 On way to the pow-wow with the Woods
 family, 1922 (photo), Ridington, p143

Jol-Lee: Cherokee
 (watercolor by George Catlin), Troccoli, p128

Jolly, John (Col-le): Cherokee
 (drawing), Ehle, p328+

Jonathan Parker (Fire Chief): Omaha
 (photo), Barnes, p114+

Jones, Bill: Gros Ventre
 On horseback with scalp lock and shield
 (photo) 1905, Sturtevant, v13, p687
 Singing at the Grass Dance, Fort Belnap
 Indian Reservation, July 4, 1905 (photo by
 Sumner W. Matteson), Penney, D., p56

Jones, David E.: Author
 With Sanapia (photo), Jones, D. (*Sanapia*), p3

Jones, Henry C.: White Settler
 (photo), Green, C., p33

Jones, Horace P.: Indian Interpreter
 (group photo by W. S. Soule) Nye (*Plains*),
 p391, Nye (*Carbine*), p398+

Jones, Lloyd: U.S. Army Lieutenant
 (photo), Nye (*Carbine*), p406+

Jones, William: Sioux Pipe Carver
 Carving catlinite pipe (photo) 1902, Sturtevant,
 v13, p774

Jordan, Charles P.: Businessman
 Brule Sioux, Rosebud Agency, 1894 (photo by
 J. Anderson), Hamilton, H., p259
 Family camp at Episcopal convocation, 1898
 (photo by J. Anderson), Hamilton, H., p126
 (photo by J. Anderson), Hamilton, H., p138
 Jordan, Julia (wife of Charles P.) (Winyan-
 hcaka, the True Woman, Julia) 1900
 (photo by J. Anderson), Hamilton, H., p127
 Jordan Mercantile Company
 1912 (photo by J. Anderson), Hamilton, H.,
 p123
 Jordan Trading Post
 1893 (photo by J. Anderson), Hamilton, H.,
 p118
 1899 or 1900 (photo by J. Anderson), Hamil-
 ton, H., p122
 Jordan's home, 1897
 (photo by J. Anderson), Hamilton, H., p125
 Jordan-Anderson store — interior view
 1893 (photo by J. Anderson), Hamilton, H.,
 p119

Joseph: Nez Perce Chief
 (photo), Vestal, S. (*New*), p240+, MacEwan,
 G., plate 4

Juan: Apache
 (photo), Reedstrom, p91

Jump, Jacob: Osage
 (photo) 1910, Revard (*Winning*), p38+

Jump, Louis J.: Osage
 (photo) 1955, Revard (*Winning*), p38+

K

Ka-Pol-E-Quah: Sac and Fox
 Color painting by C.B. King, 1824, Moore
 (*Native*), p34

**Kah-Kee-Tsee (The Thighs): Taovayas
Comanche**
 (drawing by George Catlin), Newcomb
 (*People*), p33, Noyes (*Los Comanches*), p48

Little Chief (Kee-mon-saw)
(color painting by G. Catlin), 1830, Heyman, p102

Kaudledaule, Harry: Apache
Blackfeet Dancers, 1961 (group photo), Schweinfurth, p151

Kaudlekule, Harry: Apache
Blackfeet dances (group photo) 1961, Schweinfurth, p151

Kauley, Mattie: Kiowa
(photo) with Saubeodle and Dorothy Rowell, Hail, p45

Kauley, Susie: Kiowa
(photo) With Maye Rowell and Hoygyohodle, Hail, p44

Kaw *see* Kansa

Kaw Mission
Council Grove (photo), Unrau (*Kaw*), p57

Kaw-tom-te (Hair Portion of Leg, Buffalo Chap): Kiowa
(group photo by W.S. Soule), Belous, p57, Nye (*Plains*), p361

Kaytah: Apache
Scouts (photo), Geronimo, p152+

Kaytennae: Apache
(group photo), Robinson, S., p16
(photo), Stockel, p40

Kaywaykla: Apache
(group photo), Robinson, S., p16
With family (photo), Stockel, p40

Ke-dah-to-he (Pious Quapaw): Quapaw
Keeper of the Sacred Fire (photo), Baird (*Quapaw People*), p64

Keahbone, Ernie: Kiowa Artist
(photo), Contemporary Painting, *Painted Tipis*, p42, p72
Drawing of Setangya's Death Song, Wunder, p62

Kearny, Stephen W.: U.S. Army General
(engraving) 1847, Chalfant (*Dangerous*), p143

Kee-kah-wah-un-ga (Reuben A. Snake, Jr.): Winnebago
(photo), Johnson (*Distinguished*), p113

Kee-mon-saw (Little Chief): Kaskaskia/Miami Chief
(color painting by G. Catlin), 1830, Heyman, p102

Kee-o-kuk *see* Keokuk

Kee-She-Waa (The Sun): Sac and Fox
(color photo), McKenney (vIII), p256+, McKenney v2, p154+
(color Painting by C.B. King), 1824, Moore (*Native*), p74

Keeler, W.W.: Principal Cherokee Chief
(color photo), Pierce, pxi

Keg Creek Complex: Iowa (State)
Tools
Mills County (drawing), McKusick (*Men*), p66

Keintaddle: Kiowa
(group photo), Hail, p90
(photo) With Grandson, Hail, p93
1935 (photo), Hail, p89

Keithtahroco (Horseback): Comanche
(photo) With Big John Pewewardy and Pahkumah, Noyes (*Comanches*), p52

Kelburn: Apache
Scouts (group photo), Geronimo, p70+

Kelley, Gertrude
(photo) With Piah Kiowa, Noyes (*Comanches*), p88

Kelley, Lon: Businessman
(photo) With Piah Kiowa, Noyes (*Comanches*), p108

Kelly, Luther S.: Scout
(photo by L.A. Huffman) 1878, Brown, M., p104

Kent, Blaine Nawanoway: Iowa
Visit to the Commissioner's office (group photo), Blaine (*Ioway*), p299

Kent, Solomon Nawanoway: Iowa
Visit to the Commissioner's office (group photo), Blaine (*Ioway*), p299

Keogh, Myles W.: U.S. Army
1870 (photo), Luce, p80+
1877 (photo) Grave, Luce, p80+
Grave (photo by L.A. Huffman), Brown, M., p111

Keokuk (Kee-o-kuk, The Watchful Fox): Sac and Fox Chief
(color painting) 1837, Moore (*Native*), p62
(color photo), McKenney v2, p116+
(group photo) 1867, Unrau (*Kaw*), p65
(photo) 1847, Green, C., p5, Vogle, p32
Monument to Keokuk, Green, C., p9
On horseback
(color painting by G. Catlin) 1832, Heyman, p219
Standing in regalia
(color painting by G. Catlin) 1832, Heyman, p218
(color painting by G. Catlin), 1835, Moore (*Native*), p153
With his son Moses (color painting by C.B. King) 1837, Moore (*Native*), p33

Keokuk, Charlie: Sac and Fox
(photo), Green, C., p37

Knows Otter: Crow
 (group photo) 1890, Sturtevant, v13, p709

Ko-a-tunk-a (Big Crow): Osage
 1834 (painting by George Catlin), Rollings
 (*Osage*), p97
 Three Osage warriors (drawing), Wilson
 (*Osage*), p20

Ko-Inga (Little Thunder): Otoe-Missouria
 (group photo), Edmunds (*Otoe*), p29

Ko-ma-ty: Kiowa
 Agency Headquarters, 1907 (group photo),
 Schweinfurth, p20

Ko-ta-to: Ioway
 (photo), Young Bear, p258

Ko-ta-to: Mesquakie
 (photo), Bataille, p66

Kobay-o-burra (Wild Horse): Quohada
 Comanche
 (photo by W. Soule), Nye (*Plains*), p307

Koi-khan-hole (Koi-kahan-hole): Kiowa
 (photo by W.S. Soule), Belous, p32
 (photo by W. Soule), Nye (*Plains*), p323

Komacheet, Dorothea Tenequer: Comanche
 (photo), Hail, p28

Kooish: Arapaho
 (photo), Trenholm, p206+

Koon-kah-zah-chy (Chief Apache John,
 Gonkin): Plains Apache Chief
 (photo) 1909, Sturtevant, v13, p931

Koon-za-ya-me (Female War Eagle Sailing):
 Ioway
 (sketch by George Catlin), Blaine (*Ioway*),
 p231

Kotay, Ralph: Kiowa
 (group photo), Lassiter, p108

Kotz-A-to-Ah (Smoked Shield): Kiowa
 (painting by G. Catlin), 1834, Heyman, p185

Koyei: Kiowa
 Carrying a shield (photo by Mrs. C.R.
 Hume), Merrill, p315

Kut-tee-o-tub-bee (How Did He Kill?):
 Choctaw
 (watercolor by George Catlin), Troccoli, p128

Kwi-ya-ma: Mesquakie
 (photo), Bataille, p64

L

La-doo-ke-a (Buffalo Bull): Pawnee
 (color painting by G. Catlin), 1832, Heyman,
 p122

La Flesche, Francis: Omaha
 (photo), Barnes, p114+, Boughter, p133, Crary,
 86+, Ridington, p74
 1905 (photo), La Flesche (*Omaha*), p88+
 First day of school (drawing), Ferris, p22
 With Susette La Flesche (photo), Crary, p86+,
 Ferris, p37

La Flesche, Joseph (Iron Eye): Omaha Chief
 1854, Tong p133+
 1866 (group photo), Milner, p48+
 (photo), Boughter p120+, Crary, p86+, Barnes,
 p114+
 (group photo), Milner p48+, Boughter, p127

La Flesche, Joseph, Jr. (Iron Eye): Omaha
 (group photo), Barnes, p114+

La Flesche, Marguerite: Omaha
 (photo), Crary, p86+
 (group photo), Ferris, p66
 With sister, Susan (photo), Ferris, p29

La Flesche, Mary Gale (The One Woman):
 Omaha
 (photo), Crary, p86+, Ferris, p14

La Flesche, Rosalie: Omaha
 (photo), Ferris, p55

La Flesche, Susan: Omaha Physician
 1880 (group photo), Tong, p133+
 1902 (group photo) with mother & sons 1902,
 Tong, p133+
 1900s (photo), Tong, p133+
 (group photo), Ferris, p66, p68
 (photo), Ferris, p75
 First Native American woman to earn a
 medical degree (photo), Sommer, R., p17
 Hampton class of 1886 (photo), Ferris, p38
 Home at Walthill, Neb., (photo), Tong, p133+
 In traditional Indian clothing with Charles
 Picotte (photo), Ferris, p38

La Flesche, Susette: Omaha
 (photo), Crary, p86+
 With Francis La Flesche (photo), Crary, p86+

La Grosse Tete: Osage
 Drawing by V. Tixier, Tixier, p204+

La-ru-chuk-are-shar: Chauis Pawnee
 (photo), Milner, p48+

La Salle, Rene-Robert Cavelier
 Gulf Coast of Texas, 1684, Rollings (*Comanche*),
 p50

La-t-new-way (Little Pipe): Otoe-Missouria
 (photo), Edmunds (*Otoe*), p59

La Villa de Delores: Texas
 Cornerstones of a building at Dolores (photo),
 Rister, p47
 Site as it appears today (photo), Rister, p29
 (map) Colony of Delores 1834–1836, Rister, p199

Lewis & Clark Expedition
Ethnographic map of Indian tribes (map), Moore, J. (*Cheyenne Nation*), p61
Holding council with Indians (engraving), Schneider, p32
Medals, peace (photo), Schneider, p33
Route of the expedition 1804–1806 (map), Wunder, p42

Light of the Way: Ponca
(group photo), Crary, p86+

Liguest, Pierre Laclede: Trader
(painting), Din, p55

Like-a-Fishhook Village: North Dakota
(Pictograph by Martin Bears), Sturtevant, v13, p392
(photo) 1872, Schneider, p68
(drawing by M. Bears Arm), Innis, p194
(map) 1880, Schneider, p71
Fort Berthold 1868 (painting by Phillippe Regis de Trobriand), Meyer, R. (*Village*), p76+
Hidatsa section of Like-a-fishhook village, 1872 (photo by Stanley J. Morrow), Meyer, R. (*Village*), p76+

Limpy: Northern Cheyenne
Pictograph of army attack, Greene, J. (*Lakota*), p122

Lincoln, Mary T.: First Lady
Indian delegation, Coel, p145

Lindneux, Robert: Artist
Sand Creek Battle (painting), 1936, Schultz, D (*Month*), p118+

Lip: Sioux Chief
(photo), *Crazy Horse School*, no paging
Headstone (photo), Walstrom, V., p112

Lip, Mrs. George: Sioux
(group photo), *Crazy Horse School*, p13

Lip, Joshua: Sioux
(photo), *Crazy Horse School*, p13

Lip, Owen: Sioux
(photo), *Crazy Horse School*, p13

Lip, Richard: Sioux
And family (photo), *Crazy Horse School*, p10

Lipan Apache (*see also* Apache)
Chebatah, 1930 (photo), Meadows, pxx+
Clothing
(drawing) 1834, Sturtevant, v13, p949
Trade cloth dress (drawing), Ewers (*Plains*), p140
Women's clothing (drawing), Ewers (*Plains*), p127
Dwellings
Family in front of house (photo) 1880, Sturtevant, v13, p948

Geographical Distribution
Eastern bands (map), Morehead, p201
Territory and 18th century missions (map), Sturtevant, v13, p942
Texas, by county (map), Ray (*Apache*), p170–171 (Pocket maps)
Map of Sonora and Nueva Vizcaya, 1803, Sturtevant, v13, p946
Parfleches
Painted various colors and tassels (photo), Sturtevant, v13, p947
Warriors
(drawing), Morehead, p226+
(drawing), Noyes (*Los Comanches*), p42
And wife (drawing), Newcomb (*Indians*), p111
Portrait by R. Petri, 1851, Mayhall (*Indian Wars*), p78+

Lisa, Manuel: Trader
(painting), Din, p334

Little, David: Oglala Lakota
Three Lakota Girls in Their Dancing Dress, 1990 (print), Maurer, E., p273

Little Badger Women's Club: Blackfoot
1933 (photo by Mae Vallance), Farr, W., p135

Little Bald Eagle (Anin Kasan Cikala): Sioux
1903 (photo by J. Anderson) Hamilton, H., p299
His home, 1889 (photo by J. Anderson), Hamilton, H., p300

Little Bear: Arapaho
(group photo by W.S. Soule), Belous, p88
Little Raven's son (photo by W. Soule), Nye (*Plains*), p209

Little Bear: Cheyenne
(group photo) 1869, Grinnell (*Fighting*), p302+

Little Bear: Hunkpapa Sioux
(color painting by G. Catlin), 1832, Heyman, p244
(color painting by G. Catlin), 1865, Heyman, p242

Little Bear: Piegan Chief
Delegation to Washington DC, 1891, (group photo), Farr, W. p63
Delegation to Washington DC, 1903, (group photo) (by D.L. Gill), Farr, W. p64

Little Bear: Southern Cheyenne Chief
(group photo), Berthrong (*Cheyenne*), p153
(photo), Jones, D. (*Treaty*), p32+
1891 (group photo), Fowler (*Tribal*), p58+
With Island & Hairless Bear (photo), Hyde (*Life*), p294+

Little Beaver: Cheyenne
Commemorating Washita Battle (group photo), Brill, p23

Little White Bear (Meach-o-shin-gaw): Kansa Chief
Drawing by G. Catlin, 1841, Unrau (*Kansa*), p78+ (watercolor by George Catlin), Troccoli, p111

Little White River Indian School: South Dakota
Children, 1888 (photo), Maurer, E. p49, photo, (by John Anderson), 1888, Hamilton, H., p144

Little Wolf: Arapaho Chief
(group photo) 1908, Fowler (*Arapahoe Politics*), p74+
Business council delegation (photo) 1908, Fowler (*Arapaho*), p62

Little Wolf: Cheyenne
(photo), *Contemporary Metalwork*, p11

Little Wolf (Shon-ta-yi-ga): Ioway
(sketch by George Catlin), Blaine (*Ioway*), p231
Color Painting by G. Catlin, 1844, Heyman, p234

Little Wolf: Northern Cheyenne Chief
(photo) 1870s, Bonvillain, *Cheyennes*, p46
1873 (photo by Gardner) with Dull Knife, Greene, J. (*Lakota*), p117
(photo) 1879, Sandoz p174+, 1879 (photo), Boye, p98
(photo), Vaughn p80+, (photo), Grinnell (*Fighting*), p46+
With Dull Knife (group photo), Hoig (*Fort Reno*), p60
With Dull Knife (photo) 1873, Boye, p50
With Dull Knife (photo) 1877, Monnett (*Tell*), p18
With wife (photo), Monnett (*Tell*), p197

Little Wolf: Pitahawiratas Pawnee
(group photo), Milner, p48+

Little Wound: Oglala Sioux Chief
Oglala delegation to Washington, 1880, (group photo), Olson, J., p178+, Fielder, M., p105
Oglala Warrior (photo), Fielder, M. p99, Price, C., p108+

Littleman, Milburn Steve: Kiowa
(photo) With Wife, Hail, p92

Littleman, Winifred Paddlety: Kiowa
(photo) With Husband, Hail, p92

Littlewalker, Clara: Kansa
(group photo) 1974, Unrau (*Kaw*), p89

Llaneros Apaches
Geographical Distribution
Eastern bands (map), Morehead, p201

L'Ietan (Chon-mon-i-case, Ietan): Otoe-Missouria Chief
(color photo), McKenney v1, p156+
(drawing by C. B. King), Irving, p70+

Lockhart, Lena S.: Kansa
(group photo) 1974, Unrau (*Kaw*), p89

Loco: (Warm Springs Apaches) Chiricahua Apache Chief
(group photo), Geronimo, p46+, Thrapp (*Apacheria*), p112+
At Mount Vernon Barracks, 1890 (group photo), Reedstrom, p84
Standing with rifle (photo), Adams, p321

Loco, John: Apache
Scouts (group photo), Geronimo, p70+

Logan, Wilfred: Archeologist
Effigy Mounds National Monument (group photo), McKusick (*Men*), p130

Logging Crew
Old Agency, 1890s (group photo), Farr, W., p32

Lone Bear: Arapaho Chief
(group photo) 1908, Fowler (*Arapahoe Politics*), p74+
Business council delegation (photo) 1908, Fowler (*Arapaho*), p62

Lone Bull: Lakota
Leaders who survived Ghost Dance massacre (photo), Starita, J., p132

Lone Chief (Eagle Chief, Ckara Rare-sa-ru): Skidi Pawnee
1900 (photo by DeLancey Gill), Murie (*Part II*), p375
(drawing), Grinnell (*Pawnee*), p160
In front of earth lodge (group photo), Dorsey (*Traditions*), pxxii+

Lone Chief, Mary: Pawnee
Indian Boarding School (group photo), Blaine (*Some*), p42+

Lone Dog: Yanktonais Dakota
Calendar (photo), Wemett, W., p179

Lone Horn: Sioux
Pawnee enemies (group photo), Blaine (*Pawnee Passage*), p250

Lone Tipi (Albert Atocknie): Comanche
1924 (photo), Wallace (*Comanches*), p350+

Lone Wolf (Guipago, Gui-pah-go): Kiowa Chief
(group photo), Hoig, S. (*Kiowas*), p73
(photo by W.S. Soule), Belous, p40, Mayhall (*Indian Wars*), p30+
(photo by William S. Soule), Ewers (*Murals*), p15, Nye (*Plains*), p221
(photo), Brill, p197, Marrin, p136, Hoig, S. (*Kiowas*), p196, Nye (*Carbine*), p94+, Wunder, p63
1872 (photo by Alexander Gardner), Mayhall (*Kiowas*), p142+
Agency Headquarters, 1907 (group photo), Schweinfurth, p20
Daughter of, with husband (drawing), Battey, p189
With Geronimo (photo), Geronimo, p108+

Reservation at White River, est. by Treaty: Oct 14, 1865 (map), *Indians of South Dakota*, p18

Lower Sioux Agency: Minnesota
Attacking the Lower Agency (painting), Carley, K. p20
Redwood Agency, 1862 (map), Anderson, G. p137
Stone Warehouse (photo by Ryberg), Carley, K. p22

Lower Sioux Agency: Morton, Minnesota
(photo) Santee school children, 1901, Bonvillain (*Santee*), p78

Lowery, George: Cherokee
(painting by George Catlin), Malone, p82+, Pierce, p11

Lozen: Apache
1886 (group photo), Robinson, S., p2
Prisoners on the way to Florida prison 1886 (group photo), Aleshire, p306, Stockel, p44–45

Luce, Edward S.: Seventh U.S. Cavalry
1907 (photo), Luce, p80+

Lujan, Carolyn Hunt: Kiowa
(photo), Hail, p110

Lumpkin, Wilson: Governor of Georgia
(photo), Ehle, p328+

Lumpmouth, Homer: Arapaho
(photo), *Contemporary Metalwork*, p70

Lumpwood Society
Crow, carving (drawing), Mails (*Mystic*), p252

Lunderman, Alex: Sioux
(photo), Doll, D., p33

Lynch, Patrick: U.S. Army Private
Grave (photo), Hoig (*Fort Reno*), p69

Lyons, Marcella: Pawnee
Pocahontas Club (group photo), Tyson, p95

M

Ma-chet-seh: Osage
(photo), Wilson (*Underground*), p4

Ma-ha-ninga (No Knife): Omaha Chief
(group photo), Milner p48+

Ma-has-kah (White Cloud): Ioway Chief
(color painting by C.B. King), 1824, Moore (*Native*), p 63, p113
(color photo), McKenney v1, p284+
(drawing), Foster, T., p42+

Ma-has-kah (The Younger): Ioway Chief
(drawing), Miner, p43
(color painting by C.B. King), 1837, Moore (*Native*), p72

Ma-ka-tai-me-she-kia-kiah (Black Hawk): Sauk
(color photo), McKenney v2, p58+

Ma-kwi-ba-tti-to: Ioway
(photo), Young Bear, p257

Ma-min-nic (Ma-nim-ick): Cheyenne Chief
(photo by W.S. Soule), Belous, p76

Mackenzie, Ranald S.: U.S. Army General
1876 (photo), Wallace (*Texas Frontier*), p178+
(photo by W. S. Soule), Mayhall (*Indian Wars*), p78+
(photo), Capps, 144+, Collins, p141, Kime, p369, Marrin, p113
1880 (photo), Neeley, p132+

Mackinaw Boats
Carrying furs and robes down the Missouri to St. Louis (drawing), Ewers, J. (*Story*), p26

Macleod, James F.: U.S. Army Colonel
1870 (photo), MacEwan, G. plate 6

Macy: Nebraska
Circle of tipis surrounding a lodge at Macy, Nebraska, 1917 (photo), Ridington, pxviii

Mad Plume, Albert: Piegan Indian
Wearing "the Lord's shirt" (photo), Ewers, J. (*Blackfeet*), p190+
With family (photo), Farr, W., p119
With wife Susan, son Fred & granddaughter Irene in vegetable garden (photo), Farr, W., p113

Mad Wolf: Blackfoot Chief
Logging Crew from Old Agency early 1890s (group photo), Farr, W., p32
Snow Tipi (photo), McClintock, W., title page

Magee, Thomas: Photographer
4th of July Parade at Browning, 1904 (photo by T. Magee), Farr, W., p41
Blackfoot burial — scaffold in cottonwood trees (photo), Farr, W., pxx
Blackfoot Indians
Offerings in the medicine lodge, July 1899 (photo), Farr, W., p85
Raising the Medicine Lodge, 1910 (photo by T. Magee), Farr, W., p82
Sham battle, 1899 (photo), Farr, W. p79
Blackfoot medicine lodge dance with Mike Shorman leading the Crazy Dogs July 4, 1907 (photo), Farr, W., p90
Blackfoot policeman, 1902 (photo by T. Magee), Farr, W., p47
Burial grounds at Old Agency (photo by T. Magee), Farr, W., p36
Calf Shirt: Blackfoot
1898 (photo), Farr, W., p95
Calf Tail, medicine lodge ceremony — giving a name to a man (photo), Farr, W., p96
Chouquette, Charley (photo by Thomas Magee), Farr, W., p26

Map 208

Map 210

Map 212

Map 214

Map 216

Map 218

Mauck, Clarence: U.S. Army
(photo), Kime, p99

Mauls
Kiowa
Stone mauls (photo), Merrill, p124
Otoe-Missouria
Stone maul (photo), Sturtevant, v13, p448

Maunkaugoodle (Mable Hummingbird): Kiowa
(photo), Hail, p14

Maximilian, Prince of Wied: European Prince
Prince Maximilian of Wied with his brother
Prince Charles
Color Painting by K. Bodmer, Ewers (*Views*),
frontispiece

Mayer, Frank Blackwell: Artist
Leaving for a Hunt, Kaposia (Artwork),
Anderson, G., p49
Pounding Hominy — The Chief's Children
(painting), Anderson, G., p47
Kaposia — an Indian Village, 1851 (sketch),
Anderson, G., p47
Lacrosse during Traverse des Sioux (Pen and
Pencil), Anderson, G., p49
Little Crow, 1851 (portrait), Anderson, G.,
frontispiece

Mazakutemani: Sisseton-Wahpeton
Sioux Indian delegation to Washington, DC,
Group Photo, 1858, Meyer, R. (*History*),
p108+
Sisseton-Wahpeton delegation to Washington,
1858 (photo), Anderson, G., p98

Mazasha: Sioux
Delegation to Washington, DC, (group
photo), 1858, Meyer, R. (*History*), p108+

Mazomani *see* **Mazzomanee**

**Mazzomanee (Iron Walker, Walking Iron,
Mazomani): Wahpeton Sioux**
Delegation to Washington, DC, (group
photo), 1858, Meyer, R. (*History*), p108+
(group photo) 1858, Sturtevant, v13, p771

McCauley, Claude: Kansa
(group photo), 1925, Unrau (*Kaw*), p43

McCauley, Johnny Ray: Kansa
(group photo) 1974, Unrau (*Kaw*), p89

McCauley, Mary Mitchell: Omaha
Showing the "Mark of Honor," 1925 (photo),
Ridington, p140

McClintock, Walter: Photographer
Blackfoot Indians construction of the Medicine
lodge
Bringing in the willows (photo), Farr, W.,
p84
Blackfoot Indians On the Move, 1899 (photo),
Farr, W., pxvi

Blackfoot Indians raising the center pole of
the medicine lodge (photo), Farr, W., p80
Blackfoot woman pitching a tipi (photo),
Farr, W., pvi
Elk Horn: Blackfoot, the camp crier (photo),
Farr, W., p74
Resting during a dance, Blackfoot Reservation,
Montana, 1890 (photo), Penney, D., p51
Shortie White Grass: Blackfoot, head of the
Buffalo Dung band, 1899
(photo by W. McClintock), Farr, W., px
Three Bears, Blackfoot, relating how he killed
an enemy warrior (photo), Farr, W., p83

McCoy, James: Artist
Rosebud Agency, May 3, 1879 (drawing),
Hamilton, H., p55
Rosebud Agency, inside of building, May 3,
1879 (drawing), Hamilton, H., p56

McCusker, Philip: Interpreter
(photo), Nye (*Carbine*), p206+
1871 (group photo), Fowler (*Tribal*), p58+
With Buffalo Good (photo), Smith, F., p99

McDonald, A.J.: Photographer
Photo of Laura Doanmoe on horseback,
Merrill, p313

McDonald, Charles: Osage/Ponca
(group photo) 1904, Revard (*Winning*), p38+

McDonald, Jewell: Osage/Ponca
(photo) 1929, Revard (*Winning*), p38+

McDonald, Louisa: Osage/Ponca
(group photo) 1904, Revard (*Winning*), p38+

McDowell, Irvin: U.S. Army Major General
(photo), Collins, p83

McElderry, Henry: U.S. Army
(photo), Jones, W., p70+

McFatridge, Arthur E.: Superintendent
Blackfoot Agency, 1910–15 (photo), Farr, W., p48
Medicine lodge at 1911 Sun Dance with Super-
intendent McFatridge in attendance (photo
by J.H. Sherburne), Farr, W., p91

**McGillycuddy, Valentine T.: Physician & Indian
Agent**
(group photo) Washington, 1883, Larson, R.,
p169+
(photo), McGillycuddy, J. title page, (photo),
Olson, J., p178+
1884 (photo), Hyde, G., (*Sioux*), p76+
Agent at Pine Ridge 1879–1886 (photo),
Fielder, M., p99
Indian Agent (photo), *Killing of Chief Crazy
Horse*, p105
On "Starvation March" (photo), McGilly-
cuddy, J., p58
Skinning a horse on "Starvation March"
(photo), McGillycuddy, J., p58

Mow-way (Shaking Hand, Hand Shaker):
Kochateka (Yamparika) Comanche Chief
 (photo by W.S. Soule), Belous, p106, Nye
 (*Plains*), p299
 (photo by W.S. Soule) 1875, Mayhall (*Indian
 Wars*), p78+
 (photo), Cash, J. (*Comanche*), p11, Nye (*Car-
 bine*), p126+
 Camp, 1867–74 (photo), Chalfant (*Without*),
 p61
 Camp, 1873 (photo), Hagan, p129

Mower: Cheyenne Chief
 (group photo) 1909, Moore, J. (*Cheyenne
 Nation*), p107

Mu-kwa-pu-shi-to: Mesquakie
 (photo), Bataille, p67

Muchacho Negro: Mescalero Apache
 (photo), Robinson, S., p152

Mud-sat-sie: Shoshone Chief
 (group photo) 1883, Fowler (*Arapahoe Politics*),
 p74+

Muk-a-tah-mish-o-kah-kaik (The Black Hawk):
Sac and Fox Chief
 (color painting) 1832, Heyman, p216
 (watercolor by George Catlin), Troccoli,
 p116
 Color painting by G. Catlin, 1832, Heyman,
 p217

Mukluk (*see also* Footwear)
 Cree, 1975–77 (photo), Coe, R., p69
 Montagnais/Naskapi, Legging Boots, 1980
 (photo), Coe, R., p61
 Shuswap Indians (Interior Salish)
 Deer hide, rabbit fur, beads and sequins,
 (1983), Coe, R., p250
 Subarctic, 1980 (photo), Coe, R., p60

Mule, Seth: Arapaho
 1904 (group photo), Fowler (*Arapahoe Politics*),
 p74+

Mumshukawa: Comanche
 (photo), Wallace (*Comanches*), p271+

Mun-ne-pus-kee (He Who Is Not Afraid):
Osage
 Helped guide the dragoon expedition of 1834
 (painting by George Catlin), Rollings
 (*Osage*), p97
 Three Osage warriors (drawing), Wilson
 (*Osage*), p20

Munger, Hattie: Sioux
 House after the blizzard (photo), *Crazy Horse
 School*, p53

Muntcehuntce (Big Bear): Otoe-Missouria Chief
 (photo), Sturtevant, v13, p455

Murie, James Rolfe (Coming Sun, Sakuru Ta):
Skidi Pawnee
 1900 (photo), Murie, (*Part 1*), frontispiece
 (group photo), Blaine (*Some*), p42+
 (photo), Chamberlain, frontispiece
 Delegation to Washington, 1916 (photo),
 Chamberlain, p39
 Famous Pawnee Scouts, 1906 (group photo),
 Chamberlain, p36
 Pawnee Scouts (group photo), Lacey, p80

Musical Instruments (*see also specific names of
instruments*)
 Apache Indians
 Fiddle with bow, 1984 (photo), Coe, R.,
 p190
 Fiddle, miniature with bow, 1983 (photo),
 Coe, R., p186
 Assiniboine
 Drums
 Hand drums (photo), Sturtevant, v13,
 p587
 Wood, cow rawhide, paint (color photo),
 Howell, p79
 Assiniboine/Yanktonais
 Hand drum
 Wood, deerskin, pigment, 1860–70,
 Penney, D. p284
 Large round drum (photo), Sturtevant, v13,
 p587
 Courting Flute
 Leonard Crow Dog with a courting flute
 (photo), Crow Dog, L., p152+
 Drum
 Beater, 1980 (photo), Coe, R., p61
 Drummers inside the medicine lodge, July
 1900 (photo by J.H. Sherburne), Farr, W.,
 p94
 Flathead Indians, 1976 (photo), Coe, R., p165
 Four-man drum (drawing), Mails (*Mystic*), p63
 Hand drum (drawing), Mails (*Mystic*), p98
 Mandan Indians
 Back view of turtle drum with feather
 collar (photo), Bowers, A., p137
 Ojibwa/Potawatomi
 Wood, deerskin, iron nails, pigment, 1840,
 Penney, D., p252
 Drumbeater
 With beaded handle (drawing), Mails
 (*Mystic*), p63
 Eagle Bone Whistle
 Sioux Indians
 (photo), *Crazy Horse School*, p78
 Flute
 Cedar love flute (color photo), Terry, p33
 Quapaw (photo), Sturtevant, v13, p503
 Sioux Indians, 1980–81 (photo), Coe, R.,
 p138

N

Chief Joseph
(photo), MacEwan, G. plate 4), Vestal, S.
(*New*), p240+
Hee-oh'ks-te-kin (Rabbit's Skin Leggings)
(color painting by G. Catlin), 1832, Heyman,
p110
Miles campaign against, 1876–77 (map),
DeMontravel, p231+
Rabbit's Skin Leggings (Hee-on'ks-te-kin)
(color painting by G. Catlin), 1832, Heyman,
p110
Tipi, detail, 1984 (photo), Coe, R., p166

Niatohsa: Atsina Chief
(watercolor by K. Bodmer), Bodmer, p237,
Fowler p32

Nickerson, H.G.: Captain U.S. Army
(group photo) 1904, Fowler (*Arapahoe Politics*),
p74+

Nicoli, Antonio: Artist
Fort Phil Kearny
Drawing by Antonio Nicoli, 2nd Cavalry
Bugler, Brown, D., p128+

Night Chief: Skidi Pawnee
Group of Pawnee (group photo), Dorsey
(*Traditions*), no paging

Night Gun, John: Blackfoot
1895 (group photo), Farr, W., p30

Nightwalker, Roy: Southern Cheyenne
(photo), Moore, J. (*Cheyenne Nation*), p220

Niles, Sherman: Tonkawa
(photo), Newcomb (*Indians*), p142+

Ninoch-Kiaiu (Chief of Bears): Piegan Blackfeet
(watercolor by K. Bodmer), Bodmer, p243

No Coat: Blackfoot
And daughter, July 1899 (photo by T. Magee),
Farr, W., p147
And Wades-in-Water with their wives, 1899
(photo by T. Magee), Farr, W., p148
Blackfoot Tribal Council
Group photo, 1909 (by E.L. Chase), Farr, W.,
p65
Campbell, Fred C.: Superintendent with Heart
Butte farmers (group photo), Farr, W., p120
With John Little Blaze and Sure Chief making
baskets, 1932 (photo), Farr, W., p131

No Fool (Wa-hon-ga-shee): Kansa
(color painting by G. Catlin, 1832, Heyman, p118
(painting by G. Catlin), 1831, Unrau (*Kaw*), p46

No Heart (Natchininga, No Heart of Fear,
Notch-ee-ning-a, Not-chi-me-ne,
Notch-ee-ning-a, Notchininga, White Cloud):
Ioway Chief
(color photo), McKenney v2, p110+
(painting by G. Catlin), 1832, Heyman, p71,
Troccoli, p112

1846, Sturtevant, v13, p443
1837 (painting by Charles Bird King), Blaine
(*Ioway*), p206
(photo), Blaine (*Ioway*), p207,

No Heart of Fear *see* **No Heart**

No-ho-mun-ya (One Who Gives No Attention):
Ioway
(color Painting by G. Catlin), 1844, Heyman,
p330

No Knife (Frederick Tyndall): Omaha
(group photo), Barnes, p114+
(group photo), Boughter, p127
1866 (group photo), Milner, p48+

No-ta-nee: Southern Arapaho Chief
(group photo) 1864, Coel, p230, p231

No Two Horns: Hunkpapa Lakota
Buffalo Society headdress, 1900 (photo),
Maurer, E., p232
Horse effigy, 1900 (photo), Maurer, E. p207
Kit Fox Society bow lance, 1900 (photo),
Maurer, E., p234
Painting of tipi detail, Maurer, E., p75
Shield, 1900 (photo), Maurer, E., p113
Six scenes of war exploits, 1900 (photo),
Maurer, E., p209
Tipi cover with battle exploits, 1915 (photo),
Maurer, E., p207

No-way-ke-Sug-ga: Otoe
(color photo), McKenney (vIII), p16+

Noapeh (Troop of Soldiers): Assiniboine
1833, (watercolor by K. Bodmer), Bodmer,
p197, Moore (*Native*), p243

Noble Red Man: (Matthew King) Sioux
Chief
Also known as Matthew King, Headstone —
Photo, Walstrom, V., p116

Noble Star: Plains Apache
(photo) 1934, p934, Sturtevant, v13

Noconee Comanche
Champion Rider (Nau-qua-hip, Horse Back,
Tuh-huh-yet)
(photo by W.S. Soule), Belous, p105
Horse Back *see* Champion Rider
Nau-qua-hip *see* Champion Rider
Tuh-huh-yet *see* Champion Rider

Noise (Muttering Thunder): Omaha Chief
(group photo), Barnes, p114+

Noisy Walker (Noisy Walking): Northern
Cheyenne
(group photo) 1879, Boye, p168, Monnett
(*Tell*), p180, p183, Sandoz, p174+

Nom-ba-mon-nee (Double Walker): Omaha
(painting by G. Catlin), 1832, Heyman, p124,
Ridington, p42

Notoie-Poochsen (Word of Life):
 Piegan Blackfeet
 (watercolor by K. Bodmer), Bodmer, p244,
 Moore (*Native*), p247

Nowaykesugga (Strikes Two at Once):
 Otoe-Missouria
 (color painting) 1832, Moore (*Native*), p125

Noyes, Henry E.: Captain U.S. Army
 (photo), Vaughn, p112+

Nuttle, Josie: Pawnee
 Pocahontas Club (group photo), Tyson,
 p95

O

O-lo-hah-wah-la (Black Dog): Osage
 Osage Council, 1895 (group photo), Baird
 (*Osage People*), p69

Oatman, Lorenzo
 (photo), Jones, G., p104

Oatman, Olive: White Indian Captive
 (photo), Jones, G., p104

Ocoya: Tonkawa
 (photo), Jones, W., p70+

Octopus Bags
 Metis-Cree Indians
 Buckskin, caribou hide, porcupine quills,
 1840 (photo), Penney, D., p177
 Subarctic Indians (tribe unknown)
 Caribou hide, beads, 1980 (photo), Coe, R.,
 p248

Odl-kaun't-say-hah (Short Greasy Hair):
 Kiowa
 (group photo by W.S. Soule), Belous, p57,
 Nye (*Plains*), p361

Odlety, Nettie: Kiowa
 (photo), Hail, p118

O'Fallon, Benjamin: Major U.S. Army
 Council at Council Bluffs, 1819, Blaine
 (*Pawnee Passage*), p56

Ogilby, Frederick Darley: U.S. Army Captain
 With four Apaches (photo), Collins, p181

Oglala Sioux (*see also* Lakota Indians, Teton
 Sioux, *names of individuals*, Sioux Indians
 general heading)
 Agencies
 Oglala and Brule (map), Price, C., p117
 American Horse
 1879 (photo by Rocher), Greene, J. (*Lakota*)
 p151, Taylor, p7
 Amiotte, Arthur
 "Prince Albert," 1989 (collage), Maurer, E.,
 p285

Amulet
 Umbilical: cotton, 1900 (photo), Maurer, E.,
 p138
Baby bonnet
 1991 (photo), Maurer, E., p270
Bag
 Leather (photo), Maurer, E., p148
Beef issues (photo), McGillycuddy, J., p187
Black Elk
 And Elk (photo), Hanson, J.A., p82
Boarding School
 Soldier stationed outside, 1890 (photo),
 Eastman, E., p48+
Bonnet
 Baby, 1991 (photo), Maurer, E., p270
Buffalo chase (drawing), Hyde, G. (*Red*), p41
Bull Bear
 (painting by Miller), Hyde, G. (*Red*), p40
Calico, Frank
 Page of school notebook, 1890 (drawing),
 Maurer, E., p284
Catholic Congress, 1950 (photo), Powers, M.,
 Number 10
Cooking
 Making papa (sausage), 1916 (photo),
 Powers, M., Number 14
 Making wasna (pemmican), 1945 (photo),
 Powers, M., Number 16
 Women, 1940 (photo), Powers, M., Number
 15
Cradleboard
 Hide, 1910 (photo), Maurer, E., p276
Crazy Horse
 Fighting the Pawnee, 1877 (drawing),
 Maurer, E., p214
Cross
 Nickle plated brass (photo), Hanson, J.A.,
 p93
 Warrior's (photo), Maurer, E., p117
Dances
 Sun Dance at Pine Ridge, 1960 (photo),
 Powers, M., Number 13
David Little
 "Three Lakota Girls in Their Dancing Dress,"
 1990 (print), Maurer, E., p273
Delegation to Washington
 (group photo), Olson, J., p242+
 1870 (photo), Hyde, G. (*Red*), p176
 1880 (photo), Fielder, M., p105
Dolls
 Ghost Dance Costume, 1900 (photo),
 Maurer, E. p175
Eagle Shield
 1913 (photo by Densmore), Greene, J.
 (*Lakota*), p127
Effigy
 Horse: wood, 1880 (photo), Maurer, E.,
 p145

Ohio (State)

Oh'Zan (Pretty Hawk): Yankton Sioux

Oil Rig

Oil Wells

Ojibwa

Ojibwa/Sioux
Pipe Bowls
1978–79 (photo), Coe, R., p122

Oka, Mike: Blackfoot
(photo), Hungry Wolf, A., p317

Okawinga Win (Amelia E. Catches): Sioux Indian
(photo) 1991, Catches, p198

Okawta: Bear Butte, South Dakota
The Gathering Mountains, Black Hills (photo), Doll, D., p20

Oke-we-me (Female Bear that Walks on the Back of Another): Ioway
(sketch by George Catlin), Blaine (*Ioway*), p231

Okipa Ceremony
Impersonator, Okipa ceremony
Bull Dancer (drawing), Bowers, A., p141
Night and First Day of Creation (drawing), Bowers, A., p142
Oxinhede (Foolish One) (drawing), Bowers, A., p140
Snake and Beaver (drawing), Bowers, A., p143
Mandan Indians
Alter arrangement and torture feature (drawings), Bowers, A., p136
Back view of turtle drum with feather collar (photo), Bowers, A., p137
Ceremonial Lodge, plan for (line drawing by White Calf), Bowers, A., p112
Condition of the Sacred Cedar, 1950 (photo), Bowers, A., p138
Direction symbolism for the bull dances (drawing), Bowers, A., p133
Lodge plan prior to torture feature (drawing), Bowers, A., p134
Seating arrangement for first night of Okipa (drawing), Bowers, A., p127

Oklahoma (State)
Burbank oil field (photo) 1925, Wilson (*Underground*), p128
Darlington Agency
Commissary buildings (photo), Monnett (*Tell*), p28
Dust Bowl
Farm machinery in Cimarron County (photo), Wilson (*Osage*), p83
Farmer (photo), Wilson (*Osage*), p84
Homesteaders
Dewey County (photo) 1892, Fowler (*Arapaho*), p98
Indian land cessions (group photo), 1901, Rollings (*Comanche*), p97
Indian Territory
1890 (map), Din, p61

Territory (map), Blaine (*Pawnee Passage*) p267
Indian tribes (map), Callahan, p23
Oil Rig
Osage County (photo), Wilson (*Osage*), p62
Osage County (map), Callahan, p24
Otoe-Missouria Reservation, Edmunds (*Otoe*), p63
Reservation individual land holdings, Cash, J. (*Comanche*), p89
Reservations
Kiowa, Comanche, and Apache Reservation (map), Foster, M., p103
Tribal complexes (map), Lassiter, p74

Old Agency
Blackfoot Indians
Agency employees, 1891 (photo by Lt. J. Beacom), Farr, W., p17
Issuing old clothing at Old Agency, 1880's (photo), Farr, W., p13
On Badger Creek, 1898 (photo by J. H. Sherburne), Farr, W., p16
Day School
Sisseton Reservation, 1965 (photo), Meyer, R. (*History*), p322+
(group photo), 1887, Farr, W., p22
Logging Crew, early 1890's (group photo), Farr, W., p32

Old Bear (Mah-to-he-ha): Mandan Medicine Man
(color painting by G. Catlin), 1832, Heyman, p161

Old Bull: Hunkpapa Lakota
Exploits of Old Bull, 1910 (drawing), Maurer, E., p205

Old Coyote, Barney: Crow
1905 (photo by Throssel), Albright, P., p147

Old Crow: Arapaho Chief
Giveaway (group photo) 1901, Fowler (*Arapaho*), p28

Old Crow (Peerits-har-sts): Crow
(group photo) 1873, Sturtevant, v13, p699

Old Crow: Northern Cheyenne
(group photo) 1879, Boye, p168, Monnett (*Tell*), p180, Sandoz, p174+

Old Eagle: Oto
(photo by E. Curtis) 1927, Curtis (*Plains*), plate 8

Old Face: Chippewa
1898 (photo), Schulenberg, R., p28

Old Harney: Sioux
1900 (photo by J. Anderson), Hamilton, H., p297
With his family, 1889 (photo by J. Anderson), Hamilton, H., p298

Ottawa

Pawnee: Oklahoma

Pawnee Agency

Pawnee Bill's Wild West Show

Pawnee Killer: Oglala Sioux

Pawnee Rock: Kansas

Pawnee Scouts

**Payne, David L.: Oklahoma Boomer movement
leader**

Q

R

291 Red

Red Cloud Agency distributions, 1875
(drawing), Buecker, T., p14
Rosebud Reservation, beef, 1893 (photo),
Maurer, E., p49
Sioux women wait for rations on reservation
(photo), Bonvillain (*Santee*), p88

Ration Ticket
(photo), Schneider p81

Ration Ticket Bags
Crow
Beaded design (photo), Sturtevant, v13,
p708

Rattle (*see also* **Musical Instruments**)
Arapaho
Hoof rattle (drawing), Kroeber, p449
Representing a face (drawing), Kroeber,
p448
Representing a person (drawing), Kroeber,
p446
Star dancer (drawing), Kroeber, p181
With symbolic decoration (drawing), Kroeber, p425
Wood, hide, declaw & horsehair (photo),
Hunt, D., p143
Assiniboine
Medicine rattle (photo), Sturtevant, v13,
p578
Cree/Ojibwa
Pepper shaker, 1970 (photo), Coe, R., p153
Crow
Buffalo rawhide, wood handle, brass hawk
bells (color photo), Howell, p62
Society buffalo horn rattle (drawing), Mails
(*Mystic*), p46
Two Legging's Rattle (photo), Wildschut, W.
(*Medicine Bundles*), Fig. 4
Deer hide with horsehair pendant (drawing),
Mails (*Mystic*), p63
Gros Ventre
Dance rattle Star Society (photo), Sturtevant,
v13, p684
Kiowa
Gourd rattle (photo), Greene, C., p49
Peyote ceremony (photo), Merrill, p114
Lakota
Hide, 1860 (photo), Maurer, E., p156
Wood, 1870 (photo), Maurer, E., p156
Medicine
Made from buffalo bladder & buffalo tail
(drawing), Mails (*Mystic*), p135
Medicine rattle
Rawhide (drawing), Mails (*Mystic*), p112
Mescalero Apache
Dewclaw rattle (puberty ceremony) (photo),
Mails (*Apache*), p322
Mesquakie
(photo) 1850, Torrance, p55+

Northern Cheyenne
Gourd, wood handle, beads, leather thong
(color photo), Howell, p62
Ojibwa/Cree
Pepper shaker, 1970 (photo), Coe, R., p153
Plains Indian
Various types (drawings), Minor, p323
Quapaw
Qourd rattle with beaded handle (photo),
Sturtevant, v13, p508
Sioux
Sitting Bull's rattle, Diessner, D., p144
Turtle shell, rawhide beads, wood handle
(color photo), Howell, p62
Tonkawa
Gourd, with feathers and horsehair (photo),
Sturtevant, v13, p961
Turtle shell rattle (drawing), Mails (*Mystic*),
p63
Yanktonais Sioux
Made from gourds (photo), Hoover, H., p84

Rave, Austin: Miniconjou Artist
(photo), *Contemporary Sioux Painting* p74
Scout Signal, 1965 (painting), *Contemporary
Sioux Painting* p75

Rave, John: Winnebago
(photo), Petersen, p340+

Raven Belt
1830 (photo), Torrance, p21

Ray Long Archaeological Site: South Dakota
Southeast of the Black Hills (photo), Wood, R.
(*Archaeology*), p17

Reagan, Ronald: U.S. President
Meets with Wilma Mankiller, Cherokee Chief,
1988 (photo), Sommer, R. p124

Rector, Deanna: Osage
With Asa and Dana Cunningham (color photo),
Baird (*Osage People*), p97

Red Antelope: Sioux Chief
Headstone (photo), Walstrom, V. p86

Red-Armed Panther (Red Sleeve): Cheyenne
(photo by L.A. Huffman) 1879, Brown, M., p102

Red Bead Woman: Cheyenne
(photo), Grinnell (*Cheyenne*) p128+

Red Bear, Martin: Oglala Lakota
Akicita Waste (Good Soldier), 1991 (painting),
Maurer, E., p227

Red Bird: Winnebago
(color photo), McKenney (vII), p426+

Red Bird, Ernest: Kiowa
(group photo), Hail, p47

Red Bonnet: Kiowa
Morning Star tipi (photo), Ewers (*Murals*),
p37

Dancing with sacred rattle (photo), Hungry
Wolf, A., p154
Sacred headdress, 1892 (photo), Hungry Wolf,
A., p253
Single Circle Painted Lodge, 1892 (photo),
Hungry Wolf, A., p74
With head wife in Blood Camp, late 1800s
(photo), Hungry Wolf, A., p244

Red Dog: Yankton Sioux
(photo), *Crazy Horse*, p179, Buecker, T., p179
Red Dog's Village (photo), Buecker, T., p179
With rifle (photo), Flood, R. v2 p.v, (photo),
Hanson, J.A., p24
Village (photo), *Crazy Horse*, p179

Red Dress (Hoodle-tau-goodle): Kiowa
(photo by W. Soule), Nye (*Plains*), p369

Red Eagle, Ed: Osage
(group photo), Callahan, p39

Red Eagle, Ed, Sr.: Osage
(photo), Callahan, p132

Red Eagle, Harry: Osage
(group photo), Callahan, p39

Red Eagle, Henry: Osage
Men of the tribe (group photo), Wilson
(*Osage*), p97

Red Elk, Herman: Yanktonais Artist
Attack, 1970 (painting), *Contemporary Sioux
Painting*, p55
Dakota Scout, 1969 (painting), *Contemporary
Sioux Painting*, p53
Horse Dance, 1969 (painting), *Contemporary
Sioux Painting*, p54
Painted Bison Hide
1963, *Contemporary Sioux Painting*, p9, p11
1966, *Contemporary Sioux Painting*, pp,
16–17
(photo), *Contemporary Sioux Painting*, p52
Robe with biography of Lakota warrior, 1965
(photo), Maurer, E., p226

Red Feather (Sih-Sa): Mandan
(watercolor by K. Bodmer), Bodmer, p306

Red Feather: Santee Sioux
Delegation to Washington, DC, (group
photo), 1858, Meyer, R. (*History*) p108+
With Father Buechel (photo), Anderson, J. no
paging

Red Fish: Yanktonais Sioux Chief
(photo by Russell Reid), Schulenberg, R. p23

Red Hat, Edward: Southern Cheyenne
With his wife (photo), Moore, J. (*Cheyenne
Nation*), p217

Red Hat, Edward, Sr.: Cheyenne Indian
(photo) Keeper of the Sacred Arrows, Moore, J.
(*Cheyenne*), p242

Red Hat, Minnie: Southern Cheyenne
With her husband (photo), Moore, J. (*Cheyenne
Nation*), p217

Red Hawk: Lakota Sioux
A courting couple, 1885 (drawing), Maurer, E.,
p265
Testing the Ghost Shirt, 1885 (drawing),
Maurer, E., p174

Red Hawk: Sioux Chief
On horseback
(photo by E. Curtis) 1905, Curtis (*Plains*),
plate 90

Red Horse: Minneconjou Lakota
(photo), Michno, G., p189
Battle of the Little Big Horn, 1881 (drawing),
Maurer, E., p201
(photo by Barry), Greene, J. (*Lakota*), p34
Pictographs
Custer's Dead Cavalry, Greene, J. (*Lakota*),
p41
Dead Sioux, Greene, J. (*Lakota*), p39
Sioux Fighting, Greene, J. (*Lakota*), p38
Soldiers Charging, Greene, J., (*Lakota*), p36

Red Iron: Santee Sioux Chief
Delegation to Washington, DC, (group photo),
1858, Meyer, R. (*History*), p108+
(photo by Whitney), 1862, Carley, K. p61
Sisseton-Wahpeton delegation to Washington,
1858 (photo), Anderson, G., p98

Red Kettle, Burgess: Sioux
(photo), *Crazy Horse School*, p33

Red Kettle, Chester: Sioux Minister
(photo), *Crazy Horse School*, p13

Red Kettle, Mrs. Chester: Sioux
(group photo), *Crazy Horse School*, p12

Red Leaf Day School: Locale
1912 (photo by J. Anderson), Hamilton, H.,
p147

Red Legs: Sioux
Mdewakanton-Wahpekute delegation to
Washington, 1858 (photo), Anderson, G. p96

Red Moon: Cheyenne Chief
On horseback (photo by W. Soule), Nye
(*Plains*), p273

Red Owl, Mabel: Northern Cheyenne
With Sallie Stand Out, dressing and drying
meat (photo), Limbaugh, R.H., pVIII

Red River War
1874 (map), Hoig, S., (*Kiowas*), p221

Red Shirt: Sioux
1880's (photo by W.H. Jackson), Hassrick, R.,
p100+
Holding lead inlaid pipe (photo), Hanson, J.
p85

Oglala delegation to Washington, 1880
(photo), Fielder, M., p105
Red Shirt, son of Red Dog (photo), Hyde, G.,
(*Sioux*) p140+
Sioux Indian
Oglala delegation to Washington, 1880,
group photo, Olson, J., p242+
(photo), Price, C., p108+

Red Skirt: Minneconjou
(photo), Greene, J. (*Yellowstone*), p110

Red Sleeve (Red Armed Panther): Cheyenne
(photo by L.A. Huffman) 1879, Brown, M., p102

Red Star, Amy: Crow
(photo), *Painted Tipis*, p43

Red Star, Annie: Arikara
Wearing traditional clothing (photo) 1904,
Sturtevant, v13, p375

Red Star, Kevin: Crow
(photo), *Painted Tipis*, p43

Red Stick Ceremony
Mandan Indians
Arrangement of the lodge for the Buffalo
Dance (line drawing), Bowers, A. p317

Red Thing That Touches in Walking: Sioux
1834 (portrait by G. Catlin), Hassrick, R.,
p100+

Red Thunder (E'e-a-chin-che-a): Hidatsa
(color painting by G. Catlin), 1832, Heyman,
p176

Red Wing (Black Man): Crow Indian
(painting by J.H. Sharp), Riebeth p118+

Red Wing: Mdewakanton Santee
(Artist conception by Loren Zephier), Sneve,
V. (*They*) p5

Redbird, Robert: Kiowa
(photo), *Contemporary Painting*, p76
Painting of Tribal Memories, Wunder, p88
Painting of the Kiowa Submission to the
Agency, Wunder, p66

Redbone Society
Apache
Honor Dance, 1993 (photo), Meadows,
pxx+

Redwood Agency: Minnesota
Lower Sioux Agency, 1862 (map), Anderson, G.,
p137

Reevis, Charles: Blackfoot
Early dance hall with young men performing,
1900 (group photo by J.H. Sherburne), Farr,
W., p152

Reevis, Charley: Blackfoot
Shrine convention June 27, 1923, Washington
DC (group photo), Farr, W., p125

Reid, Russell: Photographer
Arikara Woman pounding choke cherries
(photo), Schulenberg, R., p76
Red Fish, a Yanktonai Sioux Chief (photo),
Schulenberg, R., p23
Scattered Corn, daughter of Moves Slowly, the
lst Corn Priest of the Mandans (photo),
Schulenberg, R., p72
Sioux Hoop Dance (photo), Schulenberg, R.,
p113

Reifel, Lucy: Sioux
(photo), Doll, D., p114

Reifel, William: Sioux U.S. Congressman
Appropriation Commitee session, 1964 (photo),
Fielder, M., p143
Campaigning in Huron SD, Aug 1968 (photo),
Fielder, M., p144
Committee discussing Oahe Irrigation Project,
Feb 1, 1966 (photo), Fielder, M., p143
Daughter, 1969 (photo), Fielder, M., p145
Eisenhower, Dwight, June 12, 1973 (photo),
Feilder, M., p142
Extension agent on Pine Ridge Indian Reserva-
tion, 1933 (photo), Fiedler, M., p133
Family (photo), Fielder, M. p141, (photo),
Fielder, M., p130, April 1971 (photo),
Fielder, M., p146
First District Congressman, SD, from 1961 to
1971 (photo), Fiedler, M., p128
Freshman at SDSU, Brookings SD, 1928
(photo), Fiedler, M., p131
Goldwater, Barry (photo), Fielder, M., p142
Honarary Degrees
Doctor Law, USD, Vermillion SD, 1971
(photo), Fielder, M., p147
Doctor of Humanities, SDSU, Brooking SD,
1971 (photo), Fielder, M., p147
Master of ceremonies at dedication of Jewel
Cave Visitor Center, May 28,1972 (photo),
Fielder, M., p148
Nixon, Richard (photo), Fielder, M., p145
R.O.T.C. at SDSU, Brookings SD, 1930 (photo),
Fielder, M., p131
Washington DC, May 7, 1968 (photo), Fielder,
M., p144

**Religion (*see also spiritual acitivities*,
Sun Dance)**
Bear Butte, South Dakota (photo), Wunder,
p40
Quapaw Indians
House of worship (photo), Baird (*Quapaw
People*), p83
Round House (photo), Barid (*Quapaws*),
p92
Yanktonai Sioux
Native American Church, exterior (photo),
Hoover, H. (*Yankton*), p80

Native American Church, interior (photo),
Hoover, H. (*Yankton*), p76
Tipi camp (photo), Hoover, H. (*Yankton*),
p23

Reno, Jesse: U.S. Army Major
(photo), Hoig (*Fort Reno*), p37

Reno, Marcus A.: Major U.S. Army
(photo), Fielder, M., p.60, Hutton, P., p382
With his troops (photo), Milton, J., p46

Renville, Gabriel (Ti-wakan): Santee Sioux
1880–1881 (photo by C.M. Bell), Meyer, R.
(*History*), p228+
(portrait by Loren Zephier), Sneve V. (*They*),
p35

Renville, Joseph Akipa: Santee Sioux
Sisseton-Wahpeton delegation to Washington,
1858 (photo), Anderson, G., p98

**Reservations (*see also names of reservations
and subdivisions under tribal name*)**
Comanche
Land reductions since 1865, Cash, J.
(*Comanche*), p57
Oklahoma
Kiowa, Comanche, and Apache Reservation
(map), Foster, M., p103

Returns Again: Hunkpapa Sioux Chief
Possible location of grave (photo), Walstrom,
V., p160

Reynolds, Carrie B.
(photo), Riebeth, p66

Reynolds, George: Interpreter
(group photo) 1879, Sandoz, p174+
Boye, p168, Monnett (*Tell*), p180

Reynolds, Joseph: U.S. Army Colonel
(photo), Robinson, C., p192+, Vaughn, p48+
Commanded assault on Cheyennes at Powder
River (photo), Greene, J. (*Battles*), p9

Reynolds, Milton H.: Journalist
(photo), Jones, D. (*Treaty*), p32+

Reynolds, S.G.: Crow Indian Agent
(group photo), Riebeth, p124

Reynolds Battle
Battle of Powder River, 1876 (map), Greene, J.
(*Bettles*), p12
Reynolds Battle on Powder River, March 17,
1876 (map), Vestal, S. (*New*), p178+

Rhoades, A.C.: Kiowa
(group photo) Family Outing, Hail, p49

Rhoades, Everett: Kiowa
(group photo) Family Outing, Hail, p49

Rhodes, Robert Sun: Arapaho
1975 (group photo), Fowler (*Arapahoe Politics*),
p170+

Richards, Alvina: Sioux
(photo), *Crazy Horse School*, p13

Richards, Chuck: Sioux
(photo), Doll, D. p133

Richards, Grant: Tonkawa Chief
(photo), Newcomb (*Indians*), p142+

Richards, Winnie: Tonkawa
(photo), Newcomb (*Indians*), p142+

Riddles, Leonard: Comanche
(photo), *Contemporary Painting*, p76

Ride for the Elderly: Sioux
(photo), Walstrom, V. p35

**Rides-at-the-Door (Stabs-Down-By-Mistake):
Blackfoot**
Stabs-Down-By-Mistake addressing Tribal
Council with White Calf and Rides-at-the-
Door looking on, 1930s(photo), Farr, W.,
p137
1951 (photo), Hungry Wolf, A., p322
The Last Blood Holy Woman (photo), Hun-
gry Wolf, A., p26

Ridge, John: Cherokee
(drawing), Ehle, p88+

Ridge, John: Cherokee Interpreter
(color photo), McKenney v2, p326+

Ridge, Major: Cherokee
(painting), Malone, p82+
(photo), Pierce, p30
Confederate Cherokee Delegates to Washing-
ton, 1866 (group photo), Pierce, p41

Ridington, Jillian: Photographer
Photo of Maggie Johnson, Ridington, p167

Rifle *see* Firearms

Rifle Case (*see also* Scabbards)
Cheyenne
Deerskin, beads, sinew (color photo),
Howell, p60
Crow
Hide, beads, cloth (color photo) 1870–80,
Hunt, D., p148
Sioux
Deerskin, lazy stitch beadwork (color photo),
Howell, p60

Riggs, Lynn: Cherokee
(photo), Pierce, p55

Riggs, Stephen Return: Missionary
(photo by Whitney), 1860, Carley, K., p26
(photo), Meyer, R. (*History*), p108+
With wife Mary, 1852, Riggs, M., p179

Rinehart, F.A.: Photographer
Photo of Anko, 1898, Mayhall (*Kiowas*), p222+
Wichita Indians at Omaha Exposition, 1898
(group photo), Newcomb (*People*), p89

Rock Drawings: Plains Indian
1600–1800 (photo by Maurer), Maurer, E., p21
Anthropomorphic figures (photo by Maurer),
Maurer, E., p21
Battle scene (drawing), Maurer, E., p27
Battle scene, large (drawing), Maurer, E., p27
Deer (photo by Maurer), Maurer, E., p24
Elk (photo by Maurer), Maurer, E., p24
Horned figures
1000–1775 (photo by Maurer), Maurer, E.,
p23
Horned figures (photo by Maurer), Maurer,
E., p22
Horned figures with elongated bodies
(photo by Maurer), Maurer, E., p23
Horned figures, animals, shield (photo by
Maurer), Maurer, E., p26
Humans, animals, shields (photo by Maurer),
Maurer, E., p25
Mountain sheep (photo by Maurer), Maurer,
E., p26
V-necked figure, 1750–1850 (drawing), Maurer,
E., p27
Warrior (photo by Maurer), Maurer, E., p24
Warrior with shield
(photo by Maurer), Maurer, E., p24
1750–1850 (drawing), Maurer, E., p27

Rocky Bear
With Red Cloud and Major John Burke, 1890
(photo), Larson, R., p169+

Roe, Walter C.: Missionary
(group photo) with wife, 1900, Seger (*Early,
1979*), p114+ Trenholm, p302+

Roe, Mrs. Walter C.: Indian Missionary
(group photo) 1900, Seger (*Early*), p114+,
Trenholm, p302+

Roff: Episcopal Missionary
Visiting Kiowas (photo), Schweinfurth, p189

**Rogers, Thomas L.: Justice of the Osage
Supreme Court**
(photo) 1882, Wilson (*Underground*), p55

Rogers, Will: Cherokee
(photo), Pierce, p2

Rolling Pony: Kiowa
1900 (photo), Meadows, pxx+

Roman Nose: Cheyenne Chief
(group photo) 1868, Berthrong (*Southern*),
p368+
(group photo) Sweat Lodge, Moore, J.
(*Cheyenne*), p236

Roman Nose, Henry: Southern Cheyenne Chief
1900 (group photo), Berthrong (*Cheyenne*),
p155, (group photo), Berthrong (*Cheyenne*),
p157, Seger (*Early, 1934*), p78+
(group photo by W.S. Soule), Nye (*Plains*), p191

Pawnee enemies (group photo), Blaine (*Pawnee
Passage*), p250

Romick, Elizabeth: Quapaw-Kiowa Indian
(color photo), Baird (*Quapaw People*), p93

Roosevelt, Theodore: U.S. President
Coyote hunting (group photo) 1905, Marrin,
p172
On a wolf hunt with Quanah Parker, 1905
(photo), Neeley, p132+
Speaking tour in 1910 (photo), DeMontravel,
p231+

Root, Elihu: Secretary of War
(portrait), DeMontravel, p231+

Roper, Laura: Indian captive
(group photo), Coel, p227

Ropes
Buffalo hair ropes
(drawing), Mails (*Mystic*), p224

Rose, Thomas E.: U.S. Army
(photo), Kime, p85

Rosebud Sioux (Brule): South Dakota
Agency
1879 (drawing by James McCoy), Hamilton,
H., p55
1879, inside of building (drawing by James
McCoy), Hamilton, H., p56
1885 (photo), Fielder, M., p38
1889 (photo), Sneve, V. (*Completing*) p85,
Anderson, J., no paging
Annuity payment, 1895 (photo by J. Ander-
son), Hamilton, H., p114
Beef Issues (photo by J. Anderson), Hamil-
ton, H., p106
Branding Cattle, 1889 (photo by J. Ander-
son), Hamilton, H., p96
Facing east-southest, 1891 (photo by J.
Anderson), Hamilton, H., p59
Indian Police, 1888 (photo by J. Anderson),
Hamilton, H., p83
Stockade
Horse herd being driven past, 1895 (photo
by J. Anderson), Hamilton, H., p217
View
Looking Northwest, 1889 (photo by J.
Anderson), Hamilton, H., p58
Looking Southwest
1889 (photo by J. Anderson), Hamilton,
H., p57
1892 (photo by J. Anderson), Hamilton,
H., p60
West (photo by J. Anderson), Hamilton, H.,
p61
Women preparing a meal, 1893 (photo by J.
Anderson), Hamilton, H., p215
Aloysia, Mother General, 1931 (photo), Ander-
son, J., no paging

Arrows
Left Hand Bull making ceremonial (photo), Anderson, J., no paging
Automobile, first on the Rosebud Agency, 1910 (photo by J. Anderson), Hamilton, H., p304
Bad Lands north of Charles Rooks (photo), Anderson, J., no paging
Bald Eagle, Theodore
With wife, 1945 (photo), Anderson, J., no paging
Beef Issues
1893 (photo), Maurer, E., p49
Big Turkey Camp, on Rosebud Creek, 1888 (photo by J. Anderson), Hamilton, H., p66
Browning, D. M. Commissioner of Indian Affairs
Arrival, 1894 (photo by J. Anderson), Hamilton, H., p88–89
Blue Eyes, Sarah
1900 (photo), Anderson, J., no paging
Buffalo Bill Cody's Wildwest Show
1890 (photo), Anderson, J., no paging
Sioux participants (photo by J. Anderson), Hamilton, H., p136
Bulltail, Moses
And wife, 1931 (photo), Anderson, J., no paging
Cattle
Roundup for beef issue, 1902 (photo), Anderson, J., no paging
Cattle to be issued, 1889 (photo), Anderson, J. no paging
Cavalry charging at Rosebud Creek, 1876 (drawing), Greene, J., (*Battles*) p30
Chiefs, Sioux (group photo by J. Anderson), Hamilton, H., p186
Children
Carrying a child in a blanket (photo), Anderson, J., no paging
Cloudman, Corrine
Home (photo), Anderson, J., no paging
Interior of home (photo), Anderson, J., no paging
Comes a Flying, Floyd
Bringing sacred buffalo skull to Sun Dance, 1974 (drawing by Mails), Mails, T. (*Sundancing*), p102
Cooking
Cooking a meal at Spring Creek (photo), Anderson, J., no paging
High Bear cooking by throwing heated stones in beef stomach container (photo), Anderson, J., no paging
Preparing a meal (photo), Anderson, J., no paging
Preparing Easter dinner at Upper Cutmeat, 1930 (photo), Anderson, J., no paging

Council
Sale of Indian lands in Tripp and Gregory Counties, 1892 (photo by J. Anderson), Hamilton, H., p80
Crook Treaty Council
May 4, 1889 (photo by J. Anderson), Hamilton, H., p78
Hitch lot, 1889 (photo by J. Anderson), Hamilton, H., p79
Crow, Isaac
With wife, 1927 (photo), Anderson, J., no paging
Cut Meat
1893, Beef day at (photo), Anderson, J., no paging
Easter dinner in front of Cut Meat Church, 1930 (photo), Anderson, J., no paging
Dance
Omaha Dance, 1928 (photo), Anderson, J., no paging
Sun Dance
1910 (photo), Anderson, J., no paging
1928 (photo), Anderson, J., no paging
Dance Hall and camp at Norris, Armistice Day, 1930 (photo), Anderson, J., no paging
Dancers
Ready for the Dance, 1900 (photo by J. Anderson), Hamilton, H., p184–85
Eagle Feather
Mercy, 1941 (photo), Anderson, J., no paging
Eagle Man
Medicine Man (photo), Anderson, J., no paging
Easter dinner in front of Cut Meat Church, 1930 (photo), Anderson, J., no paging
Fire Heart, Joe
1939 (photo), Anderson, J., no paging
Flag-raising ceremony (photo by J. Anderson), Hamilton, H., p142–43
Fool Bull
Medicine Man (photo), Anderson, J., no paging
Four Horses
Mrs. Frank, (photo), Anderson, J., no paging
Ghost Dance revival, 1974 (photo), Crow Dog, M., p110+
Girl's initiation lodge, interior, 1892 (photo), Maurer, E., p57
Goes Among
Lucy with Quick Bear, Levi, 1924 (photo), Anderson, J., no paging
Goes to War
Aka Pretty Bird (photo), Anderson, J., no paging
Good Shield, Nellie
1889 (photo), Anderson, J., no paging
Good Voice Eagle
1911 (photo), Anderson, J., no paging

Understanding Crow, Joe
 With Holy Eagle, Melissa, on wedding day,
 1930 (photo), Anderson, J. no paging
Walking Eagle
 Alfred's son in Indian costume, 1936 (photo),
 Anderson, J., no paging
 Son at funeral home (photo), Anderson, J.
 no paging
Walking Eagle, Julia
 At husband Abel's grave, 1974 (photo),
 Anderson, J., no paging
Walking Eagle, Lonnie and Lillian
 (photo), Anderson, J. no paging
Walking Eagle, Pearl
 Giveaway" in honor of husband on day of
 funeral (photo), Anderson, J., no paging
Walking Eagle, Viola
 1930 (photo), Anderson, J. no paging
White Feather, Arthur
 And wife Nellie Running, wedding day, 1929
 (photo), Anderson, J., no paging
White Hat, Anna Rose
 With children (photo), Anderson, J., no
 paging
White Hat, Daniel
 And Little, Nellie (photo), Anderson, J. no
 paging
White Thunder Camp, Dakota Territory, 1888
 (photo by J. Anderson), Hamilton, H., p65
White-Buffalo Ceremony, 1892 (photo),
 Anderson, J., no paging
Women
 Preparing rawhide for bowl (photo), Ander-
 son, J., no paging
 Quilling moccasin, 1893 (photo), Maurer, E.,
 p55
 Washing beef entrails (photo), Anderson, J.,
 no paging
Yellow Hair
 And wife Plenty Horse (photo), Anderson, J.,
 no paging
Zoological Garden Exposition, Cincinnnati,
 OH, 1897, Sioux participation
 (photo by J. Anderson), Hamilton, H.,
 p138

Ross, John: Cherokee Chief
(color photo), McKenney (vIII), p312+
(drawing), Jones, G., p9
(photo), Pierce, p27
(painting), Malone, p82+
House in Oklahoma (photo), Ehle, p328+
With with Mary Bryan Stapler Ross (photo),
 Ehle, p328+

Ross, Joshua: Cherokee
Shop (photo), Ehle, p328+

Ross, Lewis Anderson: Cherokee
(drawing), Ehle, p328+

Ross, Mary Bryan Stapler: Cherokee
With John Ross (drawing), Ehle, p328+

Ross, Quatie: Cherokee
(drawing), Ehle, p328+

Ross, Walter: Wichita
(photo by E. Curtis) 1927, Curtis (*Plains*),
 plate 38

Ross, William Potter: Cheroke Chief
(photo), Blaine (*Pawnee Passage*), p265

Rotten Belly: Crow Chief
Ceremonial pipestem (photo), Wildschut, W.
 (Medicine Bundles), p120+

Rough Hair: Blackfoot
1910 (photo), Hungry Wolf, A., p318

Round House
Peyote cult, 1955 (photo), Baird (*Quapaw
 Indians*), p181

Roundine, Sam: Blackfoot
Willow Creek School, 1907 (group photo by
 J.H. Sherburne), Farr, W., p53

Rouwalk, John (Raruhwa-ku, His Mountain):
Chawi Pawnee
1900 (photo), Murie (*Part II*), p202

Row of Lodges: Arapaho
1891 (group photo), Fowler (*Tribal*), p58+

Rowe, Maudie McCauley: Kansa
(group photo) 1974, Unrau (*Kaw*), p89

Rowell, Charles, E: Kiowa Artist
(painting) The Lost Child, a baby's death, Hail,
 p33

Rowell, Dorothy: Kiowa
(photo) With Saubeodle and Mattie Kauley,
 Hail, p45

Rowell, James, F: Physician
(photo), Hail, p42

Rowell, Maud: Kiowa
(group photo) 1912, Hail, p41

Rowell, Maye: Kiowa
(photo) With Susie Kauley and Hoygyohodle,
 1912, Hail, p44

Rowland, William: Author
(group photo by L.A. Huffman), Brown, M., p106

Rowland, Willis: Northern Cheyenne
Interpretting the sign language of Stumphorn,
 1925 (photo), Limbaugh, R.H., piv

Rowlodge, Jess: Arapaho interpreter
1911 (group photo), Fowler (*Tribal*), p58+

Royall, William B.: U.S. Army Lieutentant
(photo), Chalfant (*Without*), p57

Ru-ton-ye-wee-ma (Strutting Pigeon): Ioway
1844 (painting by George Catlin), Blaine
 (*Ioway*), p177

S

Sees with His Ears: Crow Indian
1910 with wife (photo by Throssel), Albright, P., p137
(group photo) 1910, Harcey, p165

Seet-Sé-Be-A (The Mid-Day Sun): Hidatsa
(watercolor by George Catlin), Troccoli, p99

Seger, John H.: Indian school superintendent
(group photo), Seger (*Early*), p82+
(photo), Berthrong (*Cheyenne*), p160, Seger (*Early*), p1

Seger Indian School: Oklahoma
(group photo) 1900, schoolboys policing grounds, Seger (*Early, 1979*), p66+
Campus view (photo) 1900, Seger (*Early, 1979*), p130+
Cheyenne and Arapaho boys laying brick, 1900, Fowler (*Tribal*), p58+
Colony, Oklahoma (photo), Berthrong (*Cheyenne*), p261
Indian boys cleaning the grounds (photo), Berthrong (*Cheyenne*), p263
Indian girls entering building (photo), Berthrong (*Cheyenne*), p262
Schoolboys policing the grounds (photo) 1900, Seger (*Early, 1979*), p66+
Student entering school (group photo), Seger (*Early, 1934*), p78+

Seiber, Al: Chief of Scouts
(photo), 1880's, Reedstrom, p70

Seiling Women's Club
Cheyenne women (group photo) 1954, Fowler (*Tribal*), p58+

Seiver, John: Governor of Tennessee
(drawing), Ehle, p328+

Seminole
Black Drink (Osceola)
(color painting by G. Catlin), 1838, Heyman, p223
Chittee-Yoholo (color photo), McKenney v2, p202+
Foke-Luste-Hajo (color photo), McKenney v2, p320+
Halfpatter-Micco (Billy Bowlegs) (color photo), McKenney v2, p8+
Itcho-Tustenneuggee (color photo), McKenney (vIII), p208+
Julcee Mathla (color photo), McKenney (vIII), p224+
Micanopy (color photo), McKenney v2, p336+
Nea-Math-La (color photo), McKenney v2, p262+
Oklahoma
Indian lands in Oklahoma (map), Blaine (*Pawnee Passage*), p267

Osceola (Asseola) (color photo), Osceola (Asseola, Black Drink)
(color painting by G. Catlin), 1838, Heyman, p223, 1838, Heyman, p57
(painting), Vogel, p64, McKenney v2, p360+
Papoose (photo by John N. Chamberlain), McAndrews, p25
Reservations before allotment in the 1890s (map), Blaine (*Pawnee*), p34
Tuko-See Mathla (color photo), McKenney (vIII), p82+
Tommie, Howard (photo), *New Warriors*, p170
Yaha-Hajo (color photo), McKenney v2, p394+

Seminole/Creek
Bags
Shoulder: wool, cotton fabric, silk ribbon, felt, glass beads, 1820–30 (photo), Penney, D., p99
Beadwork (photo), Sommer, R., p123
Clothing
Couple in bridal dress, 1930 (photo), Sommer, R., p38
Skirts
Ribbon applique (photo), Sommer, R., p123

Seminole, Hubert: Northern Cheyenne
(group photo), Boye, p208

Seneca
Blacksquirrel Miller, Nancy, 1927 (photo), Sommer, R., p11
Doll, 1983 (photo), Coe, R., p77
Ki-On-Twog-Ky (Cornplanter) (color photo), McKenney v1, p174+
Paddle, 1980 (photo), Coe, R., p78
Oklahoma (map), Blaine (*Pawnee Passage*), p267
Red Jacket
(color photo), McKenney v1, p6+
(sketch by George Catlin), Troccoli, p17, p46
(watercolor by George Catlin), Troccoli, p43, p45
Reservations before allotment in the 1890s (map), Blaine (*Pawnee*), p34

Sepulcher Tree
Beaver Valley, north of Hay Spring Nebraska (photo), Walstrom, V., p59+

Sequoyah (George Gist, George Guess): Cherokee
(drawing), Ehle, p88+, Bass, p36+, Pierce, p21
Home in Oklahoma (photo), Ehle, p328+
(painting), Malone, p82+

Set-angia (Set-angy, Set-ankeah, Set-ankia, Satank, Sitting Bear): Kiowa Chief
1870 (photo by W.S. Soule), Mayhall (*Kiowas*), p62+

(photo by W.S. Soule), Belous, p23, Nye
(*Plains*), p213
(photo), Hoig, S. (*Kiowas*) p159, Nye (*Carbine*),
p182+, (photo), Wunder, p54
Death song (drawing by Ernie Keahbone),
Wunder, p62
Wearing the sash of Koitsenko Society (photo
by William S. Soule), Merrill, p302

Set-angya *see* **Set-angia**

Set-ankeah *see* **Set-angia**

Set-ankia *see* **Set-angia**

Set-imkia (Stumbling Bear): Kiowa Chief
(photo by W.S. Soule), Belous, p54, Nye
(*Plains*), p219
(photo), Nye (*Carbine*), p182+, Wunder, p58

Set-tainte (White Bear, Satanta): Kiowa Chief
(photo), Mayhall (*Kiowas*), Nye (*Carbine*),
p94+, p142+
Seated with bow (photo), Hoig, S. (*Kiowas*),
p57

Seta, Luti Augun: Kiowa
(photo), Hail, p79

Setangya *see* **Set-angia**

Setimkia *see* **Set-imkia**

Seyers, Captain: U.S. Army Captain
Scouts (group photo), Geronimo, p70+

Seymor, Samuel: Artist
Painting of a Pawnee council meeting, Blaine
(*Pawnee Passage*), p56
Drawing of a Kiowa encampment, 1820–21,
Mayhall (*Kiowas*), p62+
Drawing of Kaskai, Shienne Chief, and Arrap-
paho, 1820–21, Mayhall (*Kiowas*), p62+

Seyomour, Stephen: Artist
Painting of a Pawnee treaty council, Lacey,
p68–69

Sha-co-pay (The Six): Plains Ojibwa
(color painting by G. Catlin), 1832, Heyman,
p170

Sha-ko-ka: Mandan
(color painting G. Catlin), 1832, Heyman,
p52
In ceremonial dress, 1832 (painting by Catlin),
Sommer, R., p35

Shabbona: Potawatomi Chief
(photo) 1857, Vogel, p81

Shakespeare, Old Man West: Arapaho
1975 (group photo), Fowler (*Arapahoe Politics*),
p170+

**Shaking Hand (Mow-way): Yamparkia
(Kochateka) Comanche Chief**
(photo by W.S. Soule), Belous, p106, Nye
(*Carbine*), p126+

(photo by W.S. Soule) 1875, Mayhall (*Indian
Wars*), p78+

Shakoha (Mint): Mandan
(color painting by G. Catlin), 1832, Moore
(*Native*), p185

Shakopee: Santee
(photo), Bonvillain (*Santee*), p58, Schultz, D.
(*Over*), p148+
With Medicine Bottle (photo), Carley, D., p67,
Clodfelter, M., p76
Portrait by Loren Zephier, Sneve, V. (*They*), p7

Shakopee Mdewakanton Dakota Community
Prior Lake Community
A dancer at annual powwow, (photo), Bon-
villain (*Santee*), p90

Shane, Ralph: Artist
Crows Heart, a Mandan (drawing), Schulen-
berg, R., p26
Drags Wolf, son of Crow Flies High, a Hidatsa
Chief (drawing), Schulenberg, R., p103

Shangreau, John: Scout
(photo), Vaughn p48+

Shar-i-tar-ish: Pawnee Chief
(color painting), Moore (*Native*), p114,
McKenney v2, p294+

Sharp Claws: Otoe
Drawing of a Peace Pipe, Anderson, p103

Sharp Nose: Arapaho Chief
(photo), Trenholm, p46+
(group photo) 1904, Fowler (*Arapahoe Politics*),
p74+
Delegation to Washington, D.C. (group photo)
1877, Fowler (*Arapahoe Politics*), p74+
With Captain William C. Brown (photo),
Fowler (*Arapaho*), p78

Sharp Nose, Crook (Crook Norse): Arapaho
1904 (group photo), Fowler (*Arapahoe Politics*),
p74+

Shau-hau-napo-tinia: Sac and Fox Chief
The Man Who Killed Three Sioux (color
painting by C.B. King) 1836, Moore, J.
(*Cheyenne*), p54

Shaumonekusse: Ote-Missouria Chief
(color painting), Moore (*Native*), p67

Shaw, Dallas: Sioux
(group photo), *Crazy Horse School*, p13

Shaw, Jerry: Osage
(photo) 1975, Callahan, p42

Shaw-Da-Mon-Nee (There He Goes): Omaha
(painting by G. Catlin), 1832, Heyman, p125

Shawnee
Indian lands in Oklahoma (map), Blaine
(*Pawnee Passage*), p267

Southern Cheyenne
 Mule deer tail on bib in back (color photo)
 1850's, Horse Capture, p103
Upper Missouri Region
 Man's: buckskin, 1830–50 (photo), Penney,
 D., p150
Winnebago
 Man's: wool fabric, silk ribbon, velvet ribbon,
 glass beads, 1880 (photo), Penney, D., p140
Woman's
 Apache
 (color photo) 19th cent., Hunt, p153

Shlesinger, Sigmund: Forsyth Scout
 (photo), Monnett (*Battle*), p103

Shoes (*see also* Moccasins)
 Infant tennis shoes with beaded images, 1997
 (color photo), Hail, p129

Sho'ka: Osage
 (drawing), La Flesche (*Osage*), p109

Shon-ka (The Dog): Sioux
 (color painting by G. Catlin), 1832, Heyman,
 p245

Shon-ka-ki-he-ga (Horse Chief): Pawnee Chief
 Painting (color) by G. Catlin, 1832, Heyman,
 p122

Shon-ta-yi-ga (Little Wolf): Iowa
 (sketch by George Catlin), Blaine (*Ioway*), p231
 (color painting by G. Catlin), 1844, Heyman,
 p234

Shonka Hoska: Sioux
 And scout George Wells (photo), Manzione, J.,
 p88

Short Bull (Tatanka Ptecela): Brule Sioux
 Holy Man
 Battle scene, 1885 (painting), Maurer, E., p214
 Survived the Ghost Dance massacre (photo),
 Starita, J., p132 (photo), Hanson, J., p80
 Portrait by Loren Zephier, Sneve, V. (*They*), p32
 Wearing horn bonnet (photo) 1905, Johnson
 (*Distinguished*), p192
 With Cook, James H.: Captain (photo),
 Nebraska History, p73

Short Greasy Hair (Odl-kaun't-say-hah): Kiowa
 (group photo by W.S. Soule)), Belous, p57

Shortman, Mike: Blackfoot
 Leading the Crazy Dogs in the Blackfoot
 Medicine Lodge dance, July 4, 1907 (photo
 by T. Magee), Farr, W., p90

Shoshone
 Aah-an-golta
 His son (group photo) 1883, Fowler (*Arapa-
 hoe Politics*), p74+
 Aragon, William
 (group photo) 1935, Fowler (*Arapahoe Poli-
 tics*), p170+

Belt Buckle
 (photo), Maurer, E., p129
Buffalo hunt and Wolf Dance, 1885 (hide
 drawing), Maurer, E., p252
Camp
 On the Wind River Reservation (photo),
 Jones, G., p47
Council
 Arapaho & Shoshone joint council, 1935
 (group photo), Fowler (*Arapahoe Politics*),
 p170+
Dance
 Sun Dance
 Dancers resting, 1941 (photo), Voget, F.,
 p261
 Praying, 1948 (photo), Voget, F., p259
 Relaxing at home after dance, 1975
 (photo), Voget, F., p271
 Shoshone pledger greeting sun, 1948
 (photo), Voget, F., p260
Day, Gilbert
 (group photo) 1935, Fowler (*Arapahoe Poli-
 tics*), p170+
Driskell, Charles (Dee)
 (group photo), 1935, Fowler (*Arapahoe Pol-
 itics*), p170+
Harris, George
 (group photo) 1904, Fowler (*Arapahoe Poli-
 tics*), p74+
Lahoe, Charlie
 (group photo) 1904, Fowler (*Arapahoe Poli-
 tics*), p74+
Land Cession
 Signing 1904
 (group photo), Fowler (*Arapahoe Politics*),
 p74+
 1896–1906
 Wind River Reservation (map), Fowler
 (*Arapahoe*), p74+
Mam-a-van-a-sah
 (group photo) 1883, Fowler (*Arapahoe Poli-
 tics*), p74+
Mat-koi-ta
 (group photo) 1883, Fowler (*Arapahoe Poli-
 tics*), p74+
Meade, Irene
 (group photo) 1935, Fowler (*Arapahoe Poli-
 tics*), p170+
Meyers, Charlie
 (group photo) 1904, Fowler (*Arapahoe Poli-
 tics*), p74+
Mud-sat-sie
 (group photo) 1883, Fowler (*Arapahoe Poli-
 tics*), p74+
Necklace
 Bear claw, 1980 (photo), Coe, R., p166
Reservation
 (map), Fowler (*Arapahoe Politics*), p74+

St. Clair, Wallace
 (group photo) 1935, Fowler (*Arapahoe Politics*), p170+
Terry, George
 (group photo) 1904, Fowler (*Arapahoe Politics*), p74+
Tigee
 (group photo) 1904, Fowler (*Arapahoe Politics*), p74+
Tomahawk Pipe Club
 (color painting), Mails (*Mystic*), p506+
Treaty council of 1904
 (group photo), Fowler (*Arapaho*), p75
Village
 Wyoming, 1875 (photo), Maurer, E., p19
Warrior motifs (drawing), Schlesier, K., p29
Washakie: Chief
 Autobiographical exploits, 1865 (photo), Maurer, E., p218
Washakie, Charles
 (group photo) 1935, Fowler (*Arapahoe Politics*), p170+
Washakie, Charlie
 (group photo) 1904, Fowler (*Arapahoe Politics*), p74+
Washakie, Dick
 (group photo) 1904, Fowler (*Arapahoe*), p74+
Washakie, Jim
 (group photo) 1883, Fowler (*Arapahoe*), p74+
Wind River Joint Tribal Council, 1938
 (group photo), Fowler (*Arapaho*), p84
Yellowtail, Toml
 Offers smoke prayer, 1975 (photo), Voget, F., p151

Shoshorn, Mrs.: Comanche
(photo) With child, Hail, p34

Shot in the Hand: Crow
1910 (photo by Throssel), Albright, P., p99

Shot-on-Both-Sides, Jim: Blackfoot
1927 (photo), Dempsey, H., p8
1940 (photo), Hungry Wolf, A., p285
Driving lead wagon (photo), Hungry Wolf, A., p326
(photo), Hungry Wolf, A., p225
With council, 1930 (photo), Hungry Wolf, A., p286

Shot Pouch (*see also* Bag and Pouch)
With powder container (photo), Sturtevant, v13, p709

Shote, Cunne (Standing Turkey): Cherokee
(drawing), Ehle, p88+

Shotgun, Samuel: Arapaho Chief
(group photo) 1920's, Fowler (*Arapaho*), p81

Shoulder Bag
Beaded, Boller, H, 1858 (photo), Ewers, J. (*Plains*), p75
Creek
 Or Seminole: wool, cotton fabric, silk ribbon, felt, glass beads, 1820–30 (photo), Penney, D., p99
 Wool fabric, cotton fabric, silk ribbon, glass beads, 1810–30 (photo), Penney, D., p98
Delaware
 Wool fabric, cotton fabric, silk ribbon, glass beads, 1860 (photo), Penney, D., p115
Menominee
 Buckskin, vegetable fiber, porcupine quills, 1800–30 (photo), Penney, D., p70
Ojibwa
 1885 (photo) on, glass, D., p122
 Wool fabric and yarn, cotton fabric, silk ribbon, glass, metallic beads, 1851 (photo), Penney, D., p102
 Wool fabric, cotton fabric, silk ribbons, glass beads, 1820–40 (photo), Penney, D., p94
 Wool fabric, yarn, cotton fabric, silk ribbon, glass beads, 1850 (photo), Penney, D., p103
Ottawa
 Wool yarn, glass beads, silk ribbon, 1830–50 (photo), Penney, D., p78
Potawatomi
 Wool fabric and yarn, cotton fabric and thread, glass beads, 1890 (photo), Penney, D., p121
 Wool fabric and yarn, cotton fabric, silk ribbons, glass beads, 1860 (photo), Penney, D., p116
Seminole or Creek
 Wool, cotton fabric, silk ribbon, felt, glass beads, 1820–30 (photo), Penney, D., p99
Winnebago
 1890 (photo), Penney, D., p123

Showetat (Caddo George): Caddo Chief
(photo by W. Soule), Nye (*Plains*), p387

Shunk, Louis
1890 (photo), Flood, R. v2, p17

Shunkahmolah: Osage
(photo), La Flesche (*Osage*), p24

Sih-Chida (Yellow Feather): Mandan
(watercolor by K. Bodmer), Bodmer, p307, Moore (*Native*), p222

Sih-Sa (Red Feather): Mandan
(watercolor by K. Bodmer), Bodmer, p306, Moore (*Native*), p266

Siki: Apache
(group photo), Robinson, S., p30

Siksika Blackfeet Chief
Ihkas-Kinne (watercolor by K. Bodmer), Bodmer, p260

Snearly, Alice: Artist/Photographer
With Piah Kiowa (photo), Noyes (*Comanches*), p49

Snearly, Pete: Businessman
(group photo), Noyes (*Comanches*), p56

Snow, Frances: Stoney
Preparing moose hide (photo), Sturtevant, v13, p601

Snow, William: Stoney
(photo) 1948, Sturtevant, v13, p598

Snow shovel
Cree (photo), Coe, R., p71

Snowshoes
Cree, 1979–80 (photo), Coe, R., p70
Mandan, (watercolor by K. Bodmer), Bodmer, p335
Winnebago (photo), Petersen, p74+

So-hnee: Comanche
Peyote practitioners (group photo), 1893, Rollings (*Comanche*), p92
With husband Quanah Parker (photo), Rollings (*Comanche*), p84

Soatikee, Carol A.: Apache
(photo), *Contemporary Painting*, p77

Soldier: Arikara Chief
Holding pipe (photo) 1912, Sturtevant, v13, p374
Who served with Custer (photo), Schulenberg, R., p96

Soldier of the Oak, The (Le Soldat du Chene): Osage
(drawing), Wilson (*Osage*), p19

Soldiers (*see also names of individuals and military units*)
Mexican Soldier (drawing), Noyes (*Los Comanches*), p228
Spanish Presidial Soldier (drawing), Noyes (*Los Comanches*), p41

Soldow Site: Iowa (State)
Tools & projectile points
Humboldt Archaic Complex (drawing), McKusick (*Men*), p73

Son of the Star: Arikara Chief
(photo), Schulenberg, R., p16

Son of the Sun (Sun Boy, Pai-talyi): Kiowa Chief
(photo by W.S. Soule), Belous, p55
(photo), Hoig, S. (*Kiowas*), p171

Song boards
Ojibwa
Wood (maple), 19th century, Penney, D., p254

Sonte: Apache
Agency Headquarters, 1907 (group photo), Schweinfurth, p20

Sootkis, Andrew: Northern Cheyenne
(group photo), Boye, p208

Sootkis, Josie: Northern Cheyenne
(group photo), Boye, p208

Sophia Wisdom (Ta-pa-ta-me): Iowa
(sketch by George Catlin), Blaine (*Ioway*), p231

Soule, Silas: Lieutenant U.S. Army
Camp Weld Council
1864 (group photo), Coel, p230, Berthrong (*Southern*), p208+
(group photo), Sept. 1864, Schultz, D., (*Month*), p118+
(group photo) in Denver, Sept. 1864, Hoig, S., p146+

Soule, William S.: Photographer
(photo W. S. Soule), Nye (*Plains*), p185
Big Bow (photo), Ewers (*Murals*), p19
Big Tree (photo), 1870, Mayhall (*Kiowas*), p62+
Buffalo-Goad (photo), Newcomb (*People*), p73
Daha (photo), Ewers (*Murals*), p49
Essadna (photo) 1875, Newcomb (*People*), p103
Lone Wolf (photo), Ewers (*Murals*), p15
Never Got Shot (photo), Ewers (*Murals*), p23
Poor Buffalo (photo), Ewers (*Murals*), p24
Santana (photo), Ewers (*Murals*), p20
Set-Angia (Satank, Sitting Bull) (photo), Mayhall (*Kiowas*), p62+
Setangya (photo), Merrill, p302
Sun Boy (photo), Mayhall (*Kiowas*), p62+
Tenè-Angópte (Kicking Bird) (photo), Mayhall (*Kiowas*), p62+
Wichita encampment, Newcomb (*People*), p80–81
Wichita women wearing jewelry (photo), Newcomb (*People*), p27
With friend (photo), Nye (*Plains*), p253

South Dakota (*see also names of places, individuals and events*)
Farms 1920–87
Quantity (diagram), Moore, J. (*Political*), p28
Todd & Jones counties SD, Cherry County, NE, Moore, J. (*Political*), p30
Size in Acres (diagram), Moore, J. (*Political*), p27
Todd & Jones counties, SD, Cherry County, NE, Moore, J. (*Political*), p29
Indians other than the Sioux (map), *Indians of South Dakota*, p7
Mill Creek archaeological sites, Alex, p133
Oneota sites (map), Alex, p145
Ray Long Archeological site (photo), Wood, R. (*Archaeology*), p17
Saloon with "No Indians Allowed" sign (photo), Crow Dog, M., p110+

South Pass: Wyoming
(painting by W. H. Jackson), 1837, Fowler (*Arapaho*), p43

Standing Bear, Henry: Chief
 Headstone (photo), Walstrom, V., p146

Standing Bear, Mary Lookout: Osage
 (color photo), Baird (*Osage People*), p93

Standing Buffalo: Sisseton Chief
 (drawing by Diedrich), Diedrich, M. (*Odyssey*),
 p100
 (photo), Clodfelter, M. p96, MacEwan, G.
 plate 11, (photo by Whitney), 1852, Diedrich,
 M. (*Odyssey*), p29

Standing Elk (Hehaka Nazin): Yankton Sioux
 1898 (photo), Flood, R. v2, p2

Standing Elk, Henry T., Jr.: Arapaho
 (photo) with Addison Burdick 1977, Fowler
 (*Arapahoe Politics*), p170+

Standing Hawk: Omaha
 1866, (group photo), Boughter, p128

Standing Hawk (Eli S. Parker): Omaha Chief
 (group photo) With wife, Barnes, p114+

Standing Rock: North Dakota
 Census
 (photo), Karolivitz, R., p60
 Indian Police 1891 (photo), Hyde, G., (*Sioux*),
 p300+
 Ration Issue
 Beef issue (photo), Standing Bear, L., p72
 Reservation
 Agricultural fair (photo), Hoover, H. (*Yank-
 ton*), p53
 Location of Indian reservations in ND (map),
 Schulenberg, R., p104
 Reservation (map), *Indians of South Dakota*,
 p21
 Roads
 Clearing land for road, 1930 (photo),
 Hoover, H. (*Yankton*), p57
 Standing Rock
 The standing rock after which the reservation
 was named (photo), Wemett, W., p197
 Telephone lines installed, 1930 (photo),
 Hoover, H. (*Yankton*), p58

Standing Soldier: Oglala Lakota
 1884 (photo), Hyde, G., (*Sioux*), p76+
 1906 (photo by Gill), Greene, J. (*Lakota*), p149
 (group photo) Washington, 1883, Larson, R.,
 p169+

Standing Soldier, Andrew: Oglala Artist
 Branding Calves, 1952 (painting), *Contempo-
 rary Sioux Painting*, p42
 Bronc Rider, 1952 (painting), *Contemporary
 Sioux Painting*, p45
 Indian Family Preparing Pemmican, 1952
 (painting), *Contemporary Sioux Painting*,
 p44
 (photo), *Contemporary Sioux Painting*, p42

Standing Sweat-House (Tape-day-ah): Kiowa
 (photo by W.S. Soule), Belous, p50

Standing-Sweat-House (Tape-day-ah): Kiowa
 (photo by W. Soule), Nye (*Plains*), p329

Standing Turkey (Cunne Shote): Cherokee
 (drawing), Ehle, p88+

Standing Water: Cheyenne Chief
 (group photo), Hoig, S. (*Kiowas*), p72

Standingbird, Susie: Cheyenne
 (group photo), Moore, J. (*Cheyenne Nation*),
 p269

Stands, Albert: Sioux
 1974 (drawing by Mails), Mails, T. (*Sundanc-
 ing*), p42

Stands and Looks Back (Hakikta Najin): Sioux
Oglala
 1900 (photo by J. Anderson), Hamilton, H.,
 p278
 Wife, 1896, Hamilton, H., p279

Stands First: Sioux
 (photo), Buecker, T. p181, *Crazy Horse*, p181

Stands for Them: Plains Indian
 (photo by O. A. Vic), McAndrews, p120

Stands Looks Back *see* Stand and Looks
Back

Stands Out, Sally: Northern Cheyenne
 With Mabel Red Owl dressing and drying meat
 (photo), Limbaugh, R.H., pVIII

Stanley, David S.: U.S. Army
 (photo), Chalfant (*Cheyennes & Horse*), p169

Stanley, J.M.: Artist
 Blackfoot hunting buffalo near Three Buttes,
 1853 (drawing by J.M. Stanley), Ewers, J.
 (*Story*), p34
 Fort Benton 1853 (drawing by J.M. Stanley),
 Ewers, J. (*Story*), p25
 Fort Union, and Distribution of Goods to the
 Assinniboines (painting), Schulenberg, R.,
 p90

Stanton, T. H.: Major U.S. Army
 (photo), Vaughn, p48+

Stanton, William: U.S. Army Captain
 Officers that were involved in the Cibecue
 battle (group photo), Collins, p124–125

Star Chart
 Skiri Pawnee (photo), Sturtevant, v13, p531

Star House: Oklahoma
 Home of Quanah Parker (photo), Neeley,
 p132+
 Quanah Parker and his family on the porch,
 1908 (photo), Neeley, p132+

Star Quilt
 Sioux Indians, *Crazy Horse School*, p76

Staub, Evelyn: Sioux
(drawing by Mails), Mails, T. (*Sundancing*),
p80
Sage wreath (photo), Mails, T. (*Sundancing*),
p218
Watches trees cut (photo), Mails, T. (*Sundancing*), p206

Stays with the Horses: Crow
(group photo) 1873, Sturtevant, v13, p699

Stealing-Different-Things-Woman: Blackfoot
Imitating a buffalo (photo), Hungry Wolf, A.,
p102
(photo), Hungry Wolf, A., p101

Steamboat
Ohio River boat (engraving) 1838, Schneider,
p36
(color painting by G. Catlin), 1832, Heyman,
p109
(color painting by K. Bodmer), Ewers (*Views*),
p18
(painting by K. Bodmer), 1833, Moore (*Native*),
p206–07
(watercolor by K. Bodmer), Bodmer, p141

Stecker: U.S. Army Lieutenant
Agency Headquarters, 1907 (group photo),
Schweinfurth, p20

Steed, Millie: Sioux
And her husband (photo by J. Anderson),
Hamilton, H., p206

Steel: Blackfoot
(photo), Dempsey, H., p158

Steel, Young Bob: Blackfoot
(photo), Hungry, p310

Steell, George: Agent
Delegation to Washington DC, 1891, (group
photo), Farr, W., p63

Steep Wind (Tah-tech-a-dah-hair): Lakota Sioux
(color painting by G. Catlin), 1832, Heyman,
p247
Color painting by G. Catlin, 1865, Heyman,
p242

Steiner, Abraham G.: Reverend
(painting), Malone, p82+

Stevens, Isaac I.: U.S. Commissioner
(photo), Ewers, J. (*Story*), p38

Stevens, Jacquie: Winnebago potter
Sculpted jar (color photo), Peterson, p193
Vase
Whiteware with leather, wood and stone
(color photo) 1983, Peterson, p194
Woodweave bowl
(color photo) 1995, Peterson, p192

Stevens, William: Tonkawa
(photo), Newcomb (*People*), p142+

Stewart, Dave: Crow Indian Council
(group photo), Riebeth, p124

Stilwell, Simpson E. (Comanche Jack): U.S. Scout
(photo), Monnett (*Battle*), p123
(photo), Nye (*Carbine*), p206+

Stink, John (Ho-tah-moie): Osage
(photo), Wilson (*Underground*), p169

Stirring Iron (Nexjenayastan): Atsina Chief
(watercolor by K. Bodmer), Bodmer, p239

Stomick-Sosack (Bull's Hide): Blood Blackfoot Chief
(watercolor by K. Bodmer), Bodmer, p261

Stone, Forrest: Indian Superintendent
Arapaho & Shoshone joint council, 1935
(group photo), Fowler (*Arapahoe Politics*),
p170+

Stone, Willard: Cherokee
(photo), Pierce, p55

Stone Boiling
Food preparation (drawing), Laubin (*Indian*),
p79

Stone Calf: Cheyenne
With Wife (photo), *Contemporary Metalwork*,
p6

Stone Calf: Southern Cheyenne Chief
With his wife (photo by A. Gardner), Nye
(*Plains*), p269
With his wife (photo), Berthrong (*Cheyenne*),
p54, Hoig (*Fort Reno*), p33

Stone Circles
Archaic Indians
Wyoming (photo), Wood, R. (*Archaeology*),
p153

Stone Shell, The (Quáy-hám-kay): Kiowa
(watercolor by George Catlin), Troccoli, p144

Stoneworking
Methods of working stone, probably used by
Blackfoot (drawing), Ewers, J. (*Story*), p10

Stoney
Dixon, Lazarus (photo), Sturtevant, v13, p598
Ear, George (group photo), Sturtevant, v13,
p601
Geographical distribution
Territory early 19th century (map), Sturtevant, v13, p597
Saddle
Pad saddle, beaded (photo), Sturtevant, v13,
p598
Snow, Frances
Preparing moose hide (photo), Sturtevant,
v13, p601
Snow, William (photo) 1948, Sturtevant, v13,
p598

Sule, Silas: Lieutenant U.S. Army
(group photo) 1864, Berthrong (*Cheyenne*),
p208+

Sully, Alfred: Brevet Brigadier General
(photo), Hoig, S. (*Battle*), p76+

Sumner, Edwin V.: U.S. Army
(photo) 1855, Chalfant (*Cheyennes & Horse*),
p164

Sun, The (Kee-she-waa, Kee-shes-wa):
Sac and Fox Chief
(color painting by C.B. King), 1824, Moore
(*Native*), p102
(color photo), McKenney v2, p154+

Sun Bear: Northern Cheyenne
1925 (photo), Limbaugh, R. H., pII

Sun Boy (Paitahlee, Pai-talyi, Son-of-the-Sun):
Kiowa
(photo by W.S. Soule), Mayhall (*Kiowas*),
p62+, Belous, p55, Nye (*Plains*), p355
(photo), Hail, p42, Hoig, S. (*Kiowas*), p171
Visiting children with Big Bow at Carlisle
Indian School (photo by John N. Choate),
Merrill, p306

Sun Chief: Skidi Pawnee
(drawing), Grinnell (*Pawnee*), p385
(photo), Dorsey (*Traditions*), pxviii+

Sun Dance (*see also this subject under tribal
name elsewhere in index*)
Arapaho
Lodge construction (drawing), Mails
(*Mystic*), p161
Assinibone
Building the medicine lodge (photo),
Sturtevant, v13, p579
Blackfoot Indians
Black Bull and Stabs-Down-By-Mistake
with drum at encampment, 1900 (photo),
Farr, W., p89
Camp, Browning, July 1900 (photo), Farr, W.,
p69
Young man undergoing self-torture: Blood
Indian sun dance, 1892 (photo by R.N.
Wilson), Ewers, J., (*Blackfeet*), p174+
Cheyenne
Dancers, 1902 (drawing), Mails (*Mystic*),
p164
Dancers (photo), Moore, J. (*Cheyenne*), p225
Field diagram of Sun Dance (sketch) 1901,
Moore, J. (*Cheyenne Nation*), p329
Pledger dragging skulls (drawing), Mails
(*Mystic*), p172
Crow Indians
(photo) 1981, Yellowtail, p90
(photo) 1981, Yellowtail, p91
Doll (photo), Wildschut, W. (*Medicine
Bundles*), Fig. 9

Effigies (photo), Wildschut, W. (*Medicine
Bundles*), p30+
Effigy of Kills-With-His-Brother (photo),
Wildschut, W. (*Medicine Bundles*), Fig.
7–8
Effigy of Shows-His-Face (photo), Wild-
schut, W. (*Medicine Bundles*), Fig. 6
Lodge (photo) 1979, Yellowtail, p88–89
Two Legging's effigy (photo), Wildschut, W.
(*Medicine Bundles*), Fig. 2
War Medicine Man, wooden (photo),
Wildschut, W. (*Medicine Bundles*), Fig. 11
Yellowtail, Thomas (photo), Yellowtail, p92
Crow Dog, Leonard
At Wounded Knee Sun Dance, 1971 (photo),
Crow Dog, L., p152+
Sun dancing (photo), Crow Dog, L., p152+
With a buffalo skull for the Sun Dance
(photo), Crow Dog, L., p152+
Crow Dog's Paradise, 1971 (photo), Crow Dog,
L., p152+
Dancer
(photo by E. Curtis) 1907, Curtis (*Plains*),
plate 5
Lakota (*see also* Sioux)
Lodge, Pine Ridge, 1954 (drawing), Feraca,
S., p12
Offering the Pipe to the Singers, Pine Ridge,
1955 (photo), Feraca, S., p21
Pole, Pine Ridge, 1954 (drawing), Feraca, S.,
p16
Portion of Sun Dance Group, Pine Ridge,
1961 (photo), Feraca, S., p19
Medicine lodge at 1911 Sun Dance with Super-
intendent Mcfatridge (photo by J.H. Sher-
burne), Farr, W., p91
Piercing
1971 (photo), Crow Dog, L., p152+
Plains Cree
Lodge (photo) 1905, Sturtevant, v13, p647
Ponca
(photo) 1905, Sturtevant, v13, p425
Preparation for dance
1910 (photo by J. Anderson), Hamilton, H.,
p155
Pretty on Top
(photo) 1979, Yellowtail, p93
Sioux
(color painting by G. Catlin), 1835, Heyman,
p181
(color painting by G. Catlin), 1832, Moore
(*Native*), p172–73
Dancer with sage wreath at Wounded Knee,
1971 (photo), Crow Dog, L., p152+
Pine Ridge, 1883 (photo), Olson, J., p242+
Pine Ridge, over objections of Agent
McGillycuddy, 1883 (photo), Larson, R.,
p169+

Swift Dog: Hunkpapa Lakota
"Winter Count," 1912 (muslin painting), Maurer, E., p275
Two drawings of Swift Dog capturing horses, 1870 (photo), Maurer, E., p242

Swims Under: Piegan
Group photo at Big Badger Creek Agency, 1886 or 1887, Farr, W., p18

Switch
Arapaho
Horse-tail (drawing), Kroeber, p316

Sword
Mounted warrior 1890 (drawing), Hanson, J., p46
Teton warrior society (drawing), Hanson, J., p45
Spanish
Officer's sword (photo), Morehead, p130+

Sword: Sioux
1884 (photo), Hyde, G., (*Sioux*), p76+
Chief of Indian Police, Pine Ridge (photo), Fielder, M., p104
Group photo in Washington, 1883, Larson, R., p169+
(photos) Fielder, M., p20, McGillycuddy, J., p131, Olson, J., p178+ Price, C., p108+

Symbols
Painting horses with spiritually protected symbols and war honor marks (color photo), Terry, p28

T

Ta-ouan-li: Osage
(drawing by V. Tixier), Tixier, p240+

Ta-pa-ta-me (Sophia Wisdom): Ioway
(sketch by George Catlin), Blaine (*Ioway*), p231

Ta-sah-que-nah (Mountain of Rocks): Comanche Chief
(painting by G. Catlin), 1834, Heyman, p44, Noyes (*Los Comanches*), p128

Tabananaka (Voice of the Sunrise, Hears-the-Sun, Hears-the-Sunrise, Tabananica): Yamparika Comanche Chief
1875 (group photo), Hagan, p130
(photo), Nye (*Carbine*), p206+, Wallace (*Comanches*), p335+
(photo by W.S. Soule), Nye (*Plains*), p247

Tabatoso: Comanche
(photo), Newcomb (*Indians*), p190+

Tabba-quena (Sun Eagle): Comanche Chief
Sketch by G. Catlin, 1834, Mayhall (*Indian Wars*), p30+

Tabbaquena *see* Ta-sah-que-nahf

Tabbytite, Wick-kie: Comanche
1950 (photo), Harris, p72+
1956 (photo), Harris, p72+

Tabbytite, John: Comanche
1956 (photo), Harris, p72+

Tabenanaka: Yamparika Commache
(group photo) 1885, Kavanagh, p46

Tabeyetchy: Yamparika Commache
(group photo) 1885, Kavanagh, p46

Tachunkdahupa: Sioux
Male Dakota captives at Fort Snelling, 1864, Anderson, G., p166

Tack (*see also* Horse *and names of equipage*)
Beadwork, Horse and saddle (drawing), Wildschut, W. (*Beadwork*), Fig. 25
Collar, beaded (photo), Wildschut, W. (*Beadwork*), Pl. 2
Crow, 1982–83 (photo), Coe, R., p179
Crupper
Beaded, men's (photo), Wildschut, W. (*Beadwork*), Fig. 29
Beaded, women's (photo), Wildschut, W. (*Beadwork*), Fig. 30
Forehead ornament, beaded (photo), Wildschut, W. (*Beadwork*), Fig. 28
German Silver Bridle (drawing), Hanson, J., p106
Hitching a team of horses
1892 (photo by J. Anderson) Hamilton, H., p211
Oglala, Mexican bit (drawing), Hanson, J., p68
Outfit, 1982–83 (photo), Coe, R., p179
Saddle
Army saddle (photo), Hanson, J., p69
Captured by Tetons (photo), Hanson, J., p70
Saddle (drawing), Wildschut, W. (*Beadwork*), Fig. 25
Sioux Indians
Double saddle: buckskin, canvas, glass beads, sinew, wool, 1880 (photo), Penney, D., p189
Beaded (photo), Wildschut, W. (*Beadwork*), Fig. 31
Stirrup, beaded (photo), Wildschut, W. (*Beadwork*), Fig. 27
Upper Missouri Region
Buffalo hide, wool stroud, glass beads, tin cones, 1840 (photo), Penney, D., p154

Tah-chee (Dutch): Cherokee Chief
(color photo), McKenney v1, p330+

Tah-col-o-quoit: Sauk
(color photo), McKenney (vIII), p64+

Tah-ro-hon (Tah-ron-hon): Ioway
(color photo), McKenney v2, p158+
(color painting by C.B. King), 1837, Moore (*Native*), p19

TallChief, Rus: Osage
 (photo) with Tim TallChief, Callahan, p110

TallChief, Time: Osage
 (photo) with Rus TallChief, Callahan, p110

Tally (Tal-lee): Osage
 1834, (painting by George Catlin), Moore
 (*Native*), p190, Rollings (*Osage*), frontis-
 piece
 Lance in hand, shield on arm and bow and
 quiver on back (drawing), Wilson (*Osage*),
 p92

Tama: Fox Chief
 (painting by C.B. King), 1824, Vogel, p87

Tama: Iowa
 Mesquakie coummunity (map), Vogel, p115

Tamaha: Wahpeton Sioux
 (portrait by Loren Zephier), Sneve, V. (*They*)
 p9

Tangle Hair: Northern Cheyenne
 (group photo) 1879, Boye, p168, Monnett
 (*Tell*), p180, p183, Sandoz p174+
 With his granddaughter (photo), Monnett
 (*Tell*), p205

Tanning Hides *see* Hide Processing, Hide
 Scrapers

Taopi: Mdewakanton Chief
 1862 (photo), Carley, K., p61

Taoya Te Duta (Little Crow): Santee Sioux
 (portrait by Loren Zephier), Sneve, V. (*They*),
 p13

Taovaya: Comanche
 Wee-ta-ra-sah-ro (drawing by George Catlin),
 Noyes (*Los Comanches*), p131

Tape-day-ah (Standing-Sweat-House): Kiowa
 (photo by W.S. Soule), Belous, p50, Nye
 (*Plains*), p329

Tapehin Jila (Yellow Hair): Brule
 Rosebud Agency, 1894 (photo), Hamilton, H.,
 p259
 1900 (photo), Hamilton, H., p263

Tappan, Samuel F.: Commissioner
 (photo), Hoig, S. (*Battle*), p100+
 Medicine Lodge Commission (group photo),
 Hyde (*Life*), p294+

Tarrakee (Deer Ham): Ioway
 Ioway Chiefs visiting the Commissioner of
 Indian Affairs in Washington, 1866
 (photo by Zeno A. Shindler), Blaine (*Ioway*),
 p267

Tashunkopipape (Man-Afraid-of-His-Horses):
 Oglala Teton
 (portrait by Loren Zephier), Sneve, V. (*They*)
 p23

Tasunka-Kokipapi (Young-Man-Afraid-of-His-
 Horses): Oglala Sioux
 (photo), *Nebraska History*, p26

Tatanka Ptecela (Short Bull): Brule Sioux holy
 man
 Wearing horn bonnet (photo) 1905, Johnson
 (*Distinguished*), p192

Tatanka Yotanka *see* Sitting Bull (Hunkpapa
 Lakota Sioux)

Tatsey, Joe: Blackfoot
 Delegation to Washington DC, 1903, group
 photo (by D.L. Gill), Farr, W., p64

Tatsicki-Stomick (Middle Bull): Piegan
 Blackfoot Chief
 (painting by K. Bodmer), Moore (*Native*),
 p247
 (watercolor by K. Bodmer), Bodmer, p245

Tattoo Bundle
 Osage
 Contents (photo), Wilson (*Osage*), p16
 Items contained in bundle (photo) 1911,
 Sturtevant, v13, p480

Tattooing
 Designs
 Cree (drawing), Mails (*Mystic*), p281
 Omaha (drawing), Mails (*Mystic*), p281
 Omaha
 Designs (drawing), Mails (*Mystic*), p281

Tau-ankia (Sitting in Saddle, Sitting in the
 Saddle): Kiowa
 (photo), Nye (*Carbine*), p206+, Hoig, S.
 (*Kiowas*), p200
 (photo by W.S. Soule), Belous, p41
 (photo by W.S. Soule), 1872, Nye (*Plains*),
 p319

Taulbee, Daniel J.: Comanche
 (photo), *Contemporary Painting*, p77

Taw-Haw: Kiowa-Apache Chief
 (photo by W. Soule), Nye (*Plains*), p385

Tawakoni
 Clothing
 Women's clothing (drawing), Ewers (*Plains*),
 p127
 Tawakoni Jim
 (photo by W. Soule), Nye (*Plains*), p397

Tawakoni Jim: Tawakoni-Wichita-Waco Chief
 (photo by W.S. Soule), Nye (*Plains*), p397
 1870's (photo), Smith, F., p122

Tawha: Kiowa-Apache Medicine Man
 (photo by W.S. Soule) 1870, Mayhall (*Indian
 Wars*), p183+

Tay-nay-angopte (Kicking Bird): Kiowa Chief
 (photo by W.S. Soule), Nye (*Plains*), p217
 (photo), Nye (*Carbine*), p302+

U

Uwat: Comanche
 (photo by E.S. Curtis), Curtis (*Edward*), p291

V

Valentine, R. G.: Indian Office employee
 With Peter Clabber and family, 1906 (photo),
 Baird (*Quapaw Indians*), p173

Vallance, Mae: Photographer
 Little Badger Women's Club, 1933 (photo by
 Mae Vallance), Farr, W., p135

Valleière d'Hauterive, Captain Joseph Bernard:
 Commandant of Arkansas Post
 (photo), Arnold, p123

Vallier, Amos: Quapaw
 With brothers Frank and George (group
 photo), Baird (*Quapaw Indians*), p132

Vallier, Frank: Quapaw Interpreter
 With brothers George and Amos (group
 photo), Baird (*Quapaw Indians*), p132

Vallier, George: Quapaw
 With brothers Frank and Amos (group photo),
 Baird (*Quapaw Indians*), p132

Van Devanter, Willis: Attorney
 (photo), Clark, p78+

Van Dorn, Earl: U.S. Army Captain
 (photo), Chalfant (*Without*), p54

Vanderbilt, Cornelius: Arapaho
 With wife (group photo), Trenholm, p110+

Vann, David: Cherokee
 (drawing), Ehle, p88+
 (color photo), McKenney (vIII), p216+

Vann, James: Cherokee
 House in Georgia (photo), Ehle, p328+

Vann, Joseph: Cherokee
 (drawing), Ehle, p88+

Vegetation
 Iowa and Minnesota vegetation regions
 previous to settlement (map), Schlesier, K.,
 p129
 North American grassland (map), Schlesier, K.,
 pxix

Venegas, Hildreth: Sioux
 (photo), Doll, D., p125

Vest
 Blackfoot
 Deerskin, beads, cotton lining, silk, zircons
 (color photo), Howell, p48
 Mesquakie
 (photo) 1925, Torrance, p55+
 Plains Indian
 Pattern for (drawing), Minor, p74

Santee Sioux
 Deerskin, beads, porcupine quills (color
 photo), 1972, Howell, p29
 Deerskin, beads, porcupine quills, flag
 design (color photo), Howell, p45
Sioux
 Beaded on buckskin (photo), Minor, p41
 Deerskin, beads, leather fringes, sinew
 (color photo), Howell, p48
 Deer skin vest with beadwork design, 1900,
 Bonvillain (*Santee*), p53

Victorio: Mimbre Apache Chief
 (drawing), Sneve (*Apaches*), p25
 (photo), Adams, p 230, Greene, A., p35
 Only known photo of Victorio, Thrapp (*Apa-
 cheria*), p112+, Thrapp (*Victorio*), p110

Vik, Della B.: Photographer
 Yelllow Robe, Chauncey
 In costume from "The Silent Enemy" (photo),
 Fielder, M., p123
 At the time of the Coolidge ceremony, 1927
 (photo), Fielder, M., p120

Villa, Theodore B.: Artist
 (photo), *Contemporary Native American Art*,
 no paging
 Shield with Turtle Totem, 1982 (painting),
 Contemporary Native American Art, no
 paging

Villages (*see also* Camps *and camps as
 a division under tribal heading*)
 Comanche
 (photo) Washita, Cash, J. (*Comanche*), p46
 Pawnee
 Loup Fork village in Nebraska, 1871 (photo
 by William H. Jackson), Murie (*Part 1*), p6

Villasur-Pawnee Battle
 Painting on leather, Hyde (*Pawnee Indians*), p74

Vision Quest
 Sioux
 1975 (drawing by Mails), Mails, T. (*Sun-
 dancing*), p50
 Arrangement of pipes at camp (drawing by
 Mails), Mails, T. (*Sundancing*), p52
 Contemplating Old Man Four Generations
 Fireplace (drawing by Mails), Mails, T.
 (*Sundancing*), p54
 Contemporary vision quest (diagram), Mails,
 T. (*Sundancing*), p51
 Crow Dog, Leonard
 Entering vision pit at the Rosebud Sioux
 Reservation, 1972 (photo), Crow Dog, L.,
 p152+
 Preparing for vision quest (photo), Crow
 Dog, M., p110+
 Fasting and searching for vision (drawing by
 Mails), Mails, T. (*Sundancing*), p54

Pledger begins fasting and vision seeking
(drawing by Mails), Mails, T. (*Sundancing*),
p55
Relationship of sweatlodge, molehill, and
fireplace (drawing by Mails), Mails, T.
(*Sundancing*), p53

**Voice of the Sunrise (Tabananika): Yamparika
Comanche Chief**
(photo), Wallace (*Comanches*), p335+

**Vow Woman (title given to a woman):
Blackfoot**
Fasting at medicine lodge (photo by J.H.
Sherburne), Farr, W., p76

W

Wa-ho-beck-ee: Osage
Color painting by G. Catlin, 1834, Moore
(*Native*), p191

Wa-hon-ga-shee (No Fool): Kansa
(color painting by G. Catlin), 1832, Heyman,
p118

Wa-kaun-ha-ka (Snake Skin): Winnebago Chief
(color photo), McKenney v2, p298+

Wa-kawn (The Snake): Winnebago Chief
(color photo), McKenney v2, p308+

Wa-ma-laga-lisca (Spotted Eagle): Sioux Chief
1880 (photo by L.A. Huffman), Brown, M., p95

**Wa-she-ta-na-kwa-twa (George Morgan):
Mesquakie**
With family (group photo), Bataille, p72

Wa-ta-we-bu-ka-na: Ioway
(sketch by G. Catlin), Blaine (*Ioway*), p231

Wa-tan-ye (One Always Foremost): Ioway
(sketch by George Catlin), Blaine (*Ioway*),
p231

Wa-wa-ki-ki: Mesquakie
(photo), Bataille, p68

Wa-wa-to-se: Ioway
(photo), Young Bear, p254

Waanatan *see* **Wanata**

Wabasha: Santee Sioux Chief
(photo) 1858, Carley, K., p19
1860 (photo), Anderson, G., p150, (photo),
Bonvillain (*Santee*), p45
(photo) treaty group, 1858, Oehler, C., p144+

Wabasha II, son of Wabasha I
(drawing by Mark Diedrich from a painting
by Henry Inman), Diedrich, M., (*Famous*)
pviii

Wabaunsee (Early Day): Potawatomi Chief
(painting by C.B. King), 1835, Vogel, p101

Waco
Long Soldier (photo), Mayhall (*Indian Wars*),
p78+

Wades-in-Water: Blackfoot
Dance hall with young men performing,
1900 (group photo by J.H. Sherburne),
Farr, W., p152
With No Coat and their wives, 1899 (photo by
T. Magee), Farr, W., p148

Wadley, Marie L.: Cherokee
(photo), Pierce, p94

Wadsworth, H.E.
(group photo) 1904, Fowler (*Arapahoe Politics*),
p74+

Wagon Train
Crossing the plains in 1862 (photo), Coel, p138

Wah-ba-sha Village: Sioux village
Wah-ba-sha Village on the Mississippi, 1846–
1848 (watercolor by Seth Eastman), Eastman,
M. (*1995*), p62

Wah-chee-te: Osage
(watercolor by G. Catlin), Troccoli, p132
With child (painting by G. Catlin) 1836,
Wilson (*Osage*), p46
With child, 1834 (painting by G. Catlin),
Rollings (*Osage*), p15

Wah-he-jo-tass-e-neen: Assinniboine Chief
(painting by P. Kane), *Assiniboines*, no paging

Wah-hre-she, Charles: Osage
1921 (photo), La Flesche (*Osage*), p22

Wah-kon-ze-kaw (The Snake): Winnebago
(color painting by G. Catlin, 1828, Heyman,
p101

**Wah-Menitu (Spirit in the Water, Spirit of God
in the Water): Teton Sioux**
(painting by K. Bodmer), 1833, Moore (*Native*),
p237, Bodmer, p189

Wah-pe-kee-suck (White Cloud): Sac and Fox
(painting by G. Catlin), 1832, Heyman, p54

Wah-ro-nee-sah (The Surrounder): Otoe
(painting by G. Catlin), 1832, Heyman, p126
(watercolor by G. Catlin), Troccoli, p113

Wah-she-shah (Wah-sho-shah): Osage Chief
(group photo), Wilson (*Osage*), p97
Men of the tribe (group photo), Wilson
(*Osage*), p97

Wah-shun-gah: Kansa Chief
(photo) 1880, Unrau (*Kansa*), p78+

**Wahktageli (Gallant Warrior): Yankton Sioux
Chief**
(painting by K. Bodmer), 1833, Moore (*Native*),
p235
(watercolor by K. Bodmer), Bodmer, p186,
Schulenberg, R., p21

White Bear (Satanta, Set-tainte, Se-ti-tah): Kiowa Chief
 1870 (photo by W.S. Soule), Mayhall (*Indian Wars*), p30+
 (photo by W.S. Soule), Nye (*Plains*), p186, Belous, p28–29, Mayhall (*Kiowas*), Nye (*Carbine*), p94+, p142+
 (photo) Wearing military jacket and medal (photo), Capps, p144+
 Seated with bow (photo), Hoig, S. (*Kiowas*), p57
 (drawing), Battey, p269

White Bear: Sioux
 1888 (photo by J. Anderson) Hamilton H., p77

White Bird: Sioux
 (photo) Buecker, T., p19, *Crazy Horse*, p19

White Buckskin: Blackfoot
 (photo), 1910, Hungry Wolf, A., p344

White Buffalo: Blackfoot Medicine Man
 (color painting by G. Catlin), 1832, Moore (*Native*), p181

White Buffalo, Mrs. (Sau'totauto): Kiowa
 1929 (photo), Hail, p127

White Buffalo Ceremony
 1892 (photo by J. Anderson) Hamilton, H., p152
 Close-up of alter, 1892 (photo by J. Anderson) Hamilton, H., p153
 Daughter of Hollow Horn Bear on their way to ceremony, 1892 (photo by J. Anderson) Hamilton, H., p151
 Feast, 1892 (photo by J. Anderson) Hamilton, H., p153
 Rosebud Sioux, 1892 (photo), Anderson, J., no paging

White Buffalo Cow (Pteh-Skah): Assiniboine Chief
 (painting by K. Bodmer), 1833, Moore (*Native*), p243
 (watercolor by K. Bodmer), Bodmer, p202

White Buffalo Cow Society
 Mandan Indians, lodge plan of the White Buffalo Cow Women's Society (line drawing) Bower, A., p327
 (drawing by K. Bodmer), Schneider, p61

White Buffalo Man, Frank: Sioux Artist
 (photo), *Contemporary Sioux Painting*, p40
 Two Scouts, 1968 (painting), *Contemporary Sioux Painting*, p41

White Buffalo Woman: Cheyenne
 (group photo), Moore, J. (*Cheyenne Nation*), p269

White Bull: Minneconjou Sioux
 Custer Battle, had many coups (photo) Michno, G., p26

White Bull: Northern Cheyenne
 (photo by L.A. Huffman), Brown, M., p222, Grinnell (*Cheyenne*), p288, Vaughn, p80+
 1880 (photo by Barthelmess), Greene, J. (*Lakota*), p137
 1880 (photo by Barthelmess), Greene, J. (*Yellowstone*), p204

White Bull (Ice): Sac and Fox
 (group photo by L.A. Huffman), Brown, M., p106

White Bull, Joseph (Pte San Hunka): Sioux Chief
 1930 (photo), Hutton, P., p383
 1932 (photo) Vestal, S., (*Warpath*), p254+
 (photo), Vestal, S. (*Warpath*), p208+
 Items from White Bull's Pictorial Autobiography (Scetches), Vestal, S. (*Warpath*), p158+
 Rescue Drawings, Rice, J., p22

White Calf (Te-shu-nzt): Crow
 (group photo) 1873, Sturtevant, v13, p699

White Calf: Piegan Blackfoot
 1886 (photo) Old Agency, Farr, W., p19
 1891 (group photo) Delegation to Washington DC, (group photo), Farr, W., p63
 1897 (photo) Principal Piegan Chiefs, Ewers, J. (*Story*), p53
 (group photo by J.N. Choate), Farr, W., p37
 (photo), Ewers, J., (*Blackfeet*), p239+
 Stabs-Down-By-Mistake, addressing Tribal Council, with White Calf and Rides-at-the-Door looking on, 1930s (photo), Farr, W., p137

White Calf, Jr.: Blackfoot
 Son of White Calf, 1923 (photo), Ewers, J. (*Blackfeet*), p238

White Calf, Jim: Blackfoot
 (photo), Hungry Wolf, A., p288

White Cap: Sisseton
 (photo), 1885, Diedrich, M. (*Odyssey*) p63, p98

White Cloud (Mahaska, Ma-has-kah, Mew-hu-she-kaw): Ioway
 (painting), Blaine (*Ioway*), p141
 (painting by C.B. King), 1824, Vogle, p38
 (painting by G. Catlin), (color photo), McKenney v1, p284+
 (sketch by G. Catlin), Blaine (*Ioway*), p231, Heyman, p71

White Cloud (No Heart, Notch-ee-níng): Ioway
 (watercolor by George Catlin), Troccoli, p112

White Cloud (Wah-Pe-Kee-Suck): Sac and Fox
 (painting by G. Catlin), 1832, Heyman, p54

White Cloud, James: Ioway
 (photo), Blaine (*Ioway*), p297

White Cloud, Mary: Ioway
 (photo), Blaine (*Ioway*), p297

Wood, T.W.: Artist
Sioux Chief Little Crow (painting), Oehler, C., p144+

Wood, Thomas (Little Chief): Omaha Indian
(group photo) 1866, Barnes p114+

Woodard, Lizzie: Kiowa
(photo), Hail, p121

Wooden Ladle (A-Mis-Quam): Winnebago
(color photo), McKenney v2, p274+

Wooden Lance (Apiatan): Kiowa
After peyote meeting, 1894 (group photo), Schweinfurth, p178
Chief delegate to Washington, 1894 (photo), Mayhall (*Kiowas*), p222+

Wooden Leg: Northern Cheyenne
1920 (photo), Greene, J. (*Lakota*) p5, 1927 (photo), Limbaugh, R.H. pv., Michno, G., p35, Robinson, C., p192+
1927 (photo) Interviewed by Dr. Marquis, Limbaugh, R.H., pxi
Carrying wounded (drawing), Hedren, P., p170
Drawing in ledger, 1928 (photo by Marquis) Maurer, E., p42
Drawing of killing Reno's soldiers, Greene, J. (*Lakota*), p66
Drawing of seizing soldier's gun, Greene, J. (*Lakota*), p63

Woodland Archaeological Culture
Burials
Casey's Mound Group (drawing), McKusick (*Men*), p121
Red Ocher Burial Cult (drawing), McKusick (*Men*), p109
Stone vaults (photo), McKusick (*Men*), p112
Central Lowland Plains, 500–900 AD (map) Schlesier, K., p208
Cloth
Woven hemp (photo), McKusick (*Men*), p117
Cook Farm Mound
Effigy platform pipes (photo), McKusick (*Men*), p115
Effigy Mounds
Marching Bear Mound, Iowa, McKusick (*Men*), p126
Panthers
Clayton County (drawing), McKusick (*Men*), p125
Effigy platform pipes (photo)
Iowa, Mckusick (*Men*), p115
High Plains (map) Schlesier, K., p230
Pottery
Iowa (photo), McKusick (*Men*), p96
Tools
Ax, copper (photo), McKusick (*Men*), p117

Scrapers & knives (drawing), McKusick (*Men*), p87
Stone, McKusick (*Men*), p84

Woodpecker Shelter Site: Iowa (State)
Rock shelter (photos), McKusick (*Men*), p21

Wool Woman: Cheyenne Indians
(photo), Grinnell (*Cheyenne*), p144+

Woolworth, Arnold: Arapaho
1911 (group photo), Fowler (*Tribal*), p58+

Worcester, Samuel Austin: Missionary
(photo) Bass, frontispiece, Ehle, p328+, Pierce, p33

Word of Life (Notoie-Poochsen): Piegan Blackfeet
(painting by K. Bodmer), Moore (*Native*), p247
(watercolor by K. Bodmer), Bodmer, p244

Workman, William: Trader
(photo), Rister, p181

Worksu, Tobin: Comanche
1900 (photo) With Two U.S. Marshal friends with lady, Noyes, (*Comanches*), pv

Wounded Knee 1890
Big Foot, December 1890 (photo), Fielder, M., p54
Bracelets
Brass Wire bracelets (photo), Hanson, J., p99
Nickle plated brass (photo), Hanson, J., p84
Ribbed brass (photo), Hanson, J., p83
Burial detail (photo), Starita, J., p130
Casualties
The following day (photo by G. Trager), Larson, R., p169+
Gathering the dead (photo), Spindler, W., p5
Sioux dead
December 1890 (photo), Fielder, M., p54, Spindler, W., p27
(photo), Jones, G., p186
Chapel of the Holy Cross
Pine Ridge, used as a hospital for the Wounded Knee victims (photo), Eastman, E., p48+
Map of battlefield, Green, J., p34
Mass grave where monument was erected in memory of Chief Big Foot (photo), Spindler, W., p12

Wounded Knee 1973
Banks, Dennis
1973 (photo), Crow Dog, L., p152+
Black Elk, Wallace
Praying (photo), Crow Dog, L., p152+
Church at Wounded Knee, 1973 (photo by Luck), Crow Dog, M. p110+
Crow Dog, Leonard
1973 (photo), Crow Dog, M., p110+

Y

Z

Bibliography

Adam, Hans-Christian. *Edward Sheriff Curtis, 1868–1952*. New York: Taschen, 1999.

Adams, Alexander B. *Geronimo: A Biography*. New York: Putman, 1971.

Albright, Peggy. *Crow Indian Photographer*. Albuquerque: University of New Mexico, 1997.

Aleshire, Peter. *The Fox and the Whirlwind: General George Crook and Geronimo: A Paired Biography*. New York: Wiley, 2000.

Alex, Lynn Marie. *Exploring Iowa's Past: A Guide to Prehistoric Archaeology*. Iowa City: University of Iowa Press, 1980.

Alfred Jacob Miller: Artist on the Oregon Trail. Edited by Ron Tyler. Fort Worth, Tex.: Amon Carter Museum of Western Art, 1982.

American Indian Grandmothers: Traditions and Transitions. Albuquerque: University of New Mexico Press, 1999.

Anderson, Bernice G. *Mrs. Indian Sleep-man Tales: Authentic Legends of the Otoes Tribe*. New York: Bramhall House, 1950.

Anderson, Gary. *Little Crow: Spokesman for the Sioux*. Minneapolis: Minnesota Historical Society, 1986.

Anderson, John A. *Crying for a Vision, a Rosebud Trilogy 1886–1976*. Dobbs Ferry, N.Y.: Morgan & Morgan, 1976.

Approaches to Teaching Momaday's the Way to Rainy Mountain. Edited by Kenneth M. Roemer. New York: Modern Language Association of America, 1988.

Arnold, Morris S. *The Rumble of a Distant Drum: The Quapaws and Old World Newcomers, 1673–1804*. Fayetteville: University of Arkansas Press, 2000.

The Assiniboines. Kennedy, M. S., ed. Norman: University of Oklahoma Press, 1961.

Baird, W. David. *The Osage People*. Phoenix: Indian Tribal Series, 1972.

_____. *The Quapaw Indians: A History of the Downstream People*. Norman: University of Oklahoma Press, 1980.

_____. *The Quapaw People*. Phoenix: Indian Tribal Series, 1975.

_____. *The Quapaws*. New York: Chelsea House Publishers, 1989.

Barnes, R. H. *Two Crows Denies It: A Historical Controversy in Omaha Sociology*. Lincoln: University of Nebraska Press, 1984.

Barrett, Stephen M. *Sinkah, the Osage Indian*. Oklahoma City: Harlow Publishing Co., 1916.

Bass, Altha Leah (Bierbower). *Cherokee Messenger*. Norman: University of Oklahoma Press, 1936.

Bataille, Gretchen, et al. *The Worlds Between Two Rivers*. Ames: Iowa State University Press, 1978.

Battey, Thomas C. *The Life and Adventures of a Quaker Among the Indians*. Norman: Oklahoma: University of Oklahoma Press, 1968.

Beckwith, Martha. *Mandan-Hidatsa Myths and Ceremonies*. New York: American Folk-Lore Society, 1969.

Belous, Russell E. *Will Soule: Indian Photographer at Fort Sill, Oklahoma, 1869–74*. Los Angeles: Ward Ritche Press, 1969.

Berthrong, Donald J. *The Cheyenne and Arapaho Ordeal*. Norman: University of Oklahoma Press.

_____. *The Southern Cheyenne*. Norman: University of Oklahoma, 1963.

Blaine, Martha Royce. *The Ioway Indians*. Norman: University of Oklahoma Press, 1979.

_____. *Pawnee Passage, 1870–1875*. Norman: University of Oklahoma, 1990.

_____. *The Pawnees: A Critical Bibliography*. Bloomington: Indiana University, 1980.

_____. *Some Things Are Not Forgotten: A Pawnee Family Remembers*. Lincoln: University of Nebraska Press, 1997.

Bodmer, Karl. *Karl Bodmer's America*. Lincoln: University of Nebraska Press, 1984.

Bonvillain, Nancy. *The Cheyennes People of the Plains*. Brookfield, Conn.: Native Americans, 1996.

_____. *The Santee Sioux*. Philadelphia: Chelsea House Publishing, 1997.

Boughter, Judith A. *Betraying the Omaha Nation, 1790–1916*. Norman: University of Oklahoma Press, 1998.

Bowers, Alfred. *Mandan Social and Ceremonial Organization*. University of Chicago Press, 1950.

Boye, Alan. *Holding Stone Hands: On the Trail of the Cheyenne Exodus*. Lincoln: University of Nebraska Press, 1999.

Brill, Charles J. *Conquest of the Southern Plains: Uncensored Narrative of the Battle of the Washita and Custer's Southern Campaign*. Oklahoma City: Golden Saga Publishers, 1938.

Brokenleg, M. *Yanktonai Sioux Water Colors, Cultural Remembrances of John Saul*. Sioux Falls: Center for Western Studies, 1993.

Brown, Dee. *Fort Phil Kearny: An American Saga*. New York: G.P. Putnam's Sons, 1962.

Brown, Mark Herbert. *The Frontier Years*. New York: Holt, 1955.

Buecker, Thomas. *The Crazy Horse Surrender Ledger*. Lincoln: Nebraska State Historical Society, 1994.

Callahan, Alice Anne. *The Osage Ceremonial Dance I'n-Lon-Schka*. Norman: University of Oklahoma Press, 1990.

Capps, Benjamin. *The Warren Wagontrain Raid: The First Complete Account of an Historic Indian Attack and Its Aftermath*. New York: Dial Press, 1974.

Carley, Kenneth. *The Sioux Uprising of 1862*. St. Paul: The Minnesota Historical Society, 1961.

Carrington, Henry. *The Indian Question*. New York: Sol Lewis, 1973.

Cash, Joseph H., and Gerald W. Wolff. *The Comanche People*. Phoenix: Indian Tribal Series, 1974.

_____ and _____. *The Three-Affiliated Tribes: Mandan, Arikara and Hidatsa*. Phoenix: Indian Tribal Series, 1974.

Catches, P. S. *Sacred Fireplace (Oceti Wakan): Life and Teachings of a Lakota Medicine Man*. Santa Fe: Clear Light Publishers, 1999.

Chalfant, William Y. *Cheyennes and Horse Soldiers: The 1857 Expedition and the Battle of Solomon's Fork*. Norman: University of Oklahoma Press, 1989.

_____. *Cheyennes at Dark Water Creek*. Norman: University of Oklahoma Press, 1997.

_____. *Dangerous Passage: The Santa Fe Tail and the Mexican War*. Norman: University of Oklahoma Press, 1994.

_____. *Without Quarter: The Wichita Expedition and the Fight on Crooked Creek*. Norman: University of Oklahoma Press, 1991.

Chamberlain, Von Del. *When Stars Came Down to Earth: Cosmology of the Skidi Pawnee Indians of North America*. Los Altos, Calif.: Ballena Press, 1982.

Clark, Blue. *Lone Wolf v. Hitchcock: Treaty Rights and Indian Law at the End of the Nineteenth Century*. Lincoln: University of Nebraska Press, 1994.

Clarke, Mary (Whatley). *Chief Bowles and the Texas Cherokees*. Norman: University of Oklahoma, 1971.

Clodfelter, Micheal. *The Dakota War: The United States Army Versus the Sioux, 1862–1865*. Jefferson, N.C.: McFarland, 1998.

Coe, Ralph. *Lost and Found Traditions: Native American Art, 1965–85*. Seattle: University of Washington, 1986.

Coel, Margaret. *Chief Left Hand Southern Arapaho*. Norman: University of Oklahoma Press, 1981.

Collins, Charles. *An Apache Nightmare: The Battle at Cibecue Creek*. Norman: University of Oklahoma Press, 1999.

Contemporary Native American Art. Stillwater: Oklahoma State University, 1983.

Contemporary Southern Plains Indian Metalwork. Anadarko: Oklahoma Indian Arts and Crafts Cooperative, 1976.

Contemporary Sioux Painting. Indian Arts and Crafts Board of the United States Department of the Interior. Rapid City, S. Dakota, 1970.

Contemporary Southern Plains Indian Painting. Anadarko: Oklahoma Indian Arts and Crafts Cooperative, 1972.

Crary, Margaret. *Susette La Flesche: Voice of the Omaha Indians*. New York: Hawthorn Books, 1973.

Crazy Horse School. Pute Tiyospaye (Lip's Camp): The History and Culture of a Sioux Indian Village. Albuquerque: Skives-Bunnell, Inc., 1978.

The Crazy Horse Surrender Ledger. Lincoln: Nebraska State Historical Society, 1994.

Crow Dog, L., and R. Erdoes. *Crow Dog: Four Generations of Sioux Medicine Men*. New York: HarperCollins, 1995.

Crow Dog, M., and R. Erdoes. *Lakota Woman*. New York: Grove Weidenfeld, 1990.

Curtis, Edward S. *Edward Sheriff Curtis: Visions of a Vanishing Race*. American Legacy Press, 1981.

_____. *The Plains Indian Photographs of Edward S. Curtis*. Lincoln: University of Nebraska Press, 2001.

Dallman, John E. *A Choice of Diet: Response to Climatic Change*. Iowa City: Office of the State Archaeologist, University of Iowa, 1983.

Diedrich, M. *Famous Chiefs of the Eastern Sioux*. Minneapolis: Coyote Books, 1987.

_____. *The Odyssey of Chief Standing Buffalo and the Northern Sisseton Sioux*. Minneapolis: Coyote Books, 1988.

DeMontravel, Peter. *A Hero to His Fighting Men*. Kent, Ohio: Kent State University Press, 1998.

Dempsey, Hugh. *The Amazing Death of Calf Shirt and Other Blackfoot Stories*. Norman: University of Oklahoma Press, 1994.

Denig, Edwin. T. *The Assiniboine*. Norman: University of Oklahoma Press, 2000.

Diessner, Don. *There Are No Indians Left But Me! Sitting Bull's Story*. California: Upton and Sons, 1993.

Din, Gilbert C. *The Imperial Osages: Spanish-Indian Diplomacy in the Mississippi Valley*. Norman: University of Oklahoma Press, 1983.

Dippie, Brian. *Custer's Last Stand: The Anatomy of an American Myth*. Lincoln: University of Nebraska Press, 1976.

Dobyns, Henry F. *The Mescalero Apache People*. Phoenix: Indian Tribal Series, 1973.

Doll, Don. *Vision Quest: Men, Women, and Sacred Sites of the Sioux Nation*. New York: Crown Publishers, Inc., 1994.

Dorsey, George A. *Traditions of the Skidi Pawnee*. New York: Kraus Reprint, 1969.

Dorsey, James Owen. *Omaha Sociology*. New York: Johnson Reprint Corp, 1970.

Eastman, Elaine Goodale. *Sister to the Sioux*. Lincoln: University of Nebraska Press, 1978.

Eastman, Mary. *Dahcotah; or, Life and Legends of the Sioux Around Fort Snelling*. Minneapolis: Ross & Haines, 1962.

_____. *Dahcotah, or Life and Legends of the Sioux around Fort Snelling*. Afton, MN: Afton Historical Society, 1995.

Edmunds, R. David. *The New Warriors*. Lincoln: University of Nebraska Press, 2001.

_____. *The Otoe-Missouria People*. Phoenix: Indian Tribal Series, 1976.

Ehle, John. *Trail of Tears: The Rise and Fall of the Cherokee Nation*. New York: Doubleday, 1988.

1877: Plains Indian Sketch Books of Zo-Tom & Howling Wolf. Introduction by Dorothy Dunn. Flagstaff: Northland Press, 1969.

Ellis, Clyde. *To Change Them Forever: Indian Education at the Rainy Mountain Boarding School*. Norman: University of Oklahoma Press, 1996.

Ewers, John. *The Blackfeet: Raiders on the Northwestern Plains*. Norman: University of Oklahoma Press, 1958.

_____. *Murals in the Round: Painted Tipis of the Kiowa and Kiowa-Apache Indians*. Washington:

Published for the Renwick Gallery of the National Collection of Fine Arts by the Smithsonian Institution Press, 1978.

_____. *Plains Indians History and Culture*. Norman: University of Oklahoma, 1997.

_____. *The Story of the Blackfeet*. Lawrence, Kansas: Haskall Institute, 1952.

_____. *Views of a Vanishing Frontier*. Omaha, Neb.: Center for Western Studies/Joslyn Art Museum, 1984.

Farnell, Brenda. *Do You See What I Mean? Plains Indian Sign Talk and the Embodiment of Action*. Austin: University of Texas Press, 1995.

Farr, William. *The Reservation Blackfeet, 1882–1945: A Photographic History of Cultural Survival*. Seattle: University of Washington Press, 1984.

Farrer, Claire R. *Living Life's Circle: Mescalero Apache Cosmovision*. Albuquerque: University of New Mexico, 1991.

Feraca, Stephen. *Wakinyan Lakota Religion in the Twentieth Century*. Lincoln: University of Nebraska Press, 1998.

Ferris, Jeri. *Native American Doctor: The Story of Susan La Flesche Picotte*. Minneapolis: Carolrhoda Books, 1991.

Fielder, Mildred. *Sioux Indian Leaders*. Seattle: Superior Publishing, 1975.

Flood, R. Sansom. *Remember Your Relatives: Yankton Sioux Images, 1851–1904, Volume 1*. Marty: Marty Indian School, 1985.

_____. *Remember Your Relatives: Yankton Sioux Images, 1865–1915, Volume 2*. Marty: Yankton Sioux Elderly Advisory Board, 1989.

Fortune, Reo. F. *Omaha Secret Societies*. New York: Columbia University Press, 1932.

Foster, Morris W. *Being Comanche: A Social History of and American Indian Community*. Tucson: University of Arizona Press, 1991.

Foster, Thomas. *The Iowa*. Cedar Rapids, Iowa: Torch Press, 1911.

Fowler, Loretta. *The Arapaho*. New York: Chelsea House Publishers, 1989.

_____. *Arapahoe Politics, 1851–1978: Symbols in Crises of Authority*. Lincoln: University of Nebraska Press, 1982.

_____. *Shared Symbols, Contested Meanings: Gros Ventre Culture and History, 1778–1984*. Ithaca: Cornell University Press, 1987.

_____. *Tribal Sovereignty and the Historical Imagination: Cheyenne-Arapaho Politics*. Lincoln: University of Nebraska Press, 2002.

Geronimo, Apache Chief. *Geronimo's Story of His Life*. New York: Garrett Press, 1969.

Glenn, Elizabeth J. *Physical Affiliations of the Oneota Peoples*. Iowa City: Office of State Archaeologist, University of Iowa, 1974.

Grange, Roger T. *Pawnee and Lower Loup Pottery*.

Lincoln: Nebraska State Historical Society, 1968.

Green, Charles Ransley. *Early Days in Kansas.* Olathe: Kansas, 1913.

Green, Jerry. *After Wounded Knee: Correspondence of Major and Surgeon John Vance Lauderdale While Serving the Army Occupying the Pine Ridge Indian Reservation, 1890–1891.* East Lansing: Michigan State University Press, 1996.

Greene, A.C. *The Last Captive.* Austin: Encino Press, 1972.

Greene, Candace S. *Silver Horn: Master Illustrator of the Kiowas.* Norman: University of Oklahoma Press, 2001.

Greene, Jerome. *Battles and Skirmishes of the Great Sioux War, 1876–1877: The Military View.* Norman: University of Oklahoma, 1993.

_____. *Lakota and Cheyenne: Indian Views of the Great Sioux War, 1876–1877.* Norman: University of Oklahoma Press, 1994.

_____. *Yellowstone Command: Colonel Nelson A. Miles and the Great Sioux War, 1876–1877.* Lincoln: University of Nebraska Press, 1991.

Grinnell, George B. *The Cheyenne Indians, Their History and Ways of Life.* New Haven: Yale University Press, 1923.

_____. *The Fighting Cheyennes.* Norman: University of Oklahoma Press, 1956

_____. *Pawnee Hero Stories and Folk-Tales.* Lincoln: University of Nebraska Press, 1961.

_____. *Two Great Scouts and Their Pawnee Battalion.* Lincoln: University of Nebraska Press, 1973.

A Guide to the Kiowa Collections at the Smithsonian Institution. William L. Merrill. Washington, D.C.: Smithsonian Institution Press, 1997.

Gump, James. *The Dust Rose Like Smoke: The Subjugation of the Zulu and the Sioux.* Lincoln: University of Nebraska Press, 1994.

Hagan, William Thomas. *United States–Comanche Relations: The Reservation Years.* New Haven: Yale University Press, 1976.

Hail, Barbara A. *Gifts of Pride and Love: Kiowa and Comanche Cradles.* Bristol: Brown University, 2000.

Hamilton, Henry. & J. Hamilton. *The Sioux of the Rosebud: A History in Pictures.* Norman: University of Oklahoma Press, 1971.

Hanson, James A. *Metal Weapons, Tools, and Ornaments of the Teton Dakota Indians.* Lincoln: University of Nebraska Press, 1975.

Hanson, Jeffery R. *Hidatsa Culture Change, 1780–1845: A Cultural Ecological Approach.* Lincoln: J. & L. Reprint Company, 1987.

Harcey, Dennis W. & Brian R. *Croone with Joe Medicine Crow.* White-Man-Runs-Him: Crow Scout with Custer. Evanston, Ill.: Evanston Publishing, Inc., 1993.

Harris, LaDonna. *LaDonna Harris: A Comanche Life.* Lincoln: University of Nebraska Press, 2000.

Harvey, Amy E. *Oneota Culture in Northwestern Iowa.* Iowa City: Office of the State Archaeologist, University of Iowa, 1979.

Hassrick, Royal. *The Sioux: Life and Customs of a Warrior Society.* Norman: University of Oklahoma, 1964.

Hedren, Paul. *The Great Sioux War 1876–77.* Helena: Montana Historical Society Press, 1991.

Heyman, Therese T. & George Gurney. *George Catlin and His Indian Gallery.* Washington, D.C.: Smithsonian American Art Museum, 2002.

Hoebel, Edward A. *The Cheyennes: Indians of the Great Plains.* New York: Holt, Rinehart and Winston, Inc., 1960.

Hoig, Stan. *The Battle of the Washita: The Sheridan-Custer Indian Campaign of 1867–69.* New York: Doubleday & Company, 1976.

_____. *Fort Reno and the Indian Territory Frontier.* Fayetteville: University of Arkansas Press, 2000.

_____. *The Kiowas and the Legend of Kicking Bird.* Niwot: University Press of Colorado, 2000.

_____. *The Sand Creek Massacre.* Norman: University of Oklahoma Press, 1961.

Horse Capture, Joseph D. *Beauty, Honor and Tradition: The Legacy of Plains Indian Shirts.* Washington, D.C.: National Museum of the American Indian, Smithsonian Institution, 2001.

Hoover, Herbert. *Wildlife on the Cheyenne River and Lower Brule Sioux Reservation: A History of Use and Jurisdiction.* University of South Dakota: Dakota Books, 1992.

_____. *The Yankton Sioux.* New York: Chelsea House Publishers, 1988.

Howell, Darrel. *Reflections: The Darrel S. Howell Collection.* Stockton, Calif.: D. Howell, 1995.

Hoxie, Frederick. *Parading Through History: The Making of the Crow Nation in America, 1805–1935.* New York: Cambridge University Press, 1995.

Hungry Wolf, Adolf. *The Blood People: A Division of the Blackfoot Confederacy.* New York: Harper & Row, 1977.

Hunt, David C. *Legacy of the West.* Omaha, Neb.: Joslyn Art Museum, 1982.

Hunt, Walter Bernard. *The Golden Book of Indian Crafts and Lore.* New York: Golden Press, 1964.

Hutton, Paul. *The Custer Reader.* Lincoln: University of Nebraska Press, 1992.

Hyde, George E. *Life of George Bent: Written from His Letters.* Norman: University of Oklahoma Press, 1968.

_____. *Pawnee Indians.* The University of Denver Press, 1951.

_____. *The Pawnee Indians*. Norman: University of Oklahoma Press, 1974.

_____. *Red Cloud's Folk: A History of the Oglala Sioux Indians*. Norman: University of Oklahoma, 1967.

_____. *A Sioux Chronicle*. Norman: University of Oklahoma, 1956.

_____. *Spotted Tail's Folk: A History of the Brule Sioux*. Norman: University of Oklahoma Press, 1961.

Indians of South Dakota. Bulletin No. 67A. Revised by J. Artichoker, South Dakota Department of Public Instruction, 1956.

Innis, Ben. *Bloody Knife: Custer's Favorite Scout*. Fort Collins: The Old Army Press, 1973.

Irving, John Treat. *Indian Sketches, Taken During an Expedition to the Pawnee Tribes, 1833*. Norman: University of Oklahoma Press, 1955.

Johnson, Troy R. *Distinguished Native American Spiritual Practitioners and Healers*. Westport, Conn.: Oryx Press, 2002.

Jones, David E. *Sanapia: Comanche Medicine Woman*. New York: Holt, Rinehart and Winston, 1972.

Jones, Douglas C. *The Treaty of Medicine Lodge: The Story of the Great Treaty Council as Told by Eyewitnesses*. Norman: University of Oklahoma Press, 1966.

Jones, Gene. *Where the Wind Blew Free: Tales of Young Westerners*. New York: Norton, 1967.

Jones, William Kirkland. *Notes on the History and Material Culture of the Tonkawa Indians*. Washington: Smithsonian Press, 1969.

Karolevitz, R. *Bishop Martin Marty: "The Black Robe Lean Chief."* Yankton, S.D.: Sacred Heart Convent, 1980.

Kavanagh, Thomas. *Commanche Political History*. Lincoln: University of Nebraska Press, 1996.

Killing of Crazy Horse. Glendale, Calif.: Arthur H. Clark Company, 1976.

Kime, Wayne R. *The Indian Territory Journals of Colonel Richard Irving Dodge*. Norman: University of Oklahoma Press, 2000.

Kroeber, Alfred L. *The Arapaho*. Lincoln: University of Nebraska Press, 1983.

Lacey, Theresa Jensen. *The Pawnee*. New York: Chelsea House Publishers, 1996.

La Flesche, Francis. *The Middle Five: Indian Schoolboys of the Omaha Tribe*. Madison, University of Wisconsin Press, 1963.

_____. *The Osage and the Invisible World: From the Works of Francis Le Flesche*. Norman: University of Oklahoma, 1995.

Larson, Robert. *Red Cloud: Warrior-Statesman of the Lakota Sioux*. Norman: University of Oklahoma Press, 1997.

Lassiter, Luke E. *The Power of Kiowa Song: A Collaborative Ethnography*. Tucson: University of Arizona Press, 1998.

Laubin, Reginald. *The Indian Tipi: Its History, Construction and Use*. Norman: University of Oklahoma Press, 1977.

Lee, Nelson. *Three Years Among the Comanches*. Norman: University of Oklahoma Press, 1957.

Limbaugh, R.H. *Cheyenne and Sioux: The Reminiscences of Four Indians and a White Soldier*. Stockton, Calif.: Pacific Center for Western Historical Studies, University of the Pacific, 1973.

Linton, Ralph. *The Sacrifice to the Morning Star by the Skidi Pawnee*. Chicago: Field Museum of Natural History, 1922.

Lowie, Robert H. *The Crow Indians*. New York: Farrar & Rinehart, 1935.

Luce, Edward S. *Keogh, Comanche, and Custer*. Ashland, Oregon: L. Osborne, 1974.

MacEwan, John. *Sitting Bull: The Years in Canada*. Edmonton: Hurtig, 1973.

Mails, Thomas E. *The Mystic Warriors of the Plains*. New York: Marlowe & Company, 1972.

_____. *The People Called Apache*. Englewood Cliffs, N.J.: Prentice-Hall, 1974.

_____. *Sundancing: The Great Sioux Piercing Ritual*. San Francisco: Council Oak Books, 1978.

Malone, Henry Thompson. *Cherokees of the Old South*. Athens: University of Georgia Press, 1956.

Manzione, Joseph. *"I Am Looking to the North for My Life": Sitting Bull, 1876–1881*. Salt Lake City: University of Utah, 1991.

Marquis, Thomas. *Memories of a White Crow Indian*. New York: The Century Co., 1928.

Marrin, Albert. *Plains Warrior: Chief Quanah Parker and the Comanches*. New York: Atheneum Books for Young Readers, 1996.

Marriott, Alice Lee. *Saynday's People: The Kiowa Indians and the Stories They Told*. Lincoln: University of Nebraska Press.

_____. *The Ten Grandmothers*. Norman: University of Oklahoma Press, 1945.

Mathews, John Joseph. *The Osages: Children of the Middle Waters*. Norman: University of Oklahoma Press, 1961.

Matthiessen, Peter. *In the Spirit of Crazy Horse*. New York: Viking, 1980.

Maurer, Evan M. *Visions of the People: A Pictorial History of Plains Indian Life*. Minneapolis Institute of Arts, 1992.

Mayhall, Mildred P. *Indian Wars of Texas*. Waco, Texas: Texan Press, 1965.

_____. *The Kiowas*. Norman: University of Oklahoma Press, 1962.

McAndrews, Edward. *The American Indian Photo Post Card Book*. Los Angeles: Big Heart Pub. Co., 2002.

McClintock, Walter. *Painted Tipis and Picture-Writing of the Blackfoot Indians*. Los Angeles: Southwest Museum Leaflets.

McGaa, Ed. *Red Cloud: The Story of an American Indian.* Minneapolis: Dillon Press, 1971.

McGillycuddy, J. *McGillycuddy Agent: A Biography of Dr. Valentine T. McGillycuddy.* California: Stanford University Press, 1941.

McKenney, Thomas Loraine. *The Indian Tribes of North America, with Biographical Sketches and Anecdotes of the Principal Chiefs.* Edinburgh: J. Grant, 1933–34.

McKusick, Marshall B. *The Grant Oneota Village.* Iowa City: University of Iowa, 1973.

_____. *The Iowa Northern Brigade.* Iowa City: Office of State Archaeologist, University of Iowa, 1975.

_____. *Men of Ancient Iowa, as Revealed by Archeological Discoveries.* Ames: Iowa State University Press, 1964.

McLoughlin, William Gerald. *After the Trail of Tears: The Cherokees' Struggle for Sovereignty, 1839–1880.* Chapel Hill: University of North Carolina Press, 1993.

Meadows, William C. *Kiowa, Apache, and Comanche Military Societies: Enduring Veterans, 1800 to the Present.* Austin: University of Texas Press, 1999.

Merrill, William. *A Guide to the Kiowa Collections at the Smithsonian Institution — Washington.* Smithsonian Institution Press, 1997.

Methvin, J.J. *Andele; Or, The Mexican-Kiowa Captive.* New York: Garland Pub., 1976.

Meyer, Roy W. *History of the Santee Sioux: United States Indian Policy on Trial.* Lincoln: University of Nebraska Press, 1967.

_____. *The Village Indians of the Upper Missouri: The Mandans, Hidatsas and Arikaras.* Lincoln, University of Nebraska Press, 1977.

Michno, Gregory. *Lakota Noon: The Indian Narrative of Custer's Defeat.* Missoula: Mountain Press Publishing Company, 1997.

Miles, Nelson A. *A Hero to His Fighting Men.* Ohio: Kent State University Press, 1998.

Miller, Alfred Jacob. *Braves and Buffalo: Plains Indian Life in 1837.* Toronto: University of Toronto Press, 1973.

Milner, Clyde. A. *With Good Intentions: Quaker Work Among the Pawnees, Otos, and Omahas.* Lincoln: University of Nebraska, 1982.

Milton, John. *Crazy Horse: The Story of an American Indian.* Minneapolis: Dillon Press, 1974.

Minor, Marz. *The American Indian Craft Book.* Lincoln: University of Nebraska Press.

Monnett, John H. *The Battle of Beecher Island and the Indian War of 1867–1869.* Niwot: University of Press of Colorado, 1992.

_____. *Massacre at Cheyenne Hole: Lieutenant Austin Henely and the Sappa Creek Controversy.* Niwot: University Press of Colorado, 1999.

_____. *Tell Them We Are Going Home: The Odyssey of the Northern Cheyennes.* Norman: University of Oklahoma Press, 2001.

Moore, John H. *The Cheyenne.* Cambridge: Blackwell Publishers, 1996

_____. *The Cheyenne Nation: A Social and Demographic History.* Lincoln: University of Nebraska Press, 1987.

_____. *The Political Economy of North American Indians.* Norman: University of Oklahoma Press, 1993.

Moore, Robert J. *Native Americans: A Portrait: The Art and Travels of Charles Bird King, George Catlin, and Karl Bodmer.* New York: Stewart, Tabori & Chang, 1997.

Moorhead, Max L. *The Apache Frontier: Jacobo Ugarte and Spanish-Indian Relations in Northern New Spain.* Norman: University of Oklahoma Press, 1968.

Murie, James R. *Ceremonies of the Pawnee, Part I: The Skiri.* Washington: Smithsonian Institution Press, 1981.

_____. *Ceremonies of the Pawnee, Part II: The South Bands.* Washington: Smithsonian Institution Press, 1981.

Nabokov, Peter. *Native American Architecture.* New York: Oxford University Press, 1989.

_____. *Two Leggings: The Making of a Crow Warrior.* New York: Thomas Y. Crowell, 1967.

Nebraska History: A Quarterly Magazine, vol. xxii, Jan.–March, 1941. Editor: Sheldon, Addison E. Lincoln: Nebraska State Historical Society, Dec. 1941.

Neeley, Bill. *The Last Comanche Chief: The Life and Times of Quanah Parker.* New York: J. Wiley, 1995.

The New Warriors: Native American Leaders Since 1900. Edited by R. David Edmunds. Lincoln: University of Nebraska Press, 2001.

Newcomb, William W. *The Indians of Texas: From Prehistoric to Modern Times.* Austin: Texas: University of Texas Press, 1961.

_____. *The People Called Wichita.* Phoenix: Indian Tribal Series, 1921–.

Newlin, Deborah L. *The Tonkawa People: A Tribal History from Earliest Times to 1893.* Lubbock, Texas: West Texas Museum Association, 1982.

North, Luther. *Man of the Plains: Recollections of Luther North, 1856–1882.* Lincoln: University of Nebraska, 1961.

Noyes, Stanley. *Los Comanches.* Albuquerque: University of New Mexico Press, 1993.

_____. *Comanches in the New West, 1895–1908: Historic Photographs.* Austin: University of Texas Press, 1999.

Nye, Wilbur S. *Carbine and Lance: The Story of Old Fort Sill.* Norman, University of Oklahoma Press, 1937.

_____. *Plains Indian Raiders: The Final Phases of Warfare from the Arkansas to the Red River with Original Photographs by William S. Soule.* Norman University of Oklahoma Press, 1968.

Oehler, Chester. *The Great Sioux Uprising.* New York: Oxford University Press, 1959.

Olson, James. *Red Cloud and the Sioux Problem.* Lincoln: University of Nebraska Press, 1965.

Opler, Morris Edward. *An Apache Life-Way: The Economic, Social, and Religious Institutions of the Chiricahua Indians.* Chicago: University of Chicago press, 1941.

O'Shea, John M. *Archaeology and Ethnohistory of the Omaha Indians: The Big Village Site.* Lincoln: University of Nebraska Press in cooperation with the American Indian Studies Research Institute, Indiana University, 1992.

Painted Tipis by Contemporary Plains Indian Artists. Indian Arts and Crafts Board, Oklahoma, 1973.

Penney, David. *Art of the American Indian Frontier.* Seattle: University of Washington Press, 1992.

Perry, Richard John. *Apache Reservation: Indigenous Peoples and the American State.* Austin: University of Texas Press, 1993.

Peters, Virginia. *Women of the Earth Lodges: Tribal Life on the Plains.* New Haven, CT: Archon Books, 1995.

Petersen, Karen. D. *Howling Wolf: A Cheyenne Warriors Graphic Interpretation of His People.* Palo Alto, Calif.: American West Publ. Co., 1968.

Peterson, Susan. *Pottery by American Indian Women: The Legacy of Generations.* New York: Abbeville Press, 1997.

Pierce, Earl, and R. Strickland. *The Cherokee People.* Phoenix: Indian Tribal Series, 1973.

Powers, Marla. *Oglala Women — Myth, Ritual, and Reality.* Chicago: University of Chicago Press, 1986.

Powers, William. *Yuwipip: Vision and Experience in Oglala Ritual.* Lincoln: University of Nebraska Press, 1982.

Price, Catherine. *The Oglala People, 1841–1879: A Political History.* Lincoln: University of Nebraska Press, 1996.

Radin, Paul. *The Winnebago Tribe.* Lincoln: University of Nebraska Press, 1970.

Ray, Verne F. *Ethnohistorical Analysis of Documents Relating to the Apache Indians of Texas.* New York: Garland, 1974.

Reedstrom, Ernest Lisle. *Apache Wars: An Illustrated Battle History.* New York: Sterling Pub. Co., 1990.

Revard, Carter. *Winning the Dust Bowl.* Tucson: University of Arizona Press, 2001.

Rice, Julian. *Before the Great Spirit: The Many Faces of Sioux Spirituality.* Albuquerque: University of New Mexico Press, 1998.

Richardson, Rupert N. *The Comanche Barrier to South Plains Settlement.* New York: Kraus Reprint Co., 1973.

Ridington, Robin. *Blessing for a Long Time: The Sacred Pole of the Omaha Tribe.* Lincoln: University of Nebraska Press, 1997.

Riebeth, Carolyn. *J.H. Sharp Among the Crow Indians, 1902–1910.* Upton and Sons, 1985.

Riggs, Mary. *A Small Bit of Bread and Butter: Letters from the Dakota Territory, 1832–1869.* South Deerfield: Ash Grove Press, 1996.

Rister, Carl Coke. *Comanche Bondage.* Lincoln: University of Nebraska Press, 1955.

Robinson, Charles. *A Good Year to Die: The Story of the Great Sioux War.* Norman: University of Oklahoma Press, 1995.

Robinson, Sherry. *Apache Voices: Their Stories of Survival as Told to Eve Ball.* Albuquerque: University of New Mexico Press, 2000.

Rollings, Willard H. *The Comanche.* New York: Chelsea House Publishers, 1989.

_____. *The Osage.* Columbia: University of Missouri Press, 1992.

Samek, H. *The Blackfoot Confederacy, 1880–1920— A Comparative Study of Canadian and U.S. Indian Policy.* Albuquerque: University of New Mexico Press, 1987.

Sandoz, Mari. *Cheyenne Autumn.* New York: McGraw-Hill, 1953.

Sanford, David A. *Indian Topics; or Experiences in Indian Missions with Selections from Various Sources.* New York: Broadway Publishing Co., 1911.

Scherer, Mark R. *Imperfect Victories: The Legal Tenacity of the Omaha Tribe, 1945–1995.* Lincoln: University of Nebraska Press, 1999.

Schlesier, Karl. *Plains Indians A.D. 500–1500.* Norman: University of Oklahoma Press, 1994.

Schneider, Mary J. *The Hidatsa.* New York: Chelsea House Publishers, 1989.

Schulenberg, Raymond. *Indians of North Dakota.* Bismarck: State Historical Society of North Dakota, 1956.

Schultz, Duane. *Month of the Freezing Moon: The Sand Creek Massacre, November 1864.* New York: St. Martin's Press, 1990.

_____. *Over the Earth I Come: The Great Sioux Uprising of 1862.* New York: St. Martin's Press, 1992.

Schwandt, Mary. *The Captivity of Mary Schwandt.* Fairfield, Washington: Ye Galleon Press, 1975.

Schweinfurth, Kay Parker. *Prayer on the Top of the Earth: The Spiritual Universe of the Plains Apache.* Boulder: University Press of Colorado, 2002.

Seger, John H. *Early Days Among the Cheyenne and Arapahoe Indians*. Norman: University of Oklahoma Press, 1934.

_____. *Early Days Among the Cheyenne and Arapahoe Indians*. Norman: University of Oklahoma Press, 1979.

Skarsten, M. *Those Remarkable People: The Dakotas*. Aberdeen, S.D.: North Plains Press, 1981.

Skinner, Alanson Buck. *Societies of the Iowa, Kansa, and Ponca Indians*. New York: The Trustees, 1915.

Smith, Carlyle. *The Talking Crow Site*. Lawrence: University of Kansas, 1977.

Smith, F. Todd. *The Caddos, the Wichitas, and the United States, 1846–1901*. College Station: Texas A&M University Press, 1996.

Sneve, Virginia Driving Hawk. *The Apaches*. New York: Holiday House, 1997.

_____. *Completing the Circle*. Lincoln: University of Nebraska Press, 1995.

_____. *They Led a Nation*. Sioux Falls, S.D.: Brevet Press, 1975.

Sommer, Robin L. *North American Indian Women*. North Dighton: JG Press, 1998.

Southwell, Kristina L. *Guide to Photographs in the Western History Collections of the University of Oklahoma*. Norman: University of Oklahoma Press, 2002.

Spindler, Will. *Tragedy Strikes at Wounded Knee*. Gordon, Neb: Gordon Journal, 1955.

Standing Bear, Luther. *My People, the Sioux*. Boston: Houghton Mifflin, 1928.

Starita, Joe. *The Dull Knifes of Pine Ridge*. New York: G. P. Putnam's Sons, 1995.

Stiles, Helen E. *Pottery of the American Indians*. New York: E.P. Dutton & Co., 1939.

Stockel, H. Henrietta. *Women of the Apache Nation: Voices of Truth*. Reno: University of Nevada Press, 1991.

Stories of the People: Native American Voices. Washington, D.C: National Museum of the American Indian, Smithsonian Institution in association with Universe Publishing, 1997.

Sturtevant, William. *Handbook of North American Indians*. Washington: Smithsonian Institution, 1978.

Szabo, Joyce M. *Painters, Patrons, and Identify Essays in Native American Art to Honor J.J. Brody*. Albuquerque: University of New Mexico Press, 2001.

Tate, Michael. *The Upstream People: An Annotated Research Bibliography of the Omaha Tribe*. Metuchen, N.J.: Scarecrow Press, 1991.

Taylor, Colin F. *Buckskin and Buffalo: The Artistry of the Plains Indians*. New York: Rizzoli, 1998.

Terry, Michael Bad Hand. *Daily Life in a Plains Indian Village, 1868*. New York: Clarion Books, 1999.

Thrapp, Dan L. *The Conquest of Apacheria*. Norman: University of Oklahoma Press, 1967.

_____. *Victorio and the Mimbres Apaches*. Norman: University of Oklahoma Press, 1974.

Tixier, Victor. *Tixier's Travels on the Osage Prairies*. Edited by John F. McDermontt, translated from the French by Albert J. Salvan. Norman: University of Oklahoma Press, 1940.

Tong, Benson. *Susan La Flesche Picotte: Omaha Indian Leader and Reformer*. Norman: University of Oklahoma Press, 1999.

Torrence, Gaylord. *Art of the Red Earth People: The Mesquakie of Iowa*. Iowa City: University of Iowa Museum of Art, 1989.

Trenholm, Virginia C. *The Arapahoes: Our People*. Norman: University of Oklahoma Press, 1970.

Troccoli, Joan Carpenter. *First Artist of the West: George Catlin Paintings and Watercolors from the Collection of Gilcrease Museum*. Tulsa, Oklahoma: Gilcrease Museum, 1993.

Tyson, Carl N. *The Pawnee People*. Phoenix: Indian Tribal Series, 1976

Unrau, William E. *Kansa Indians: A History of the Wind People, 1673–1873*. Norman: University of Oklahoma Press, 1971.

_____. *The Kaw People*. Phoenix: Indian Tribal Series, 1975.

Vaughn, Jesse. W. *The Reynolds Campaign on Powder River*. Norman: University of Oklahoma Press, 1961.

Vestal, Stanley. *New Sources of Indian History, 1850–1891; The Ghost Dance — the Prairie Sioux; a Miscellany*. Norman: University of Oklahoma Press, 1934.

_____. *Sitting Bull, Champion of the Sioux: A Biography*. Boston: Houghton Mifflin, 1932.

_____. *Warpath: The True Story of the Fighting Sioux, Told in a Biography of Chief White Bull*. Boston: Houghton Mifflin, 1934.

Visions of the People: A Pictorial History of Plains Indian Life. Evan M. Maurer; with essays by Evan M. Maurer ... [et al.]. Minneapolis: The Minneapolis Institute of Arts, 1992.

Vogel, Vigil J. *Iowa Place Names of Indian Origin*. Iowa City: University of Iowa Press, 1983.

Voget, Fred. *The Shoshoni-Crow Sun Dance*. Norman: University of Oklahoma Press, 1984.

Wallace, Ernest. *Ranald S. Mackenzie on the Texas Frontier*. College Station: Texas A & M University Press, 1993.

_____, and Adamson Hoebel. *The Comanches: Lords of the South Plains*. Norman: University of Oklahoma Press, 1952.

Walstrom, Veryl. *My Search for the Burial Sites of Sioux Nation Chiefs*. Lincoln, Neb.: Dageforde, 1995.

Walters, Anna Lee. *Talking Indian: Reflections on*

Survival and Writing. Ithaca, N.Y.: Firebrand Books, 1992.

Wemett, William. M. *The Indians of North Dakota.* Fargo: Northern School Supply Co., 1927.

White, Richard. *The Roots of Dependency: Subsistence, Environment, and Social Change Among the Choctaws, Pawnees, and Navajos.* Lincoln: University of Nebraska Press, 1983.

White Horse Eagle. *We Indians, the Passing of a Great Race; Being the Recollections of the Last of the Great Indian Chiefs, Big Chief White Horse Eagle, as Told to Edgar von Schmidt-Pauli; translated by Christoper Turner...* London: T. Butterworth, 1931.

Wildschut, William. *Crow Indian Beadwork: A Descriptive and Historical Study.* New York: Museum of the American Indian Heye Foundation, 1959.

_____. *Crow Indian Medicine Bundles.* New York: Museum of the American Indian Heye Foundation, 1960.

Wilson, Ruby E. *Frank J. North: Pawnee Scout Commander and Pioneer.* Chicago: Swallow Press, 1984.

Wilson, Terry P. *The Osage.* New York: Chelsea House, 1988.

_____. *The Underground Reservation: Osage Oil.* Lincoln: University of Nebraska Press, 1985.

Wood, Raymond, ed. *Archaeology on the Great Plains.* Lawrence: University of Kansas Press, 1998.

_____, and Thiessen, T. *Early Fur Trade on the Northern Plains: Canadian Traders Among the Mandan and Hidatsa Indians, 1738–1818.* Norman: University of Oklahoma Press, 1985.

Woodruff, Janette. *Indian Oasis.* Idaho: Caxton Printers, 1939.

Wunder, John R. *The Kiowa.* New York: Chelsea House, 1989.

Yellowtail, Thomas. *Yellowtail, Crow Medicine Man and Sun Dance Chief: An Autobiography,* as told to Michael O. Fitzgerald. Norman: University of Oklahoma Press, 1991.

Young Bear, Ray A. *Black Eagle Child: The Facepaint Narratives.* Iowa City: University of Iowa Press, 1992.